Van Dyck

1599–1641

Natalia Gritsai

Van Dyck

1599–1641

Text: Natalia Gritsai

Published in 2004 by Grange Books
an imprint of Grange Books Plc
The Grange
Kingsnorth Industrial Estate
Hoo, nr Rochester
Kent ME3 9ND

www. Grangebooks.co.uk

ISBN 1 84013 580 8

© Confidential Concepts, worldwide, USA
© Sirrocco, London, UK, 2004 (English version)

Printed in Singapore

Contents

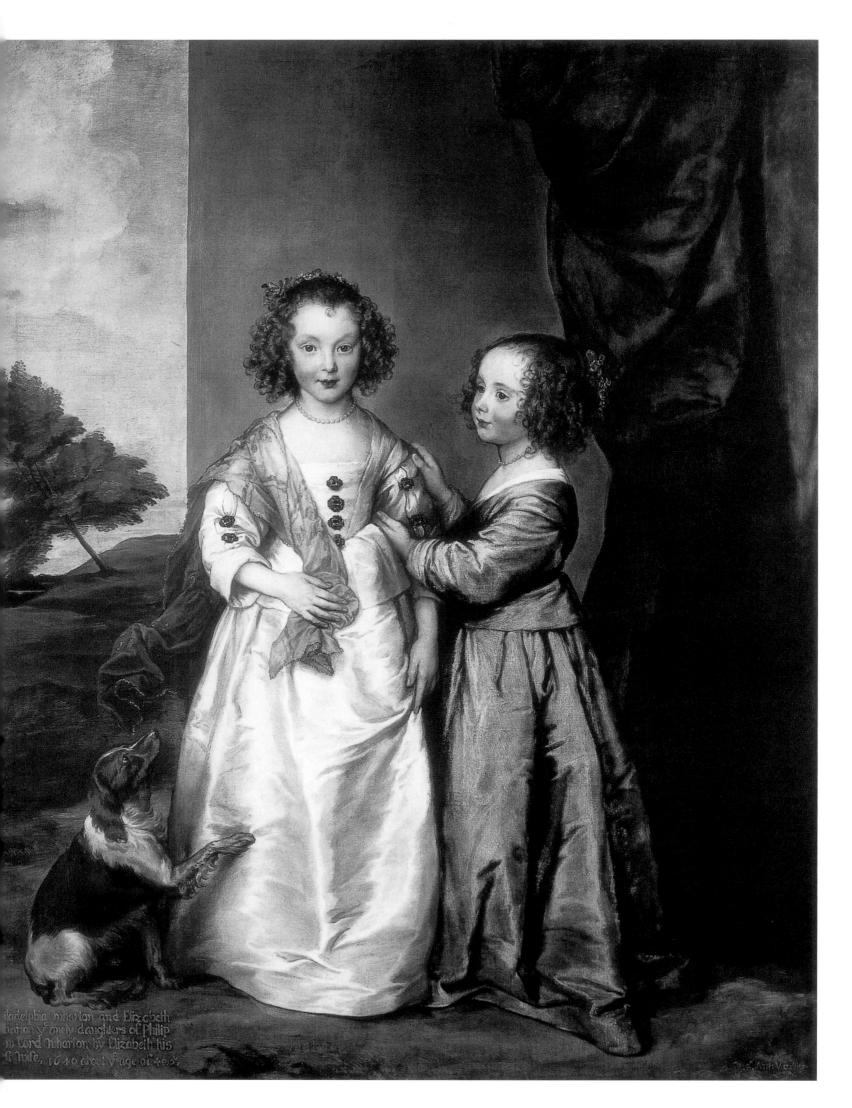

6

VAN DYCK'S PAINTINGS IN THE HERMITAGE THE HISTORY OF THE COLLECTION

To this day the name of the seventeenth-century Flemish painter Anthony van Dyck (1599–1641) remains a symbol of artistic refinement. Yet his real contribution to art lies in his novel approach to the representation of the subject, his perception of each human being as a unique individuality which reveals itself only on direct contact, not through mere contemplation. In his day Van Dyck had his greatest success as a portraitist. He created painted portraits throughout his life, and in his later periods graphic portraits as well. It was as a portraitist that the artist gained worldwide recognition and went down in the history of seventeenth-century European art.

As an artist of great creative range, however, Van Dyck worked in many genres: he produced historical compositions, allegorical pictures, landscapes – and was well able to tackle any artistic task. And if his thematic compositions often display a portraitist's power of observation, his portrait style bears the mark of the techniques used in historical pictures.

Van Dyck's portraits are of diverse type. The range of his powers as a portraitist seems infinite, stretching from fleeting sketches done on the move or from memory to painstaking studies from life, from intimate works to grand, monumental portraits and often humorous "historical pictures" depicting the subject in the guise of a character from classical mythology or a contemporary play. The artist's portrait gallery is a real monument to his time, and presents us with both a living image of the artist's

1. *Philadelphia and Elizabeth Wharton*, 1640, The Hermitage, St Petersburg.

contemporaries and that ideal of the beautiful individual which he established in his art...

Van Dyck's age marked a new stage in the art of the small country of the South Netherlands (often called Flanders, after its largest province). It was a time that saw the development, followed by the brilliant affirmation, of the national school of painting. The Dutch rebellion of the late sixteenth century led to the secession of the northern provinces (Holland) to become the independent republic of the United Provinces, while the southern provinces remained under Spanish rule. Netherlandish art split into two independent national schools – the Dutch and the Flemish.

The greatest achievements of seventeenth-century Flemish art are linked with Rubens and his close associates, of whom Van Dyck was indisputably the finest. Peter Paul Rubens (1577–1640) was the recognized leader of the Flemish School. He set Flemish culture on new paths by creating art that was closely in tune with its time, art that was imbued with a sublime humanist spirit, vividly emotional, dynamic, passionate, bursting with life-affirming power. Van Dyck transformed Rubens' artistic discoveries in his own special way, attaining a skill in portraiture that remains unmatched.

The Hermitage collection (with which this publication mostly concerns itself), supplemented by some of the master's pictures in other museums, allows us to form a comprehensive picture of Van Dyck's portrait œuvre. It includes works from all the artist's creative periods: the First and Second Antwerp Periods, the Italian Period, and the English Period, forming one of the largest sections in the Hermitage's collection of Flemish art, which also features important paintings by other leading Flemish masters – Rubens, Jordaens, and Snyders. All of these collections belong to the core of the Museum's old collection dating from the eighteenth century, a time when the works of Flemish painters were ranked as some of the most coveted items in Western Europe. They were particularly in demand in Paris – Europe's most important art market. From the 1760s almost to the end of the century, the French capital was the principal source of paintings for the rapidly expanding picture gallery of St Petersburg's Hermitage.

The foundations of this museum born in the Age of Enlightenment were laid by Empress Catherine the Great (1729–96). In 1764 she acquired the collection of the Berlin merchant Johann Ernest Gotzkowsky, who offered the Empress his pictures through the Russian ambassador in Prussia, in settlement of his debt to the Russian treasury. Ever since, 1764 has been taken as the date of the foundation of the Hermitage. Catherine the Great's successes in the field of collecting were greatly aided by the fact that she was able to enlist as intermediaries and experts such eminent connoisseurs as the celebrated French philosopher and art critic Denis Diderot, the sculptor Etienne Maurice Falconet, the encyclopedist Melchior

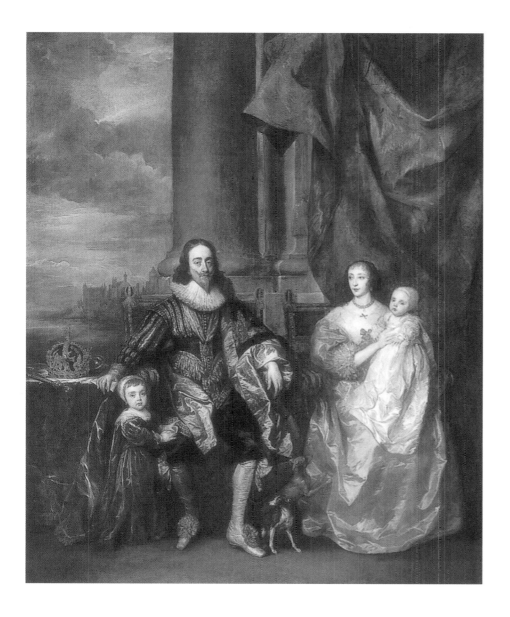

Grimm, and the Russian ambassador in Paris and subsequently The Hague, Dmitry Golitsyn. The last was one of the most enlightened figures of Catherine's time, an honorary member of the Academy of Arts in St Petersburg, and a friend of Diderot and Falconet.

It was Golitsyn, in particular, who acted on behalf of the Empress to acquire pictures for the Hermitage collection. Golitsyn maintained close links with Diderot and Grimm, and also with the Geneva collector François Tronchin, who had contacts in Parisian artistic circles. He strove never to miss the opportunity of making an interesting acquisition, both at auctions (in Paris, The Hague, and Amsterdam) and through direct negotiations with owners. The latter was probably the case with the purchase, some time before 1774, of one of the finest pictures in the Hermitage's Flemish collection – Van Dyck's *Family Portrait*. According to some sources,[1] a certain Madame Grunblots of Brussels, who had acquired the portrait in 1770 at the sale of the La Live de Jully collection in Paris, gave it to the Russian Empress soon afterwards.

2. *King Charles I and Queen Henrietta Maria with Charles, Prince of Wales and Princess Mary,* 1632,
Collection of Her Majesty Queen Elizabeth I.

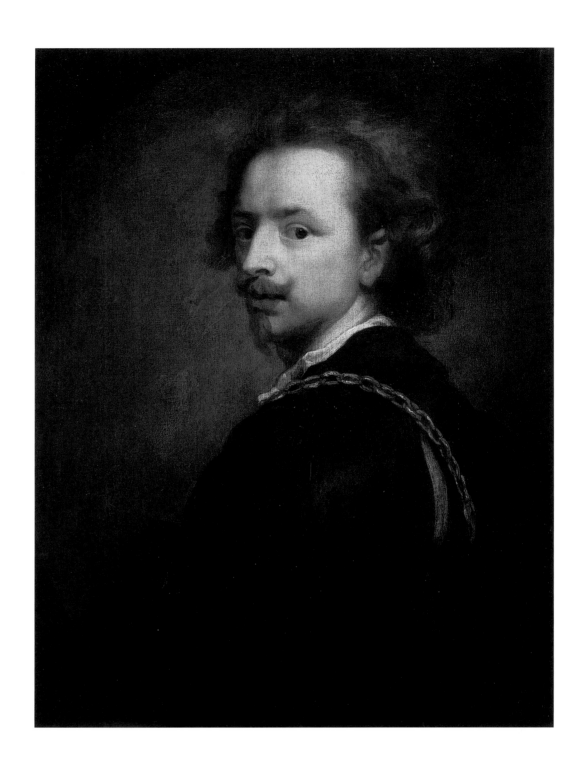

However, most of the Van Dycks currently in the Hermitage entered the museum as a result of Catherine II's purchase of two celebrated European eighteenth-century collections: the Crozat collection,[2] acquired in France in 1772, and the picture gallery of Lord Walpole,[3] acquired in England in 1779. The first enriched the Hermitage with eleven Van Dycks, the second with fourteen.

In 1783 the celebrated Parisian collection of Count Baudouin came into the Hermitage, bringing another five Van Dyck portraits.[4] A further two works whose exact provenance has not been ascertained[5] come from other, less renowned, eighteenth-century French collections, as do two portraits which only entered the museum this century (in 1932) and which were once in the possession

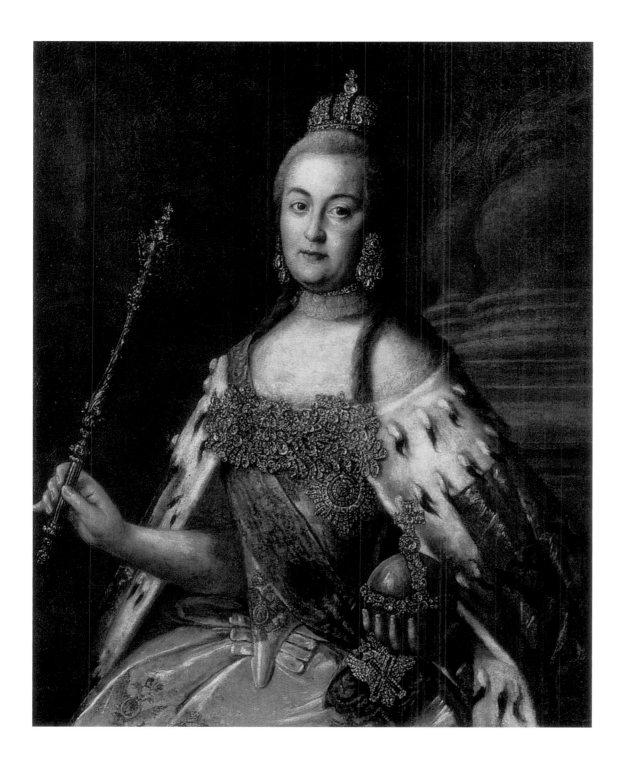

of Count Alexander Stroganov, who bought them during his sojourn in Paris, between 1769 and 1779.[6] While the Hermitage is indebted primarily to French collections for paintings from both the artist's Antwerp periods and his Italian Period, it is indebted Walpole for nearly all his English works in its possession, in particular the portraits of the Wharton family, which Robert Walpole acquired around 1725 from the last surviving member of that family in Winchendon. Given the manner of its acquisition, it is only natural that the character of the Hermitage collection reflects the tastes of eighteenth-century art-lovers.

At that time European collectors valued Van Dyck above all for his skill as a portraitist, and so bought up almost exclusively

4. Alexei Antropov, *Catherine the Great,* 1762, Museum of History and Art, Sergiyev-Posad, Moscow region.

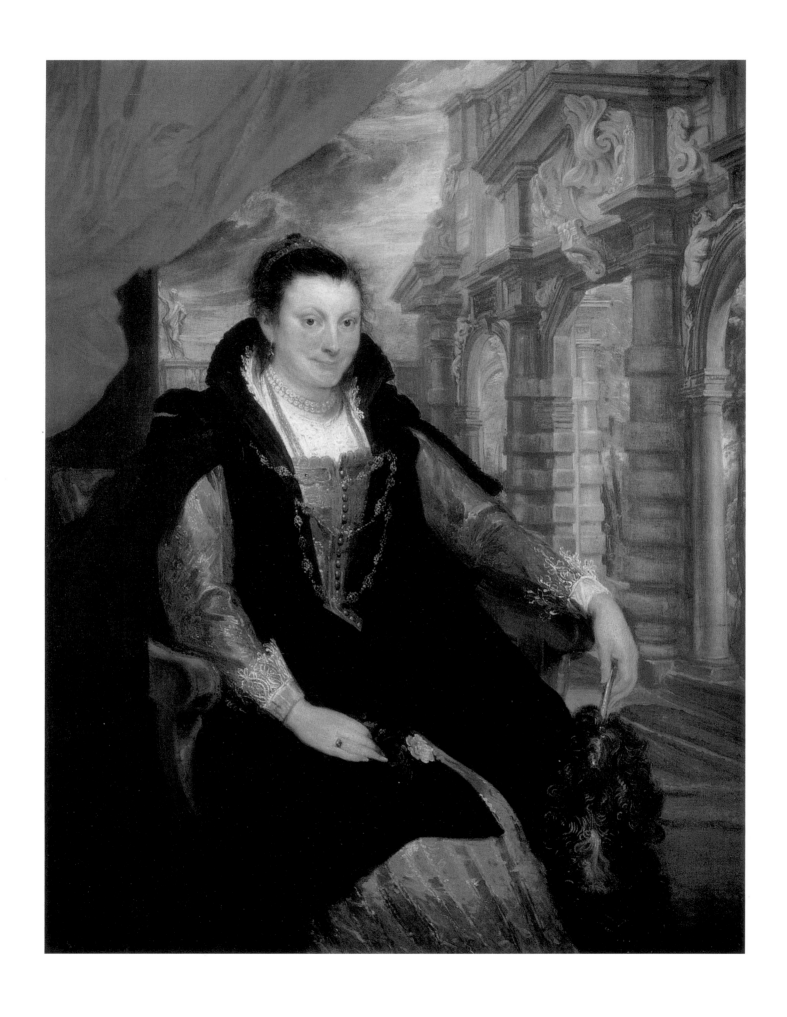

5. *Isabella Brant,* ca. 1621,
National Gallery of Art, Washington.

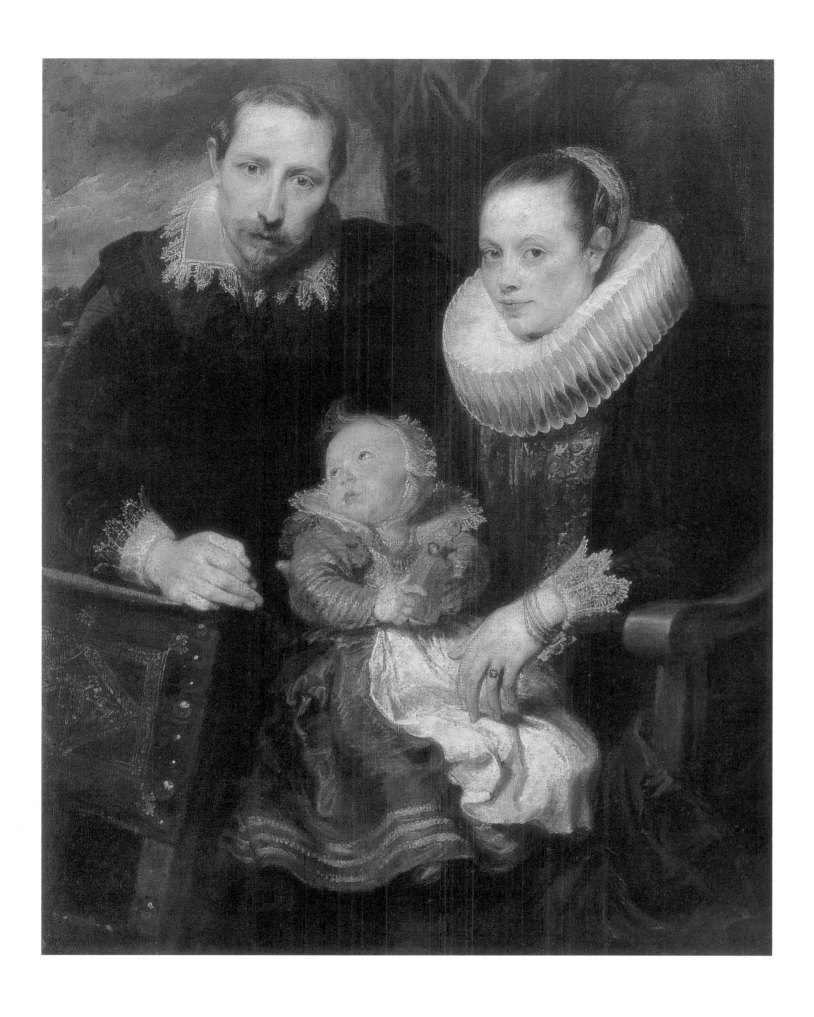

6. *Family Portrait*, 1621,
 The Hermitage, St Petersburg.

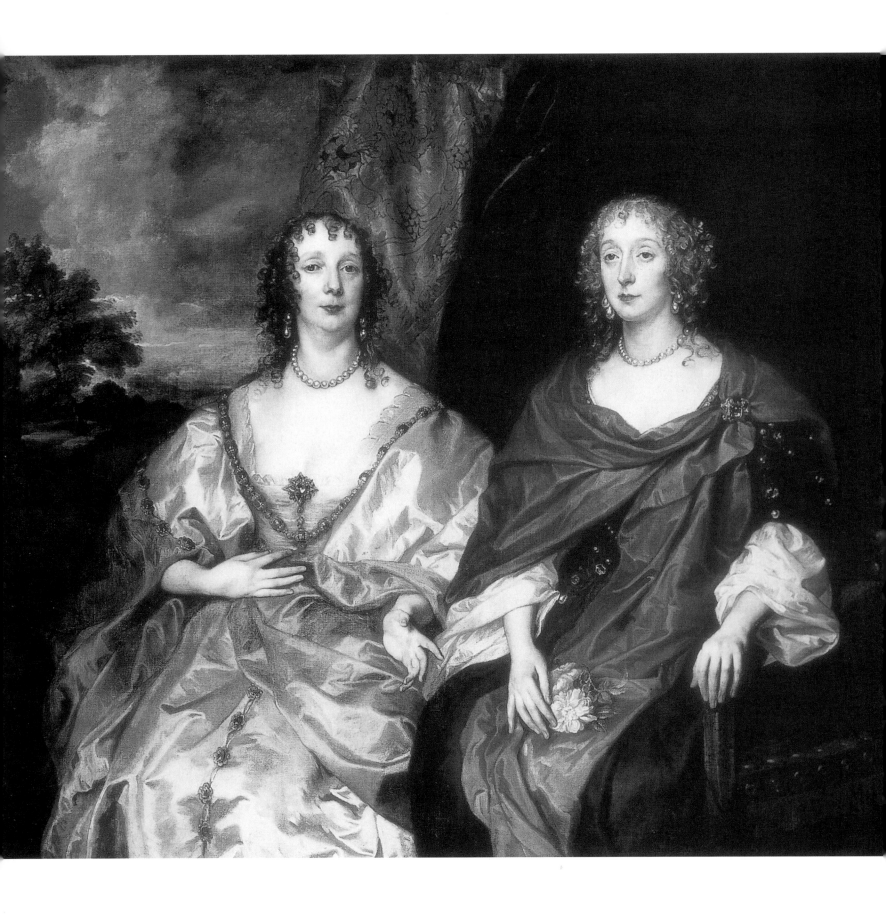

7. *Ladies-in-Waiting Ann Dalkeith,*
 Countess Morton (?), *and Ann Kirke*, late
 1630s, The Hermitage, St Petersburg.

his portrait works. The general standard of the collections from which the Hermitage acquired Van Dyck's works was extraordinarily high. Suffice it to say that in the Paris of the mid-eighteenth century the Crozat collection had no equal. It is no accident that the French collector and art connoisseur Pierre-Jean Mariette, who was himself an engraver and publisher, based his essay on Van Dyck largely on examples of his work in the Crozat collection. Those included such recognized masterpieces as *Self-Portrait*, portraits of Everhard Jabach and Marc-Antoine Lumagne, and *Portrait of a Man*, which was long thought to be a portrait of the Antwerp doctor Lazarus Maharkyzus.

In eighteenth-century England, too, artists and art lovers saw Van Dyck primarily as a brilliant portraitist. The famous English painter Joshua Reynolds, first President of the Royal Academy of Arts in London, wrote enthusiastically of him: "Van Dyck is the greatest portraitist who has ever lived." He was echoed by the painter and engraver William Hogarth, who wrote in his *Analysis of Beauty* (1753) that he considered the Flemish artist to be in many respects one of the best known portraitists.[7] So it is scarcely surprising that English collections also concentrated on Van Dyck's portrait works. Walpole's collection was no exception: it contained only one of Van Dyck's subject compositions, *The Virgin of the Partridges (The Rest on the Flight into Egypt)*, a masterpiece from his Second Antwerp Period.

At various times, and for various reasons, some of Van Dyck's works left the Hermitage. In the 1930s, for example, the museum sold several paintings that had come from Walpole's collection: portraits of Philip Wharton and Isabella Brant (the latter was then thought to be by Rubens but is in fact one of Van Dyck's early works, painted shortly before his departure for Italy), and two works from the artist's first Antwerp period: *Portrait of a Young Woman* (thought at the time to be the companion to *Portrait of a Young Man*) and *Portrait of Suzanna Fourment and her Daughter*. All four are now in the National Gallery of Art, Washington. In 1924 and 1930 three works from Van Dyck's Second Antwerp Period were transferred to the Pushkin Museum of Fine Arts in Moscow: *Portrait of Jan van den Wouwer* and two companion portraits, of Adriaen Stevens and his wife, Maria Bosschaerts. All three had been acquired by the Hermitage in 1783 from the Paris collection of Count Baudouin.

The Van Dyck pictures now in the Hermitage represent nearly every type of portrait developed by the master: from his formal commissioned works to those he painted for his own pleasure, for himself and those close to him. The museum lacks only examples of the large-scale portraits from his Italian period. The Hermitage's rich collection allows us not only to trace the artist's creative course, but also to marvel at his virtuosity as a portraitist and the sheer variety of his means of expression, technical methods, and compositional solutions.

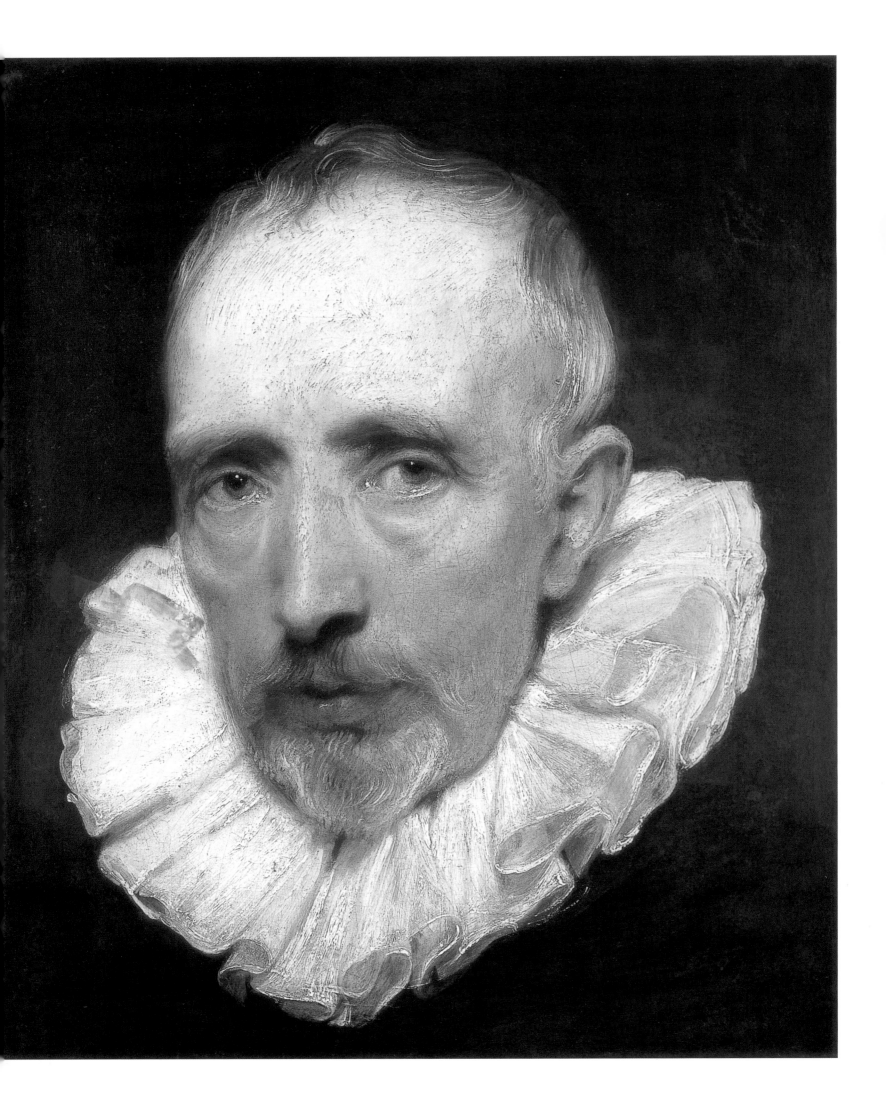

THE FIRST ANTWERP PERIOD

Around 1616-1621

Van Dyck's life was short, and he rushed to accomplish what he saw as his destiny almost as if he had a presentiment of his early death. The artist came from a well-to-do burgher family. His father was a prominent cloth merchant. Besides Anthony – their seventh child – Frans van Dyck and Maria Cuypers had another five children. Anthony's mother died when he was barely eight years old, after the birth of her twelfth child. According to biographers, she was a great expert at needlework and embroidered several historical scenes "with such startling skill that the profession's master craftsmen considered them masterpieces".[8] Perhaps it was her who gave her son his first drawing lessons. In his father's house, Anthony received a very thorough education, and was even taught music. He possessed exceptional ability and was a genuine *Wunderkind*.

Frans van Dyck, however, true to the old traditions of the Flemish burgher class, strove to give his son a solid profession and training in some trade. In Antwerp the painter's profession had long been considered one of the most respectable, and since it was to that trade that Anthony revealed a penchant he was apprenticed at the age of ten to one of Antwerp's leading artists, Hendrick van Balen, the owner of one of the city's largest studios.

Van Balen was a painter who had found greatest fame with his cabinet pictures[9] on historical, allegorical, and mythological themes, with tiny, rather doll-like figures which were not, however, without a certain elegance. However, he also painted bigger pictures with large figures, mostly for churches (for example, *The Annunciation* in

3. *Cornelis van der Geest*,
ca. 1620, National Gallery, London.

St Paul's, Antwerp). With their statuesque, idealized figures, these were but a pale imitation of the art of the Roman School of the High Renaissance, which Van Balen so admired. Van Balen was also drawn to the works of the Venetian masters, particularly Veronese, and the young Van Dyck's interest in Venetian art may have arisen as early as his apprenticeship in the studio on Antwerp's Lange Nieuwstraat, which was filled with works of art, prints, medals, and books. And although Van Balen's art exerted no discernible influence on Van Dyck's work, the young artist undoubtedly had him to thank for his excellent technical training.

At that time (the early seventeenth century) the apprenticeship system – indeed, the whole way of working in the studios – was almost identical to the practices of the mediaeval craft guilds. The young pupil (boys were apprenticed to the studios at between ten and fourteen years of age) was regularly able to observe every stage of the artist's work from beginning to end; he would learn his trade on the job, successively participating in every step of a painting's creation, from scrubbing the palette and grinding the paints to working directly on some part of his master's commission. For all its limitations, this system, which survived in Flanders throughout most of the seventeenth century, was the essential first step of the would-be painter's artistic education, his introduction to the accomplishments of the illustrious Netherlandish School, without which the future achievements of the seventeenth-century Flemish School would scarcely have been possible.

On completing his apprenticeship (which could last from six to thirteen years, depending on the pupil's ability), the young painter would submit an original work (or series) to the Guild of St Luke (a professional association of artists, mostly painters). If his work was considered good enough, he would be granted the title of Master of the Guild and the right to set up his own studio that went with it. However, the young artist's education did not normally stop there. The almost compulsory – and, by the late seventeenth century, traditional – second step was a trip to Italy.

Van Dyck, too, went through all these stages. Learning came easily to him, and he acquired his own studio as early as 1615, when he was not yet a full member of the Guild of St Luke (something unprecedented in the history of the Flemish School!). By the time he was awarded the title of Master – in February 1618 – Van Dyck was already a completely original artist, with a vividly expressive creative individuality.

It was from this time, or a little earlier (around 1617), that he began to collaborate actively with Rubens. Van Dyck took up residence in Rubens' house, and very soon became the great master's closest assistant in the execution of all his large-scale works. Although Rubens, in his letter to Carleton of 28 April 1618, describes the younger painter as "the best of my pupils",[10] in the strict sense of the

9. *Moses and the Brazen Serpent*,
Prado, Madrid.

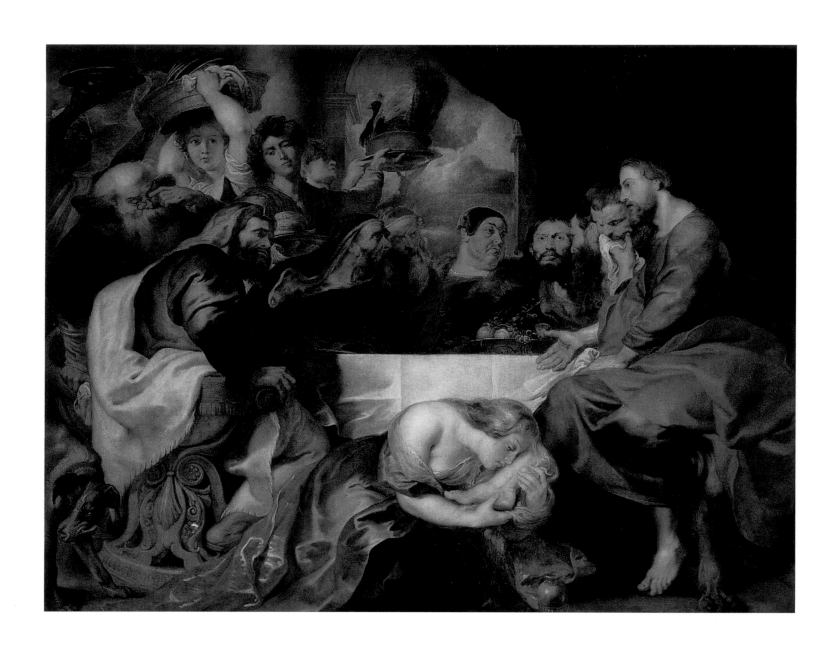

10. Peter Paul Rubens, *Feast at the House of Simon the Pharisee,*
1618-20,
The Hermitage, St Petersburg.

20

word Van Dyck was not Rubens' apprentice. However, it was here, in close contact with the celebrated Flemish artist and in the atmosphere of his studio, that the young man completed his education. Here he not only honed his craft, but also encountered interesting and educated people. For by the time Van Dyck arrived at Rubens' studio it was more than just a centre of new Flemish painting: it was the focus of artistic and intellectual life in Flanders. While working with Rubens – and he stayed in the artist's house right up until his departure for Italy – Van Dyck became acquainted with many of his compatriots, whose likenesses would eventually grace his celebrated *iconography*, the series of engraved portraits of Van Dyck's contemporaries – painters, sculptors, poets, musicians, scientists, patrons, military commanders, public figures – based on the artist's drawings.

The influence of Rubens on the young Van Dyck's creative development was undoubtedly enormous. Echoes of the great master's art can be seen in many of Van Dyck's early works. In his desire to fathom and master the secrets of Rubens' technique he studied his great colleague's manner so meticulously that he even learned to imitate his style. Sometimes it is even impossible to trace a clear dividing line between the work of the two painters. Yet every one of Van Dyck's creations, even the most Rubenesque, is stamped with his personality. His temperament, extreme, impetuous nature, and impulsiveness left their mark in the young artist's characteristic exaggeration of the stylistic traits he had borrowed from Rubens.

For example, the dynamism of the great Fleming's image is echoed in Van Dyck's early pictures by a depiction of stormy emotions uncharacteristic of his later works. A typical example of this is *The Penitent Apostle Peter* (now in the Hermitage), painted by Van Dyck as part of his work on a series of representations of the Twelve Apostles – a popular theme in Flemish art between 1600 and 1620. The painting displays a taste for conveying the uniqueness of the individual, for attaining an expressiveness of form, that distinguished even the very young artist (the painting dates from around 1617–18). It is no accident that his work is a portrait study of a specific model: we know that the subject was a certain Abraham Grapheus, a servant of the Antwerp Guild of St Luke, whose colourful appearance inspired many of the city's painters (Cornelis de Vos's *Portrait of Abraham Grapheus*, Koninklijk Museum voor Schone Kunsten, Antwerp; Jacob Jordaens's *Job*, Institute of Arts, Detroit). However, Van Dyck used Grapheus's expressive features merely as the starting point in his creation of the image: for him the important thing was not so much to reproduce his subject's physiognomy as to convey the powerful feelings that animated his rather coarse face. Here Van Dyck is still a very long way indeed from his later preoccupation with beauty and refinement of form. On the contrary, he is attracted by everything that is vividly individual and emphatically distinctive…

Van Dyck painted *The Penitent Apostle Peter* some time soon after he had started working in Rubens' studio. His work as Rubens' assistant on the *Feast at the House of Simon the Pharisee* – he painted the heads of the Apostles sitting to the right of Christ – probably dates from the same time. Van Dyck left studies for the heads of two of the Apostles: the one closest to Christ, covering his mouth with a napkin (*Head of a Man*, Staatsgalerie, Augsburg), and the one depicted full-face to the right of the fat man wearing a cap (*Head of a Man*, Gemäldegalerie, Berlin-Dahlem). These two figures are noticeably different in appearance from the corresponding figures in Rubens' original sketch for the whole composition (Gemäldegalerie der Akademie der bildenden Künste, Vienna).

Van Dyck had obviously been granted considerable freedom in the execution of the section of the painting entrusted to him – a section, incidentally, which was perhaps the most crucial and intricate, since what was required was not so much the ability to create an outwardly distinctive and memorable image as the ability to convey the character's inner emotional state, hidden beneath his outer shell.

In this context, it is interesting to note that in his studies for *Feast at the House of Simon the Pharisee* Van Dyck used the pose of the Prophet Jeremiah, immersed in painful meditation, from Michelangelo's famous fresco on the ceiling of the Sistine Chapel, as the prototype for that of the Apostle seated next to Christ. The Michelangelo fresco may have been known to Van Dyck through the sketches Rubens had brought back from Italy (now in the Louvre, Paris).

Van Dyck's participation in the creation of *Feast at the House of Simon the Pharisee* undoubtedly helped to enrich Rubens' project, as the complex images created by the young artist succeed in heightening the intensity of the conflict at the heart of the composition. Although Van Dyck's early works are by no means limited to portrait studies, portraiture was manifestly where his main interest lay. This sometimes revealed itself in the most unexpected fashion: for example, in copying (evidently for his personal enjoyment) Rubens' *Emperor Theodosius Refused Entry into Milan Cathedral by St Ambrose, Archbishop of Milan* (Kunsthistorisches Museum, Vienna; Van Dyck's copy is in the National Gallery, London), Van Dyck altered the faces of several of the figures, endowing them with the features of people he had met in Rubens' house. The second figure from the right, for instance, is recognizable as the Antwerp burgomaster Nicolaes Rockox, a friend and regular client of Rubens, whose portrait by Van Dyck is in the Hermitage, while the servant standing on the cathedral steps with his back to the observer, torch in hand, looks like the artist himself (compare it with Van Dyck's *Self-Portrait* in the Gemäldegalerie der Akademie der bildenden Künste, Vienna). Moreover, researchers have detected a similarity between the faces of the figures on the

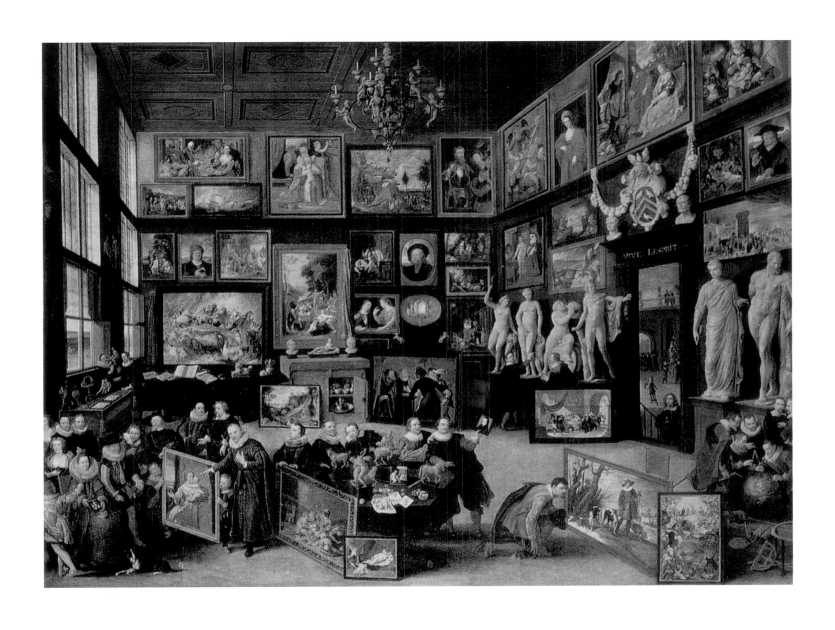

11. Willem van Haecht, *The Picture Gallery of Cornelius van der Geest*, 1628, Rubenshuis, Antwerp.

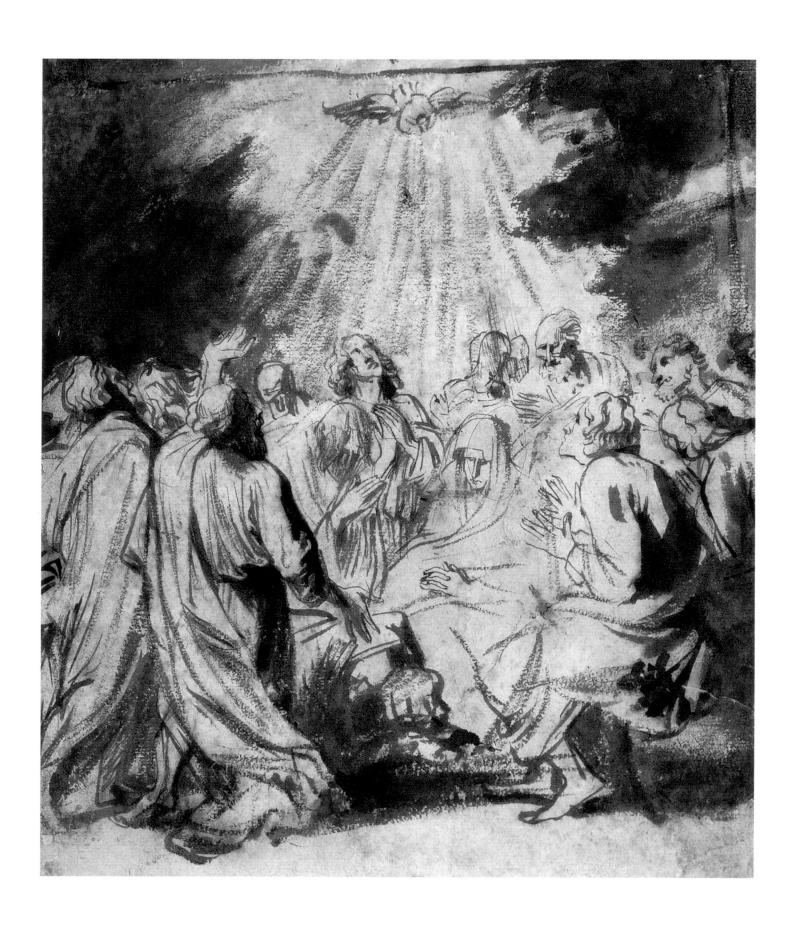

12. *The Descent of the Holy Ghost*, 1618-20,
 The Hermitage, St Petersburg.

13. Hendrick van Balen, *The Annunciation*,
 1615-20,
 Church of St Paul, Antwerp.

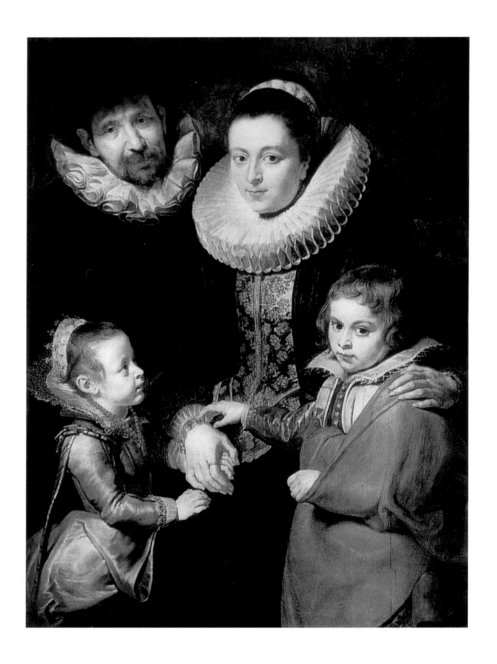

left side of the painting and several Antwerp artists who collaborated with Rubens: Paul de Vos, a painter of animals and still-lifes and also a specialist in the depiction of armour (first from the left); the landscape painter and master of floral still-lifes Jan Brueghel the Elder (second from the left); and finally, the engraver Lucas Vorsterman (third from the left).[11]

The young master's free copy seems to have pleased Rubens, since he kept it in his personal collection right up to his death. (It is mentioned in the inventory of Rubens' estate, compiled in 1640.) Portraits had a special place in Van Dyck's original works from his First Antwerp Period. In their outward appearance they were still very close to the traditional model developed by Netherlandish art. These portraits are characterized by a dark neutral background, severity and simplicity of composition, and realism in the representation of the subjects' external features and the detailing of their clothing. But Rubens' lessons had not been wasted on the young artist, and the traditional model proved to be

14. Peter Paul Rubens, *Jan Brueghel the Elder and Family*, Courtauld Institute Galleries, London.

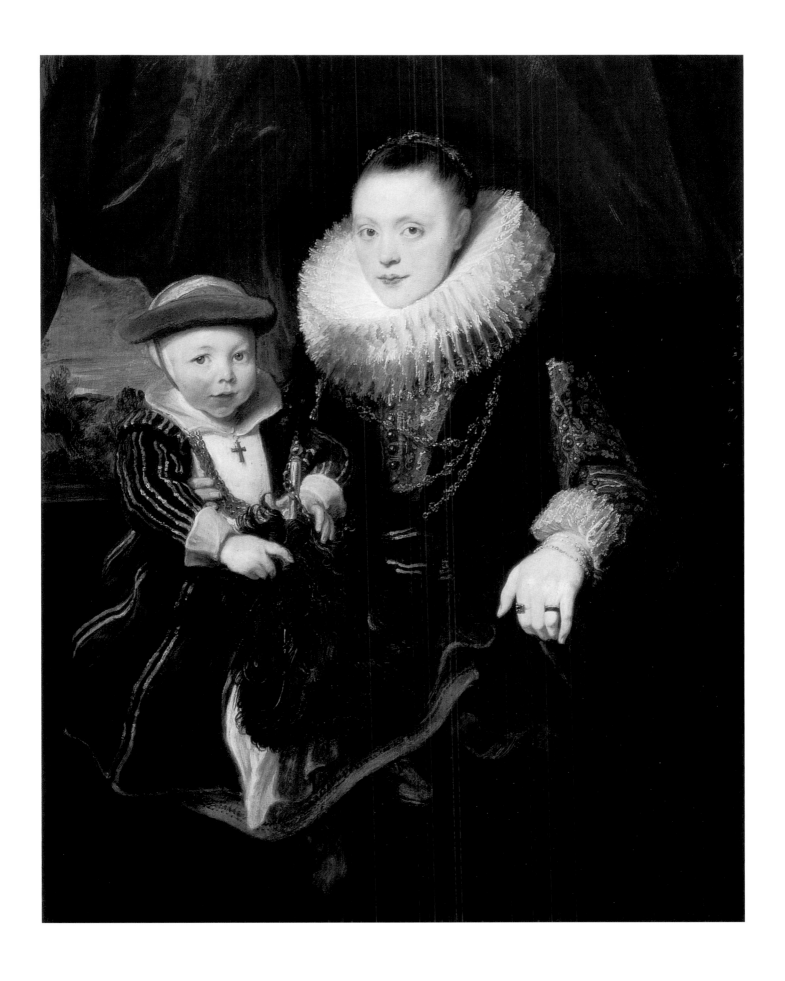

15. *Young Woman with a Child (probably*
 Baltazarina van Linick and her son Adriaen
 van den Heetvelde),
 ca. 1618,
 The Hermitage, St Petersburg.

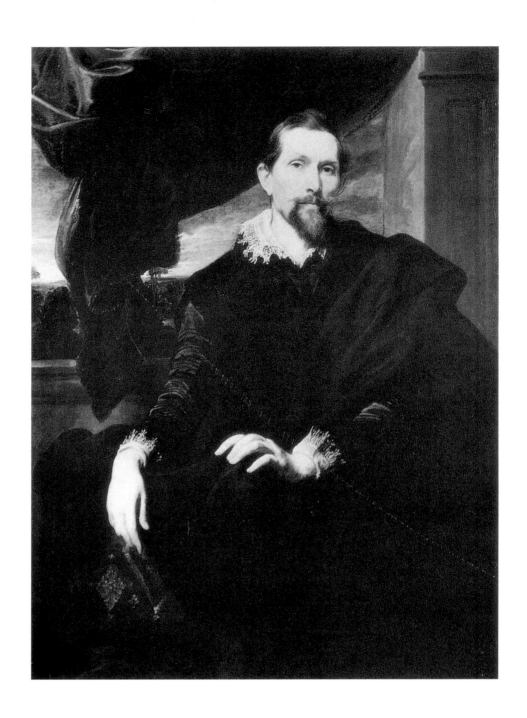

full of new content. Thus in Van Dyck's *Portrait of a Young Man* – the earliest (ca. 1618) portrait in the Hermitage – we no longer find the detailed analysis of human physiognomy and scrupulous tracing of even the tiniest lines of the subject's face and clothing that distinguished fifteenth- and sixteenth-century Netherlandish art.

Gone are the diffused and indifferent lighting, the sharp clarity of contour and the statuesque postures of his early works. The artist's confident brush follows a shape's every curve with a lightness and fluidity that brings it shimmeringly to life. Bathed in waves of warm light, the figure seems to come out of the dark space of the background, and we get the sensation that he is actually here with us. The effect is heightened by the fact that the man is looking us straight in the eye, as if he could see the observer standing in front of him…

16. *Frans Snyders,*
The Frick Collection, New York.

28

17. *Nicolaes Rockox*, 1621, drawing,
 Royal Collection, Windsor Castle.

18. *Head of a Man*, ca. 1618, study,
 Staatsgalerie, Augsburg.

Yet this astonishing craftsmanship, which makes us forget that these images were created by an artist who had thrown himself body and soul into recreating the form that springs up before our very eyes, does not in and of itself explain the originality of Van Dyck's portraits. The finest nuances of feeling are concentrated in his subjects' eyes, which glitter with an intense inner life. The trusting, wide-open eyes of the young mother with her child on her lap (*Young Woman with a Child* – probably Nicolaes Rockox's niece Baltazarina van Linick and her son Adriaen van den Heetvelde) betray a certain anxiety; the man in *Family Portrait* looks at us enquiringly and a little dolefully, while his wife fixes us with a glance that is serene and slightly sly... By compelling us to look into the eyes of his characters and creating a sensation almost of personal contact, the artist makes us share in their inner lives. It is this quality, above all, which distinguishes Van Dyck's works from those of Rubens, whose portrait figures live in another, heroicized world, aloof from the observer. Rubens concentrated on the objective depiction of the model, only rarely revealing any direct involvement with his subject (for example, his warm *Portrait of Jan Brueghel the Elder and Family*, Courtauld Institute Galleries, London).

Rubens' characters are usually reserved, and gaze past us into the distance. Van Dyck's models, on the contrary, possess the ability to actively interact with the observer. His portraits, even the earliest, are imbued with the artist's personal feelings, and bear the stamp of his individuality. Intentionally or not, he endows his models with something of his own inner character. He was impressed by people with lofty intellectual and spiritual needs and rich inner lives. It is no accident that portraits of Van Dyck's fellow artists (Frans Snyders, The Frick Collection, New York), collector-patrons (Cornelis van der Geest, National Gallery, London), and humanist scholars (Nicolaes Rockox, Hermitage) occupied a central position in the artist's work in his First Antwerp Period.

It was above all in these portraits that Van Dyck fully and originally developed the concept of the significance of the human personality that characterized Flemish art in the first three decades of the seventeenth century – a concept which Van Dyck, in turn, had taken from the work of Rubens. But Van Dyck deepened this conception and made it more concrete, by affirming in his portraits man's spiritual and intellectual essence, the refinement and rich emotional life of the creatively active individual.

To achieve this, Van Dyck re-worked the experience of other portraitists, first and foremost Rubens. The young artist's portraits became more majestic, representational, and complex. The background is no longer neutral, as in his earliest portraits, but an integral part of the composition. The figures are linked to it ever more organically, and actively interact with the architecture. The bright red fluttering curtains, ceremonial environment, and ornamental architectural details give the portraits a tint of elevation

19. *The Heads of the Apostles,* detail of Rubens' *Feast at the House of Simon the Pharisee.*

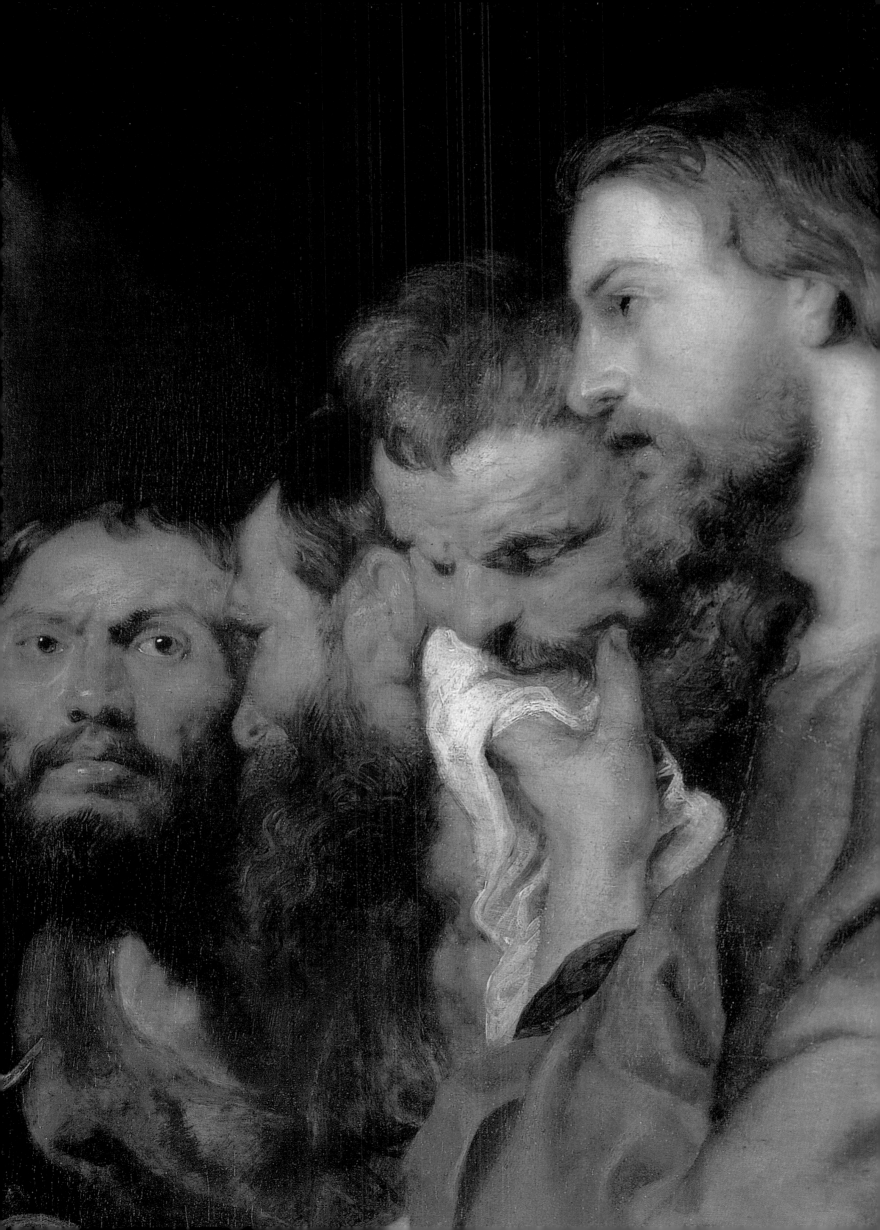

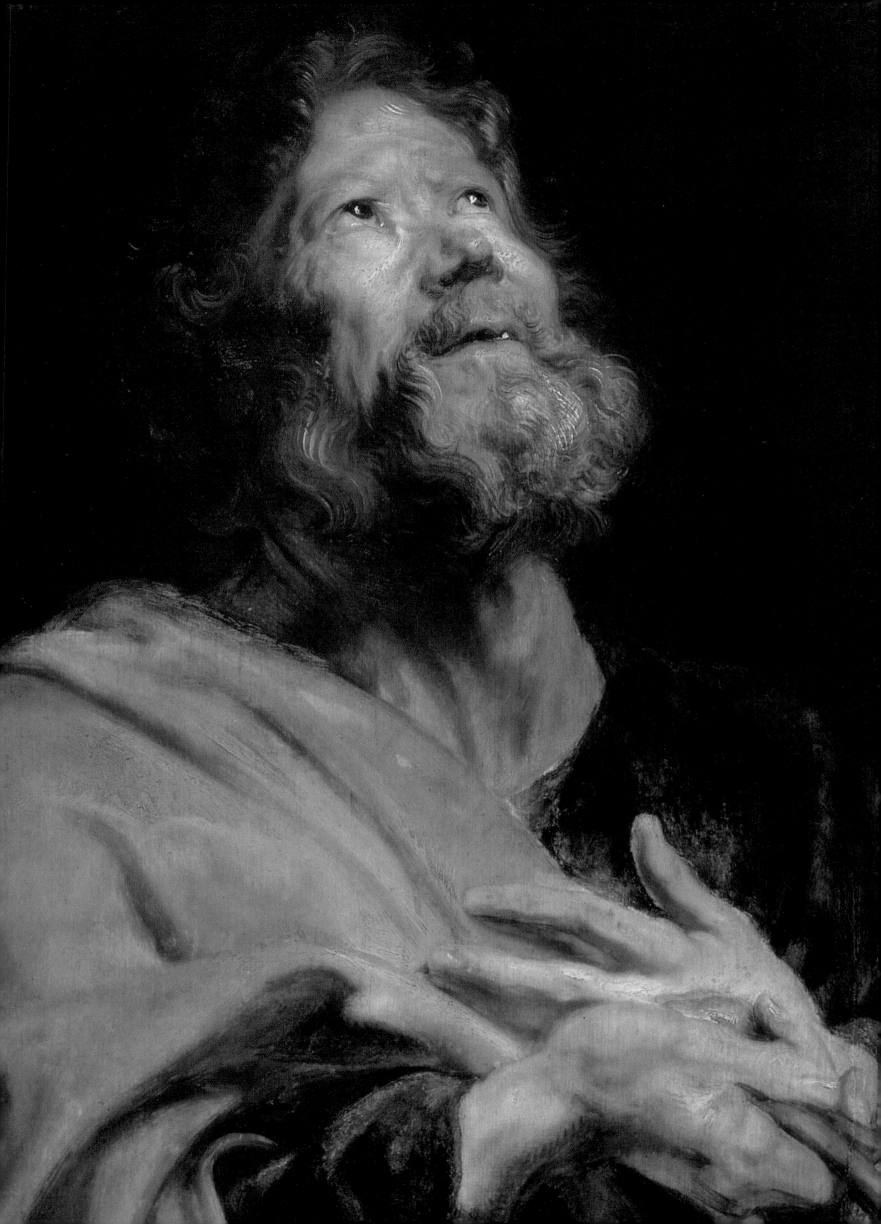

and solemnity (the companion portraits of Frans Snyders and his wife Margaretha de Vos, The Frick Collection, New York).

But in Van Dyck's portraits the subject does not get lost in these ceremonial surroundings. The details of decor not only serve to make the portraits true to life and fulfil a specific compositional function: invariably, they also help to bring a depth to the depiction of the subject. For example, the books and classical busts placed on the table in the Hermitage portrait of Nicolaes Rockox (1560–1640) reflect the rich inner life of the man who was a burgomaster of Antwerp (elected nine times to the post), a celebrated numismatist, and a prominent collector and patron of the arts. Antwerp's Hanseatic Tower (no longer extant), visible at the heart of the composition, is also an allusion to Rockox's multifarious activities: it symbolizes his trading links with the Hanseatic League.

However, Van Dyck possessed the ability to reveal the refinement of the inner man without having to resort to any accessories, as we can see from his magnificent *Portrait of Cornelis van der Geest* (National Gallery, London), one of the undisputed masterpieces of the artist's early work. Van der Geest (1555–1638), a rich Antwerp spice merchant, collector, and patron, was a prominent figure in the city's artistic and intellectual life in the early decades of the seventeenth century.

He played, for example, a key role in Rubens' career, securing for him in 1610, soon after the artist's return from Italy, the commission for *The Raising of the Cross* triptych for the main altar of the Church of St Walburga (the work is now in the Cathedral, Antwerp), the execution of which helped greatly to enhance Rubens' reputation as the city's leading painter.

Van der Geest is noted among Antwerp's collectors for his particular predilection for works of the native school. And it is no coincidence that the picture by Willem van Haecht (Rubenshuis, Antwerp), depicting the historic visit of the Archduke Albert and his wife Isabel, regents of the South Netherlands, to the house of Cornelis van der Geest, an event that took place in 1615, shows its main room hung with pictures almost exclusively by artists of the Antwerp School: from Quentin Massys, the father of the Antwerp School, to contemporary pictures – Rubens, Snyders, and Jan Brueghel the Elder ("Velvet Brueghel").

In his portrait of Van der Geest, painted around 1620, Van Dyck employs the head-and-shoulders depiction typical of the national school. It allows him to concentrate exclusively on the subject's features. Framed by a white ruff and shown in close-up, the face immediately commands our attention. The artist's brush boldly, yet delicately, brings out the subject's individual peculiarities: the elongated oval and refined features of the face, the

20. *The Penitent Apostle Peter,*
ca. 1617-18,
The Hermitage, St Petersburg.

33

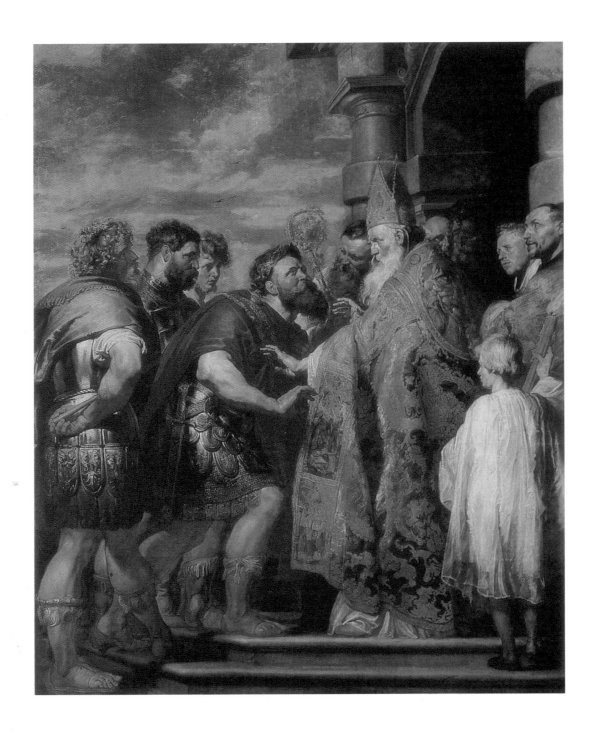

21. Peter Paul Rubens, *Emperor Theodosius Refused Entry into Milan Cathedral by St Ambrose, Archbishop of Milan*, 1617-19, Kunsthistorisches Museum, Vienna.

22. *Emperor Theodosius Refused Entry into Milan Cathedral by St Ambrose, Archbishop of Milan*, ca. 1619-20, National Gallery, London.

open, high forehead. The intelligent look in the eyes (their animated brightness is masterfully conveyed by separate strokes of white), indeed the subject's whole aspect speaks of a profound and noble nature.

But it is not just the subject's inner essence that interests the artist. With great skill he lays bare the shifts of his model's emotional life – a task which the Flemish artists of the preceding age (fifteenth and sixteenth centuries) had not set themselves. Following in Rubens' footsteps, Van Dyck set out to create psychological portraits, in the execution of which the most important task is to convey the dynamics of a man's inner life.

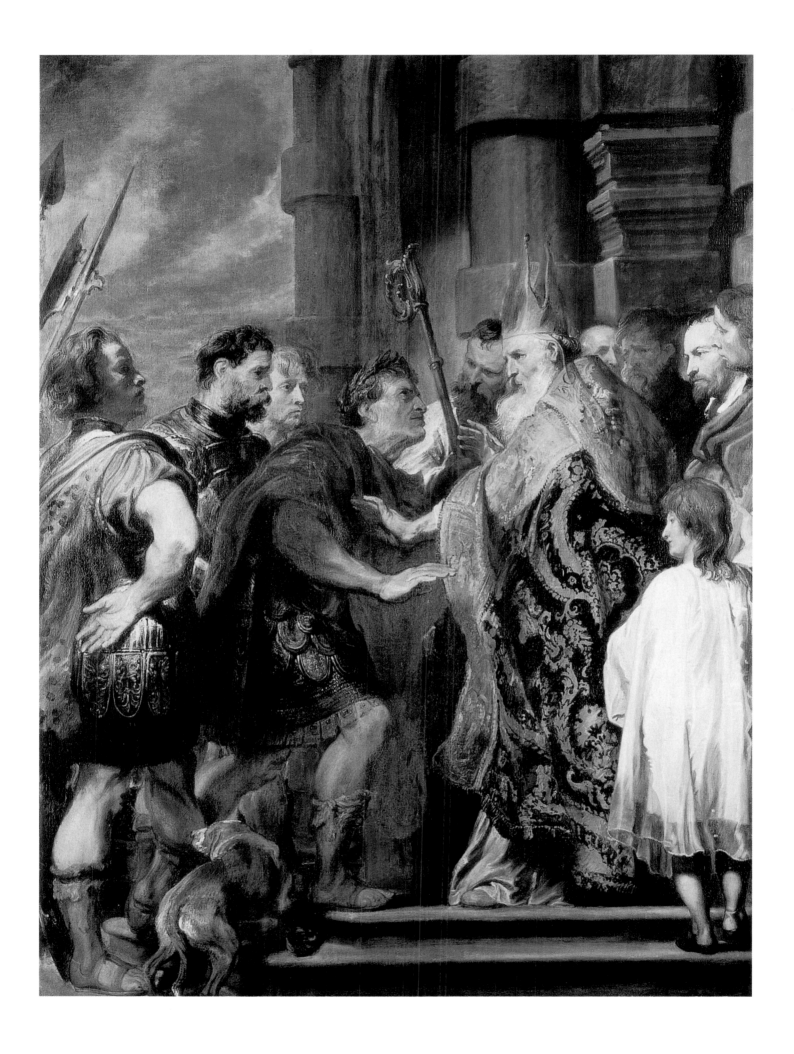

35

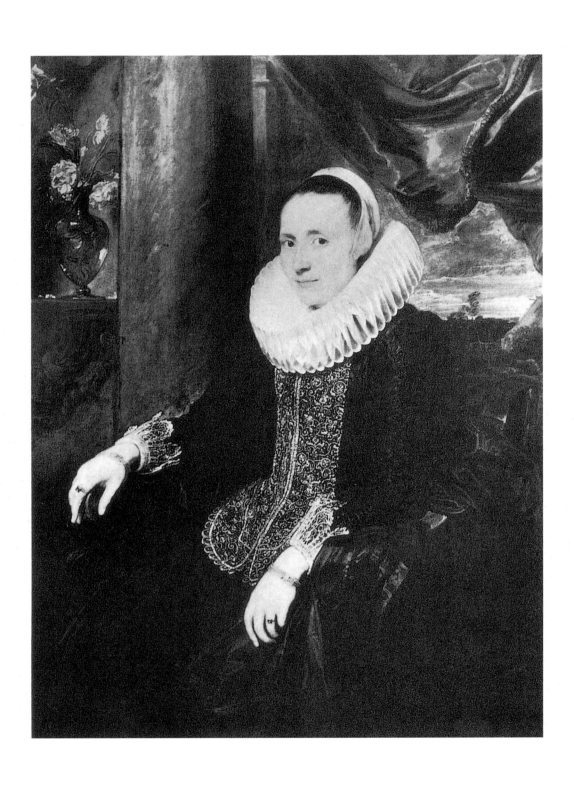

23. *Margaretha de Vos*,
 The Frick Collection, New York.

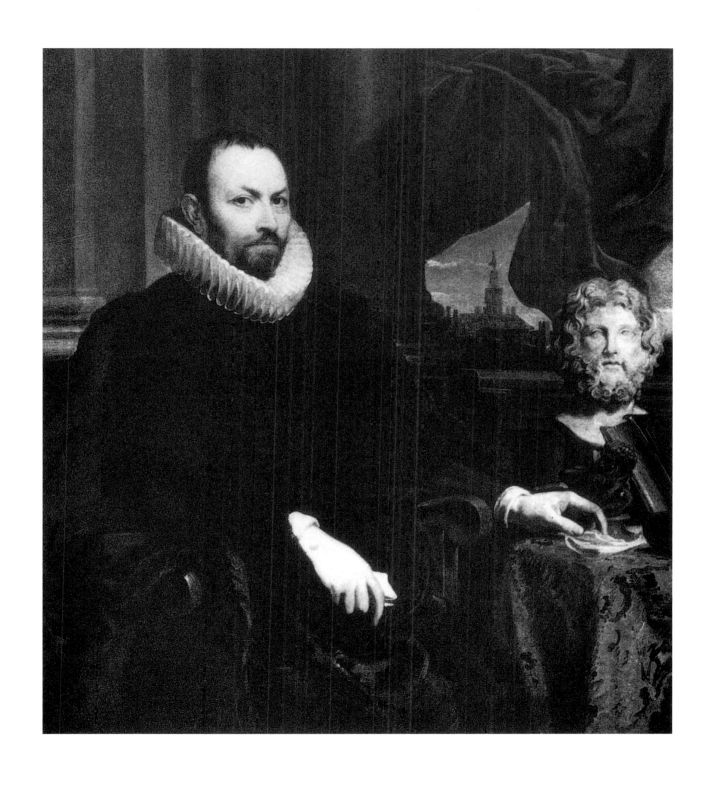

24. *Nicolaes Rockox*, 1621,
The Hermitage, St Petersburg.

In this early period Van Dyck also studied the works of the Venetian masters (particularly Titian and Tintoretto). At that time many Antwerp painters (notably Rubens) and art lovers had a number of works by these artists in their collections. The change in Van Dyck's painting technique owed not a little to the Venetian tradition. The artist turned ever more frequently to canvas, preferring it to panel. Instead of the white chalk priming traditional to the Netherlandish School, which heightens the purity and brilliance of the colours (as in the portraits of Cornelis van der Geest in the National Gallery, London, and of Baltazarina van Linick and her son in the Hermitage), he began using the dark, reddish (so-called bolus) priming prevalent in Venice, which makes his colours intense, rich, and passionate.

It is this that helps the artist to convey his subject's inner world (*Head of an Old Man*, Hermitage). While stamping every one of his portraits with the living image of the model, Van Dyck never strove to achieve merely the illusion of reality. His portraits are first and foremost painted images, in the creation of which the artist's hand plays a role of no small importance. Thus in *Family Portrait* (Hermitage) the artist applied the paint unevenly, leaving parts of the painting – and even the canvas – uncovered. And the brushstrokes – now delicate and limpid, now dense, rich, almost in relief – blending

25. *The Adoration of the Shepherds*, ca. 1616-18, Courtauld Institute Galleries, London.

26. *St John the Evangelist and St John the Baptist,* 1618-20, Academy of San Fernando, Madrid.

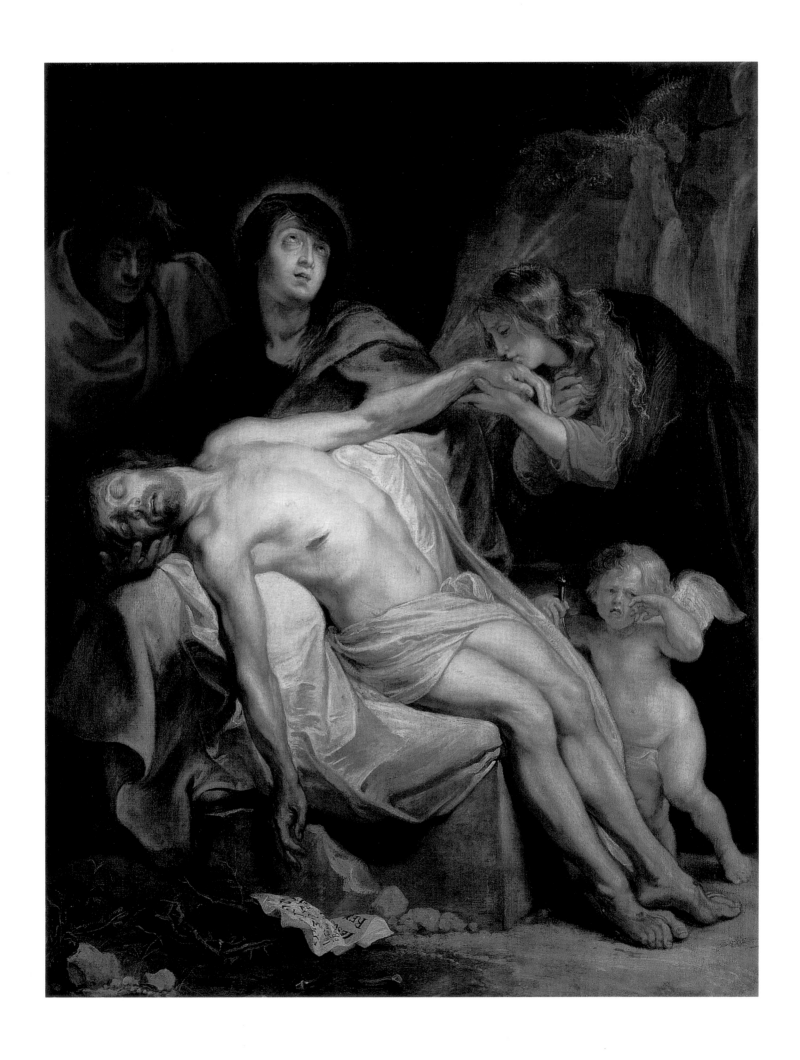

27. *The Lamentation*, ca. 1618-1620,
Kunsthistorisches Museum, Vienna.

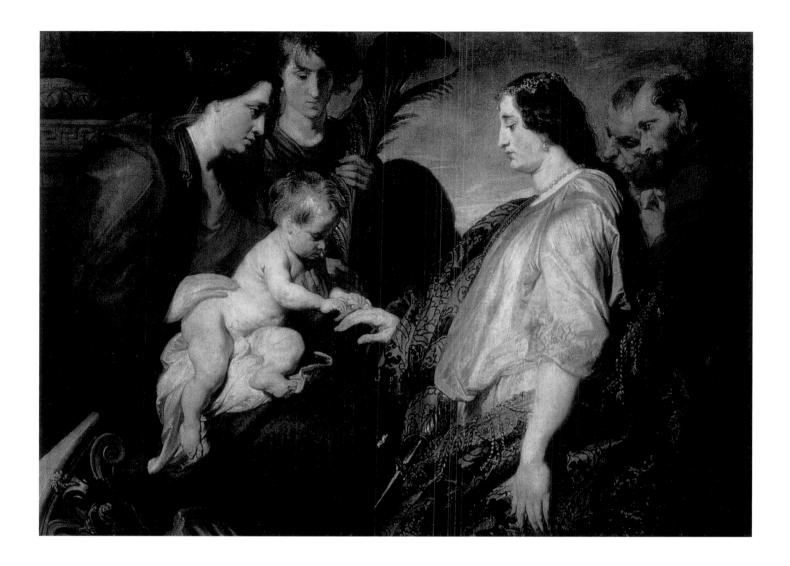

with the grainy texture of the canvas, cause the painted surface almost to vibrate and come alive.

Van Dyck's great skill quickly promoted him to the ranks of Antwerp's leading artists. His fame quickly spread beyond Flanders, and the English began to take an interest in him.

In July 1620, Sir Thomas Howard, second Earl of Arundel, one of the most celebrated patrons of his time, received a letter from his agent, in which the latter wrote: "Van Dyck is living at the house of Mr Rubens, and his works are beginning to be esteemed as highly as those of his master. He is a young man of one-and-twenty, his parents are very comfortably off and also live in this city, so it will be difficult to persuade him to leave the place, the more so as he can see the success and wealth of Rubens."[12]

Nevertheless, in October 1620 the artist came to work in London. Admittedly, Van Dyck's first stay in England was not a long one: it lasted only four months. Of the paintings known to date from this short period, perhaps the most unusual is the *Portrait of Sir George Villiers and Lady Katherine Manners, as Adonis and Venus* (Harari & Johns Ltd., London), Van Dyck's first "historical picture", in which

28. *The Mystic Marriage of St Catherine*, Prado, Madrid.

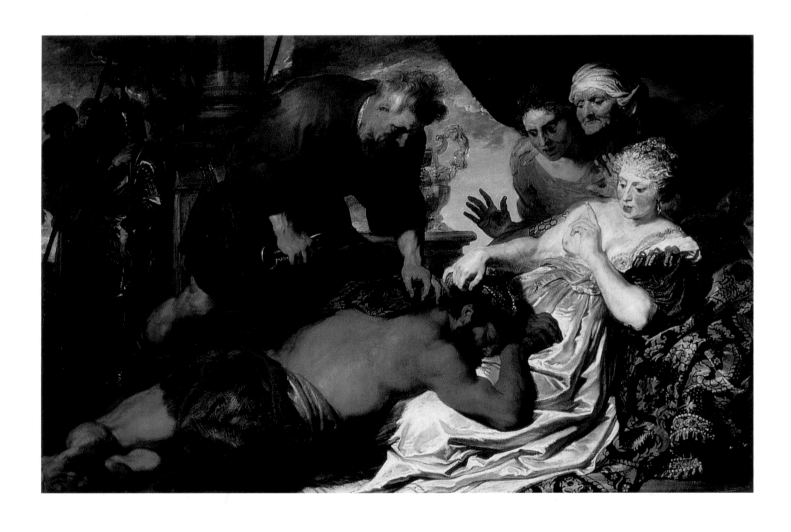

29. *Samson and Delilah*, ca. 1619-20,
Dulwich College Picture Gallery, London.

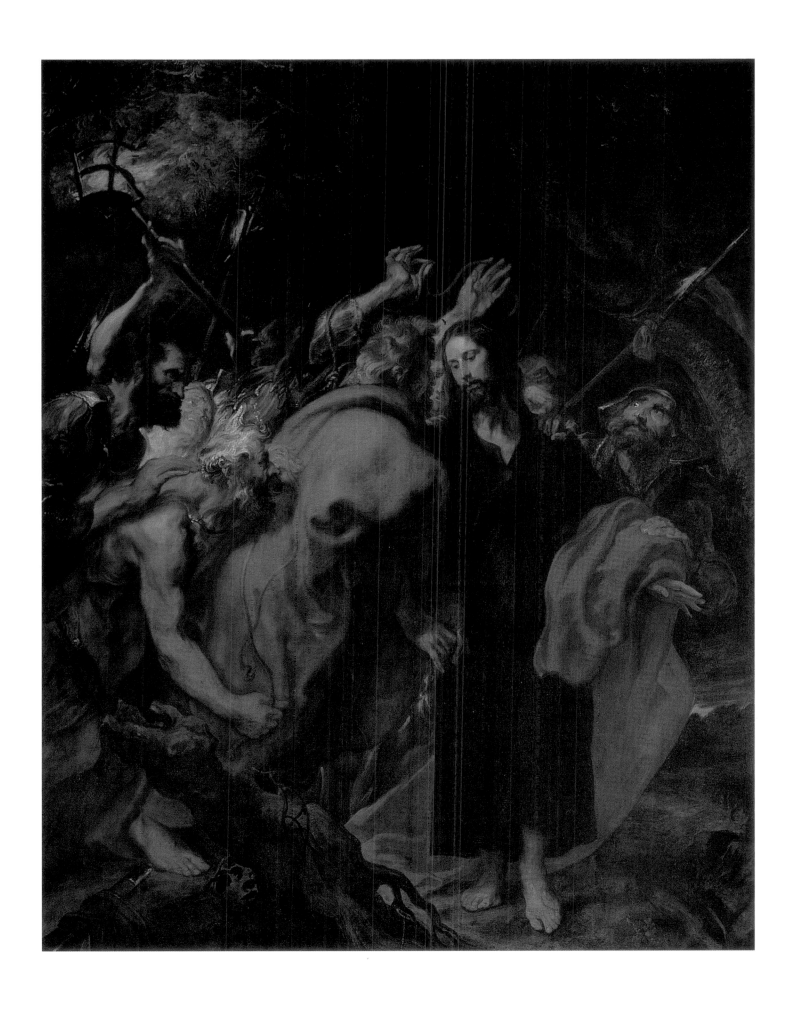

30. *The Betrayal of Christ*, ca. 1620,
City Art Gallery, Bristol.

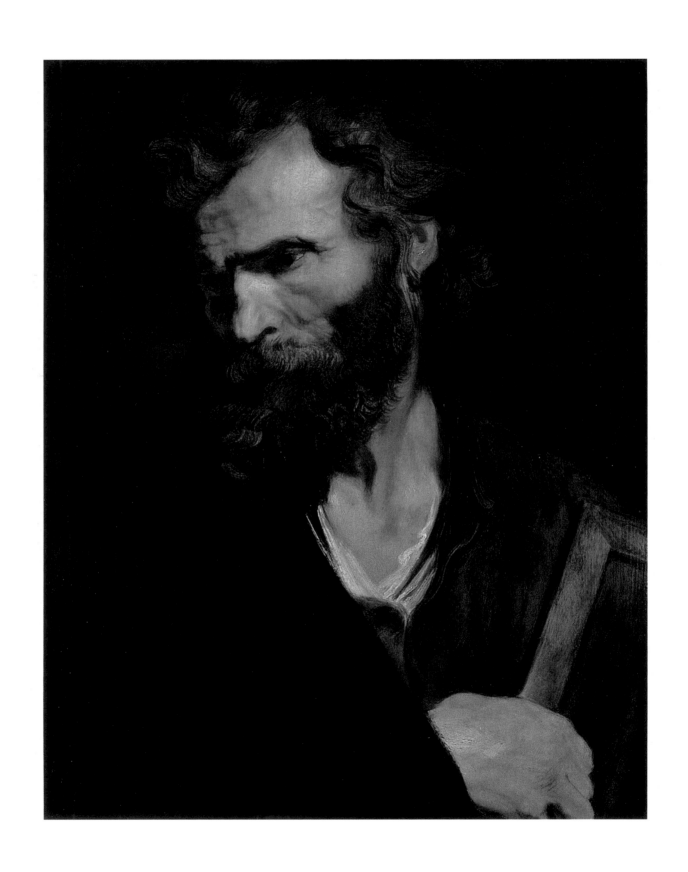

31. *Apostle Jude* (*Thaddeus*),
 ca. 1619-21,
 Kunsthistorisches Museum, Vienna.

44

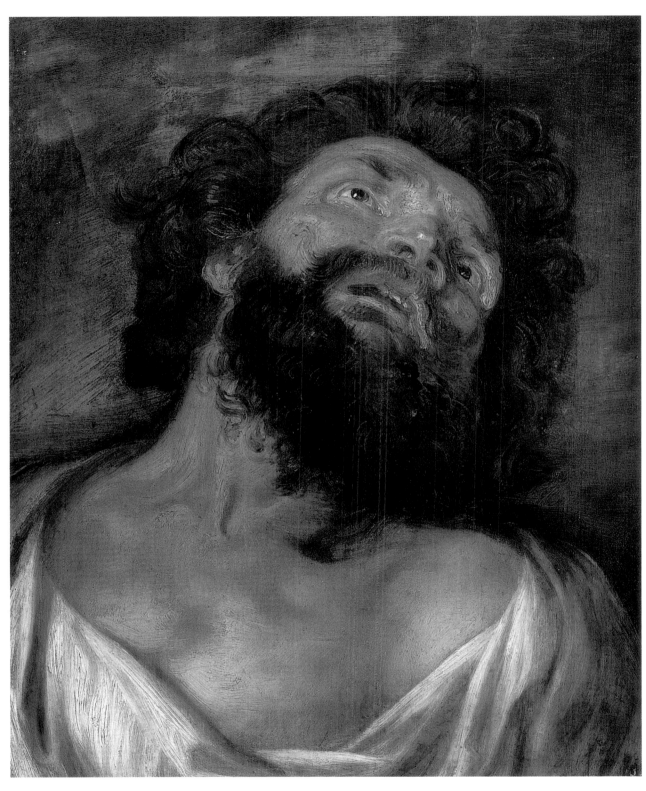

32. *Head of a Robber*, ca. 1617-18
(Study used by Rubens in his painting
Coup de Lance, now in Koninklijk
Museum voor Schone Kunsten,
Antwerp), Kunsthistorisches Museum,
Vienna.

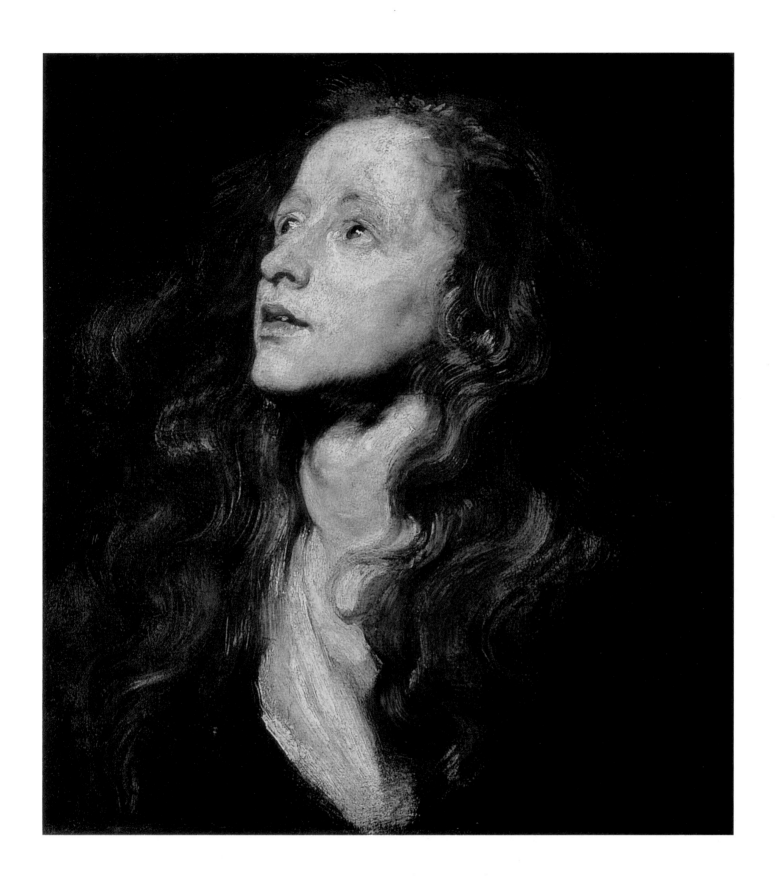

33. *Woman Looking Upwards,*
 study, 1618-20,
 Kunsthistorisches Museum, Vienna.

actual figures (here, George Villiers (1592–1628), the favourite of James I and Charles I, Marquis and, from 1623, first Duke of Buckingham, and the Earl of Rutland's daughter Katherine Manners (died 1649), whom Villiers married in May 1620) appear in the guise of characters from classical mythology. The depiction of the subjects half naked, albeit in the guise of well-known mythological characters, was unprecedented for both Flemish and English painting of the time.

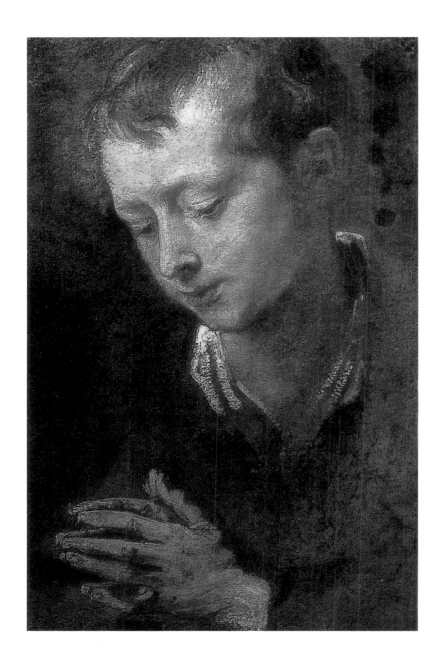

The impertinent conceit behind this portrait, for which we evidently have to thank the man who commissioned it – George Villiers, who was much given to extravagant behaviour – seems to have impressed Van Dyck too. The artist was not averse to the odd joke and himself at times inserted the painted likenesses of his contemporaries in the most unexpected places, as we have already observed in his copy of Rubens' *Emperor Theodosius Refused Entry into Milan Cathedral*.

The echoes of Venetian art perceptible in this portrait's tonality are the result of the young Fleming's attentive study of English collections (particularly the royal ones), which were even then extremely rich in paintings by Venetian masters, especially Titian, whose influence on Van Dyck's work became ever more marked after the artist's return from England. For it was then, in late 1621, that he painted the *Family Portrait* already mentioned and *Head of an Old Man*, now in the Hermitage.

34. *Head of a Boy,* ca. 1618,
Henry Welden Collection, New York.

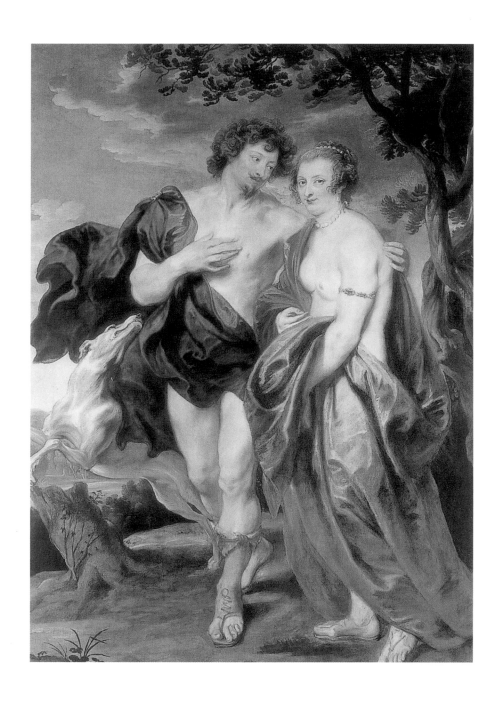

35. *Sir George Villiers and Lady Katherine*
 Manners as Adonis and Venus,
 1620-21,
 Harari & Johns Ltd., London.

The vibrant and moving *Family Portrait*, showing a young couple with their child, was at first identified as a depiction of the family of the Flemish animal- and still-life painter, Frans Snyders (1579–1657); the portrait appeared with this attribution at the sale of the collection of La Live de Jully. However, this attribution was disproved as early as the last century, on the grounds that the Snyders had no children. There were more supporters of an alternative hypothesis, according to which the portrait shows the family of the Flemish landscape painter Jan Wildens (1586–1653). But it, too, has been shown to be false, since the features of the man in the Hermitage portrait do not display an indisputable resemblance to any of the authenticated portraits of Wildens. The device on the back of the armchair, which might be a coat of arms (a possible help in the identification of the subjects), is executed too sketchily to be decipherable.

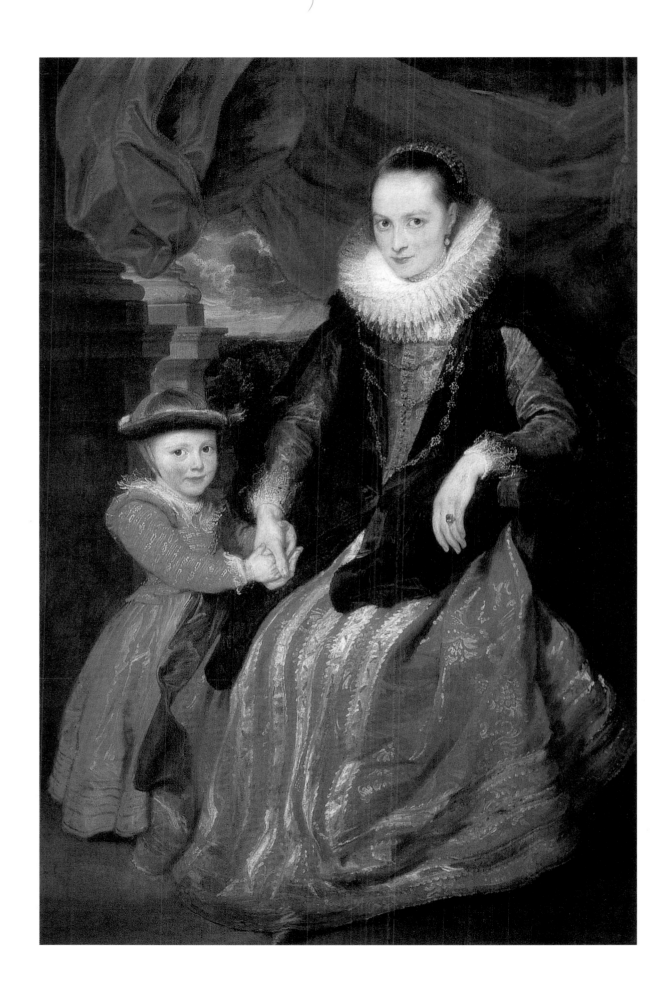

36. *Suzanna Fourment and her Daughter,*
1620-21,
National Gallery of Art, Washington.

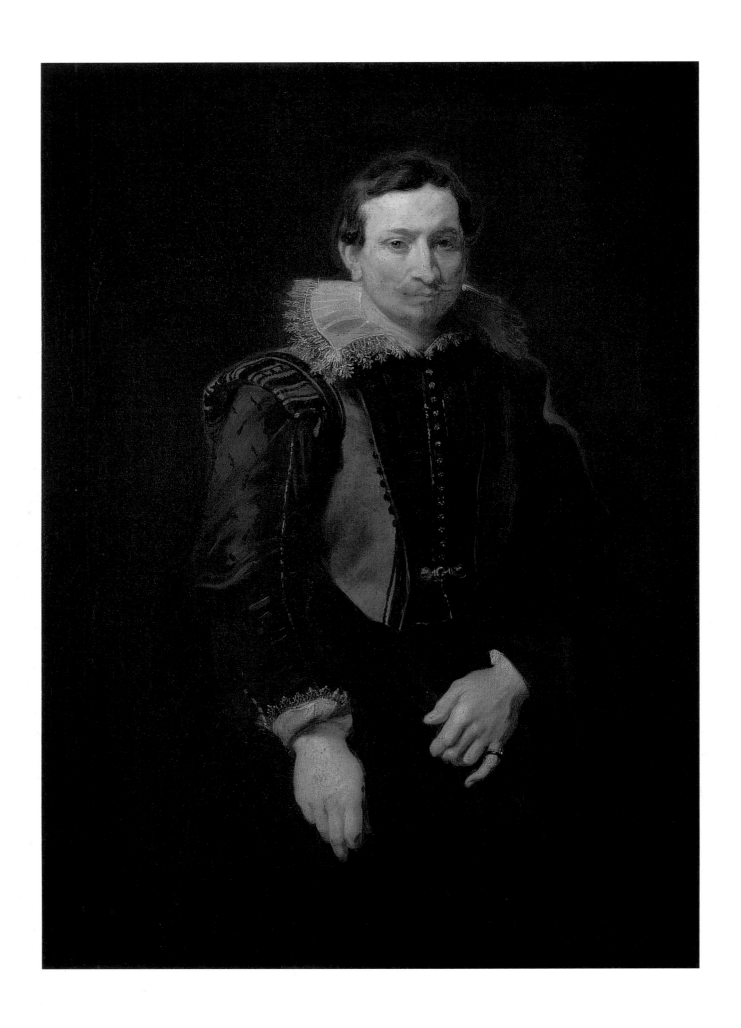

37. *Portrait of a Young Man*,
ca. 1618,
The Hermitage, St Petersburg.

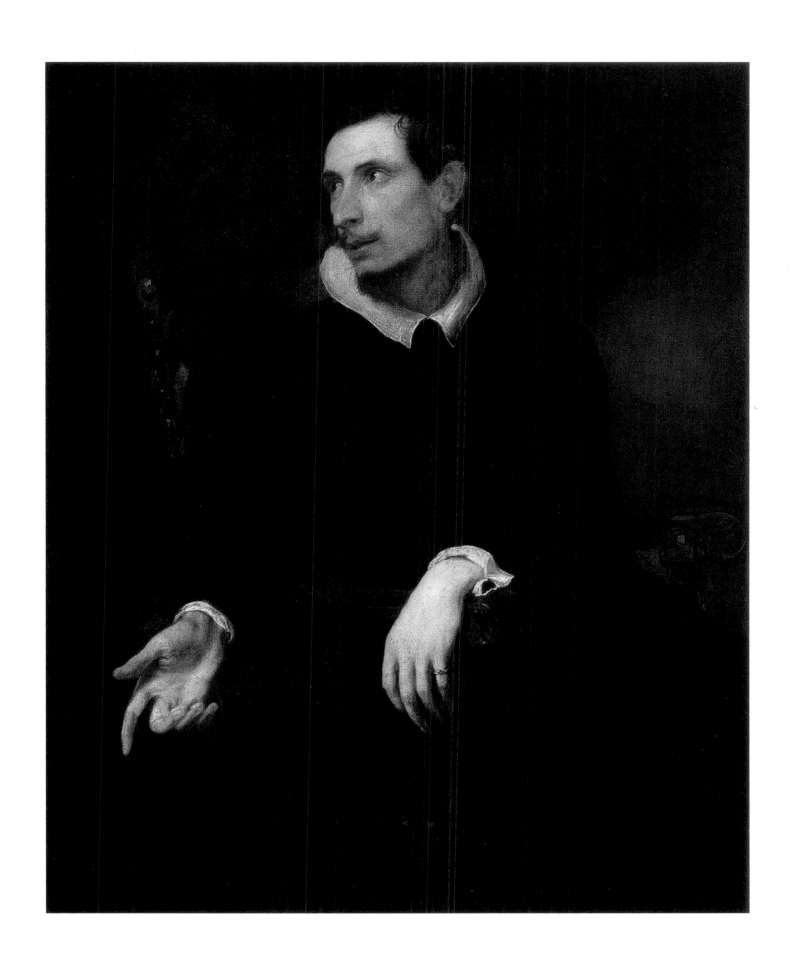

38. *Portrait of a Man* (*Virginio Cesarini*),
 1622 or 1623,
 The Hermitage, St Petersburg.

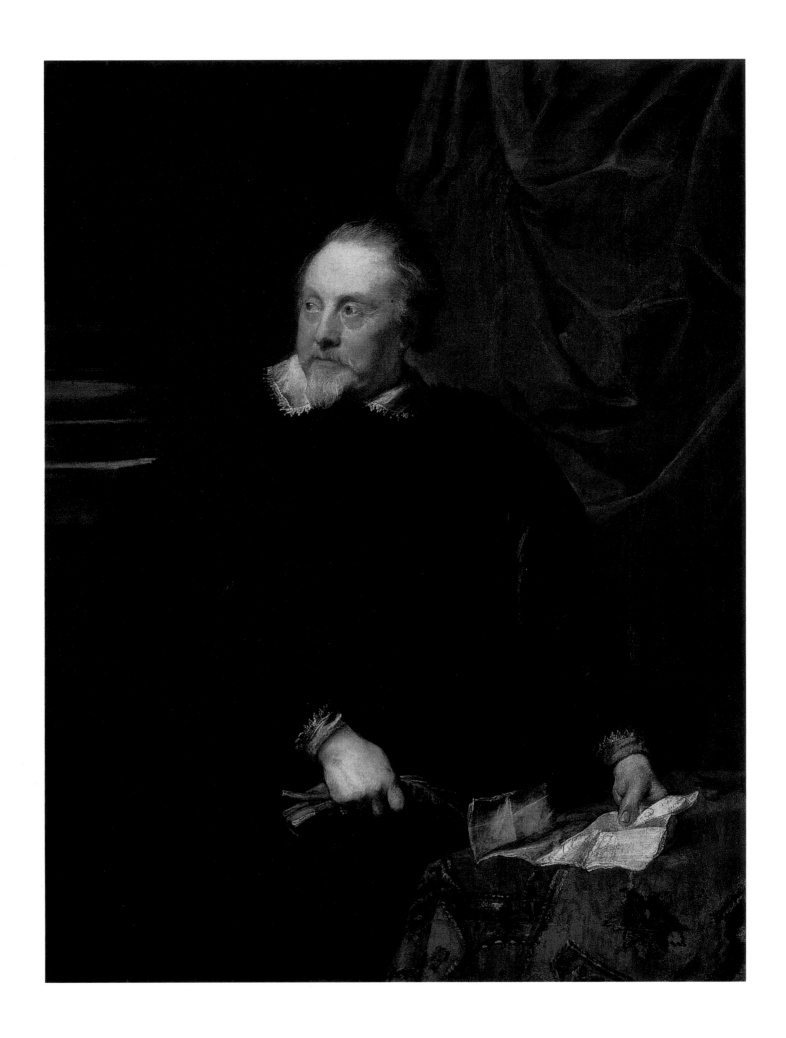

39. *Portrait of a Man* (probably Marc-Antoine
 Lumagne), mid-1620s,
 The Hermitage, St Petersburg.

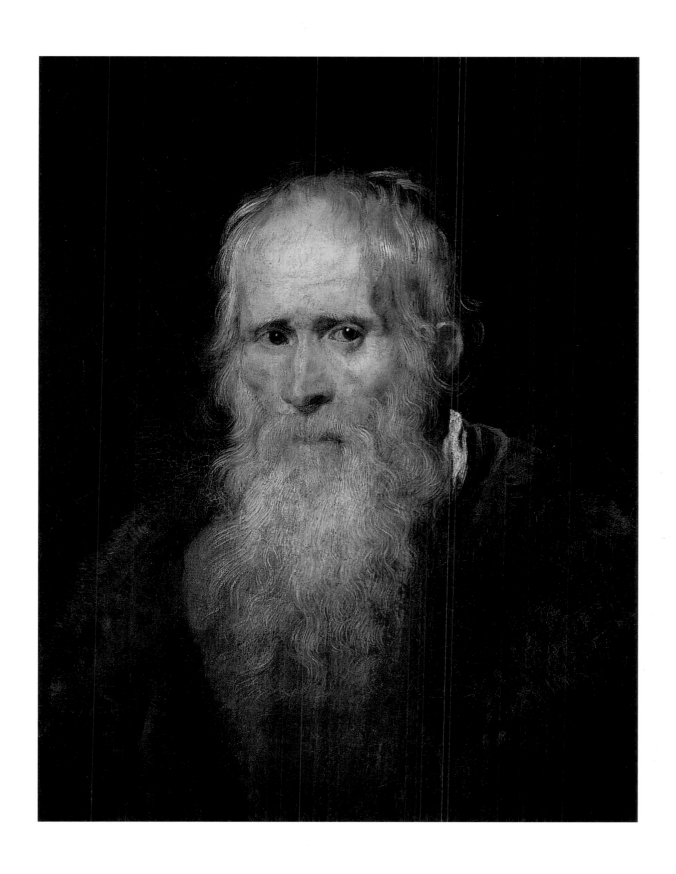

40. *Head of an Old Man*, ca. 1621,
The Hermitage, St Petersburg.

41. *Head of an Old Man*, study, ca. 1616-18, Kunsthistorisches Museum, Vienna.

The unusualness of the canvas, traditional only at first sight (the man is leaning with his hand against the slightly inclined back of the armchair, which gives an element of instability to the composition), along with the boldness of the innovative, experimental technique, that characterizes the portrait, would have been more to the tastes of a fellow artist or amateur collector than of a burgher not too well versed in the arts, who would probably have been more used to the traditional style of the sixteenth-century Netherlandish masters such as the celebrated portraitist and older contemporary of Van Dyck, Cornelis de Vos (1584–1651). Therefore the man who commissioned the *Family Portrait* was probably a member of the artist's close circle.

42. *Silenus Drunk*, ca. 1620, Staatliche
Kunstsammlungen, Dresde.

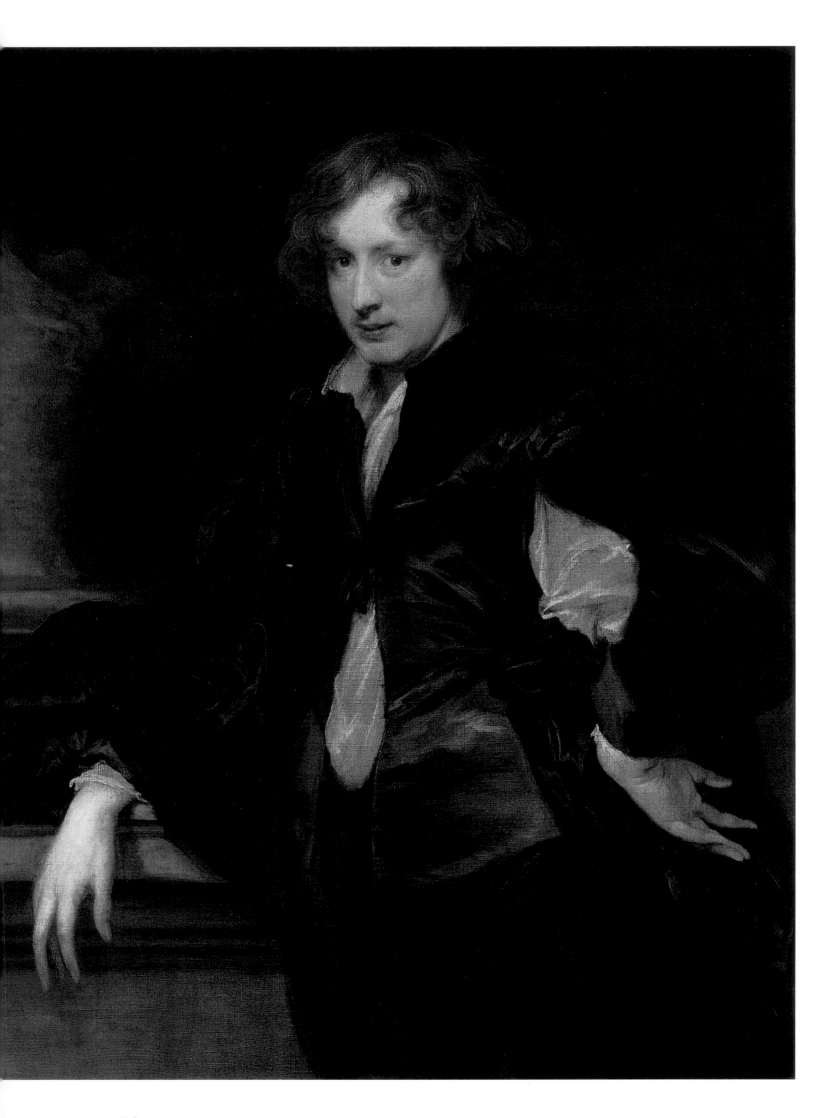

THE ITALIAN PERIOD

1621-1627

In late February 1621, Anthony van Dyck, "His Majesty's [the English king Charles I's] servant", managed to obtain an eight-month leave of absence and left London – but for eleven years, not eight months. After a short stay in Antwerp, he set out for Italy, where he remained for six years. Van Dyck visited many cities: Genoa, Rome, Venice, Florence, Milan, Mantua, Bologna, Turin, and Palermo. He diligently studied works of art and made sketches of ancient monuments and the pictures of the great masters of the Renaissance. His *Italian Sketchbook*, which survives to this day, contains sketches of the works of his favourite Venetians (Titian, Veronese, Sebastiano del Piombo) and also of Raphael, Leonardo da Vinci, and the Bolognese painters.

Van Dyck lived mostly in Genoa; it was from there that he made trips to other places, and it was to there that he would return, in the words of his biographer Bellori, "as if it were his native city; he was loved and held in high regard by everyone there".[13] Rubens' name was also well known in Genoa: during his time in Italy he had painted many portraits there. It is a relevant fact that Genoa had for a long time been home to a sizeable community of Flemish artists. The city, moreover, had close trade links with Antwerp. Van Dyck took up residence in Genoa in the house of the Flemish painter and picture dealer Cornelis de Wael (1592–1667), who introduced his young countryman into Genoese aristocratic circles and some of the city's most prominent families (the Brignole-Sales, Adornos, and Cattaneos). They became the illustrious portraitist's important clients and fervent admirers. Van Dyck's Italian Period,

43. *Self-Portrait*, 1622 or 1623,
The Hermitage, St Petersburg.

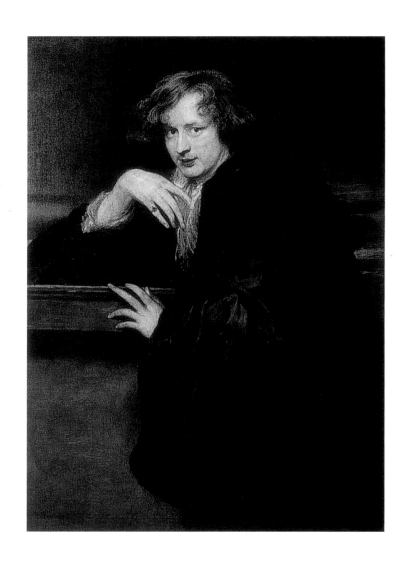

covering the years 1621 to 1627, proved extremely fruitful and saw the real explosion of his talent. Many of his masterpieces of portraiture belong to this period, as does the development of a repertoire of specific motifs in his ceremonial commissioned works. The formal commissioned portrait, a type created by Rubens, – the large (full-length) picture-portrait, the portrait as a spectacle – was perfected by Van Dyck in his Italian Period, and it is thanks to Van Dyck that it became so popular all over Europe.

During his years in Italy the artist painted dozens of similar works, which won him a reputation as the creator of the European aristocratic ceremonial portrait. The best of them are devoid of the formal touch which one would think would be endemic to the very nature of the genre. The richness of the accessories, the use of sometimes unusual, exotic costumes (as in the portraits of Sir Robert Shirley, an Englishman in the service of the Shah of Persia,

44. *Self-Portrait*, ca. 1619-20, The Metropolitan Museum of Art, New York.

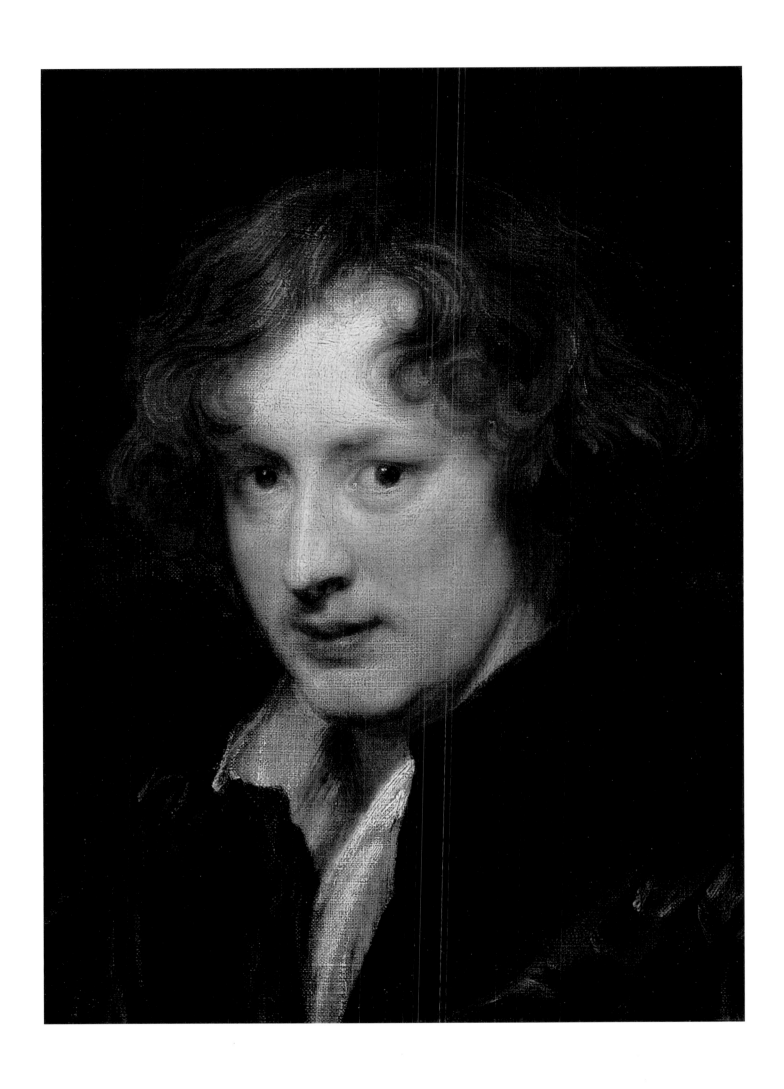

43. *Self-Portrait,* 1622 or 1623, detail.

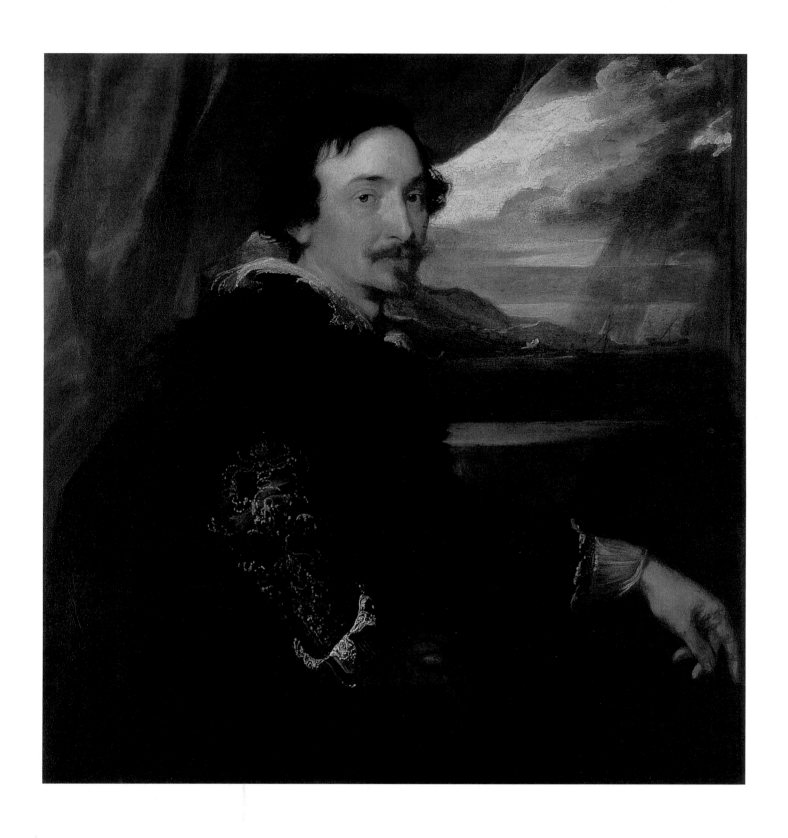

and of his wife Theresia, Lady Shirley, an aristocratic Circassian and daughter of Ismail Khan; both in Petworth House, Sussex), and the luxurious architectural backgrounds in Van Dyck's portraits do not deprive their subjects of their unique individuality. The artist is able to find the posture, gesture, and movement peculiar to each individual, and his techniques – the lengthening of the proportions, the depiction of the figure from below in the di sotto in su perspective, as if raising the subject on some kind of pedestal – help not only to bring out the person's grandeur and celebrity, but also to emphasize his or her inherent dignity (*Elena Grimaldi, Marchesa Cattaneo, with a Negro Servant*, National Gallery of Art, Washington).

46. *Lucas van Uffelen*, 1622,
Herzog-Anton-Ulrich-Museum,
Braunschweig.

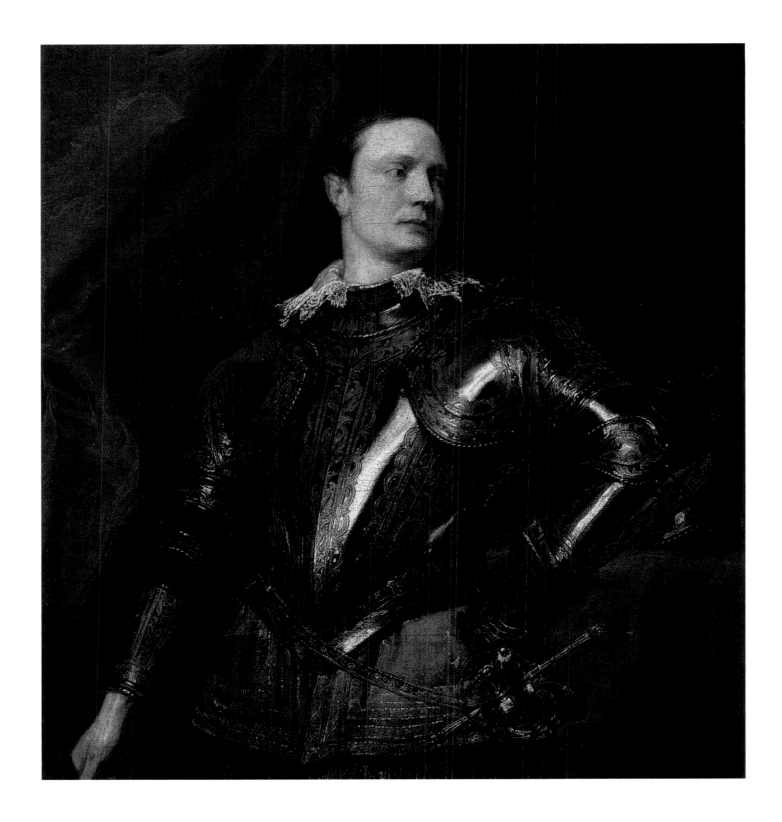

In his portraits of the Cattaneos' children Filippo and Clelia (both in the National Gallery of Art, Washington), however, Van Dyck renounces the use of di sotto in su perspective, which creates an impression of distance between the subject and the observer, and shows his models (as in the works from his First Antwerp Period) slightly from above, giving the observer a sense of intimacy with them.

This sense of intimacy with the subject is also evoked in Van Dyck's cabinet portraits from the Italian Period, in which the strivings of his First Antwerp Period – to "incarnate" the concept of

47. *Portrait of a Young General*,
 Kunsthistorisches Museum, Vienna.

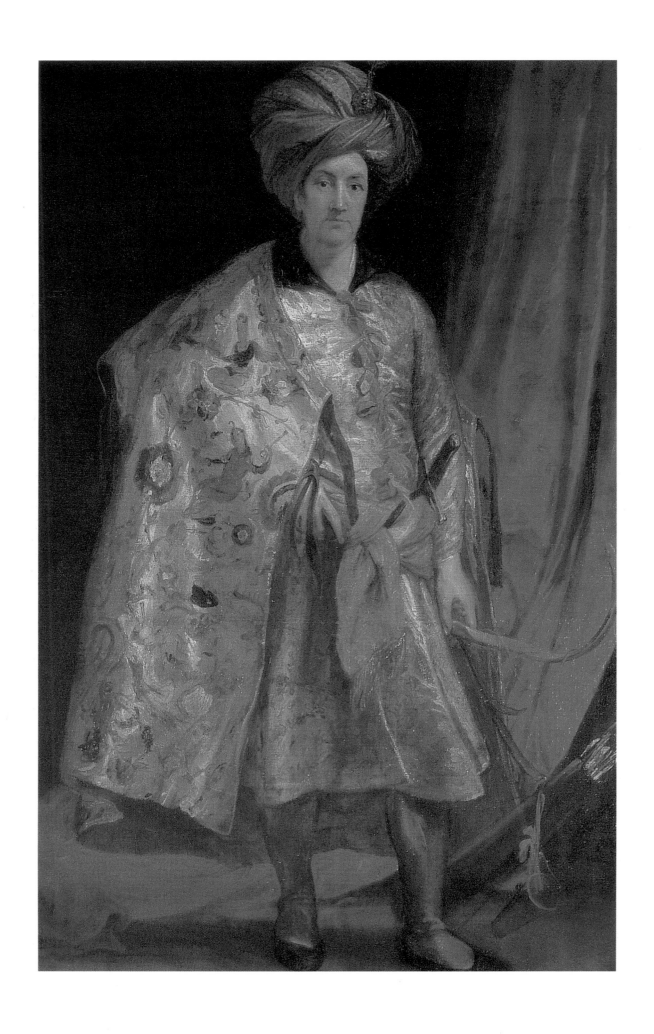

48. *Sir Robert Shirley*, 1622,
 National Trust, Petworth House, Sussex.

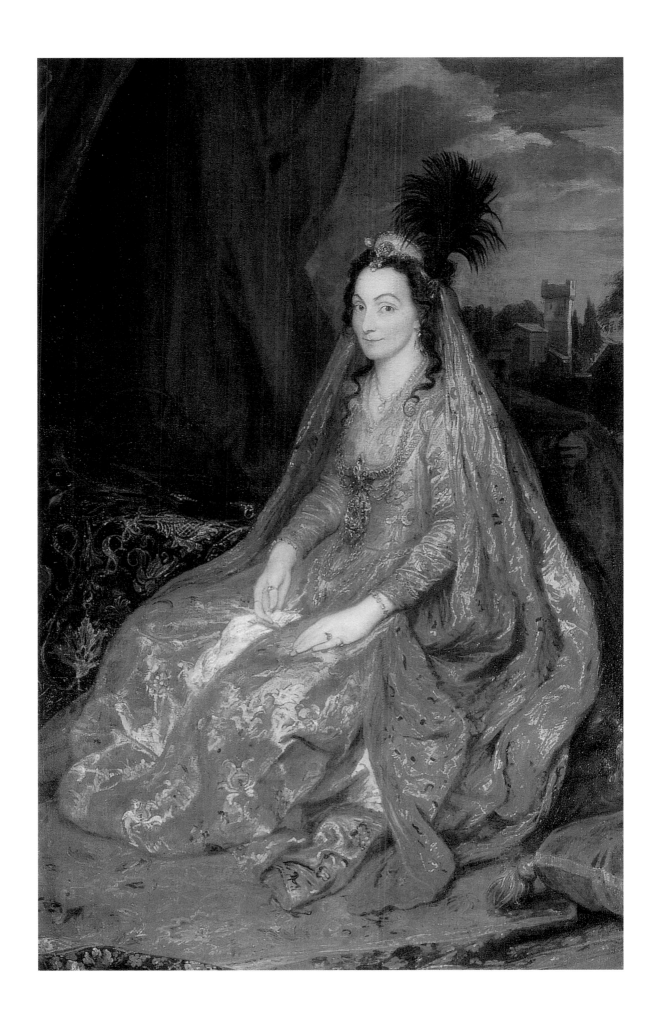

43. *Lady Shirley*, 1622,
National Trust,
Petworth House, Sussex.

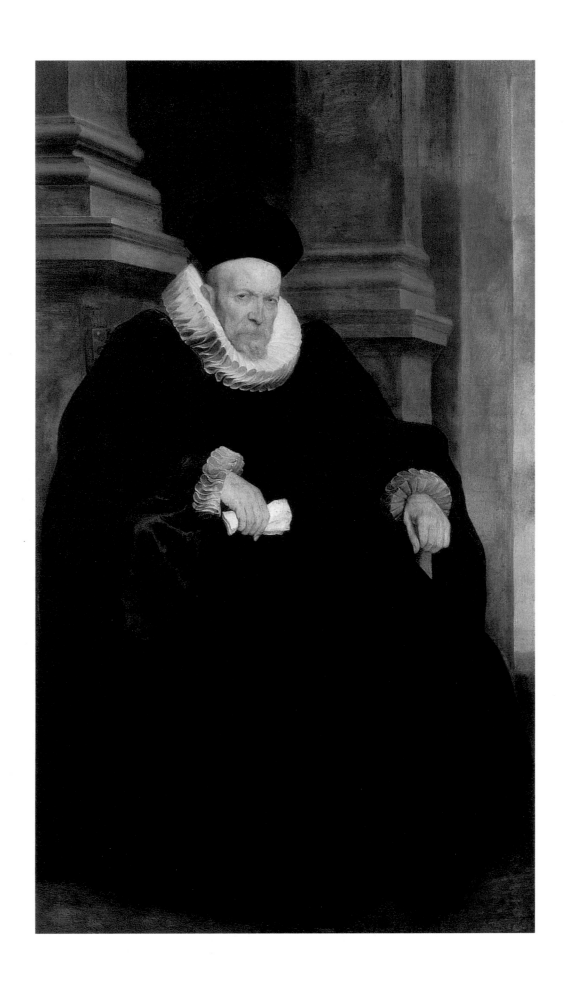

50. *The Genoese Senator*, 1621-23,
 Gemäldegalerie, Berlin.

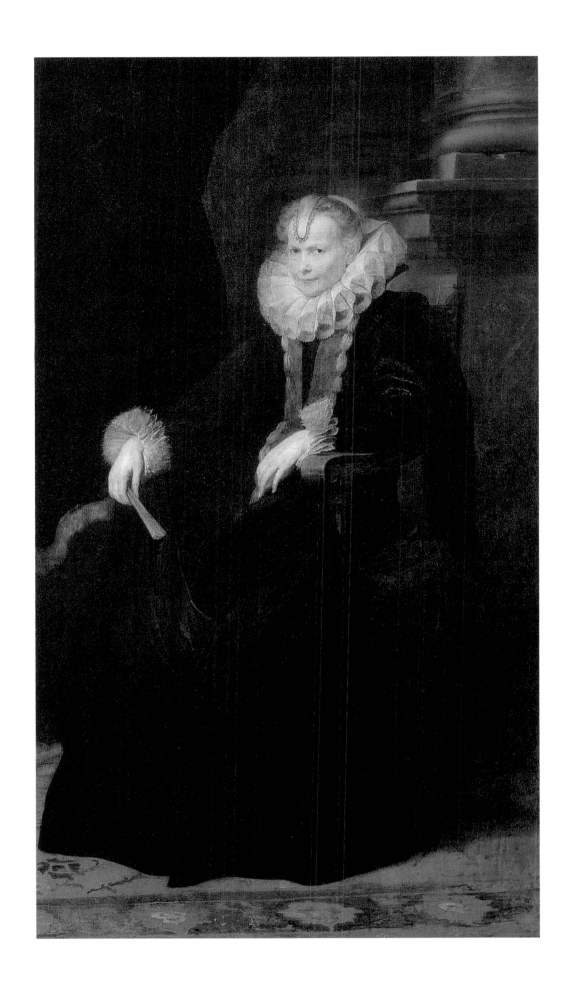

51. *The Genoese Senator's Wife*, 1621-23,
Gemäldegalerie, Berlin.

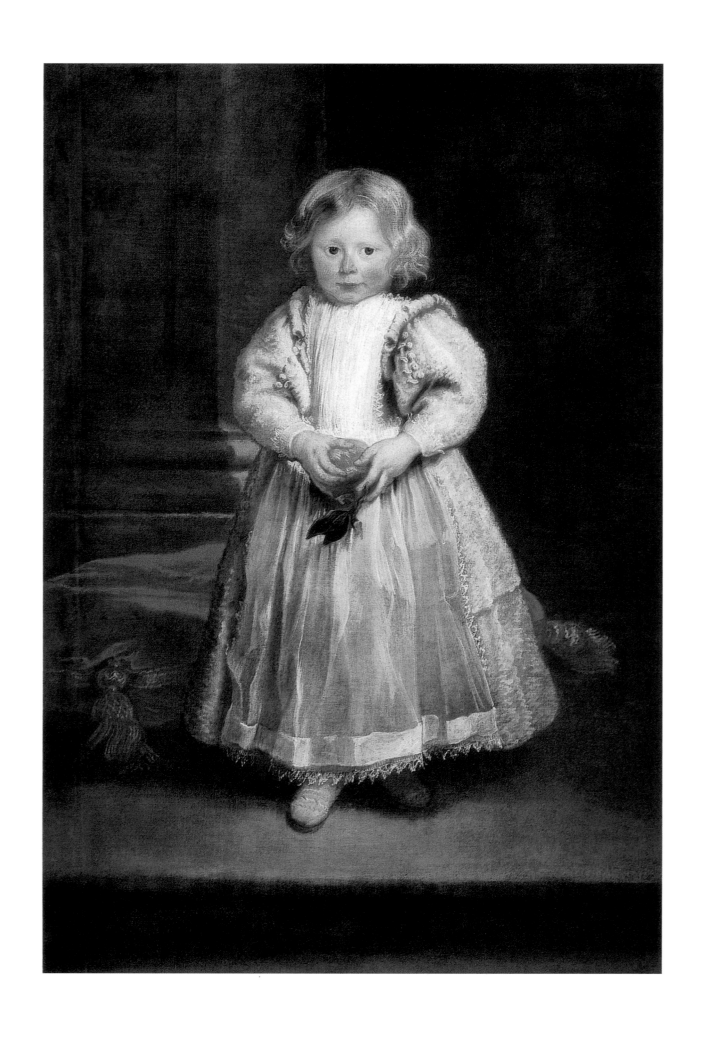

52. *Clelia Cattaneo*, 1623,
 National Gallery of Art, Washington.

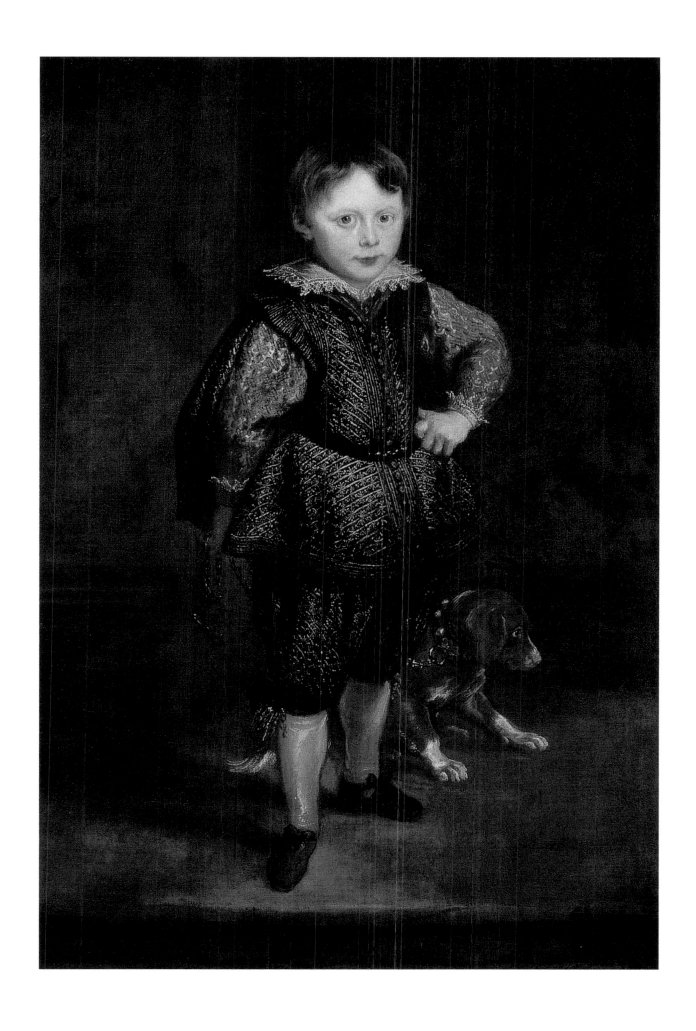

53. *Filippo Cattaneo*, 1623,
Nationa Gallery of Art, Washington.

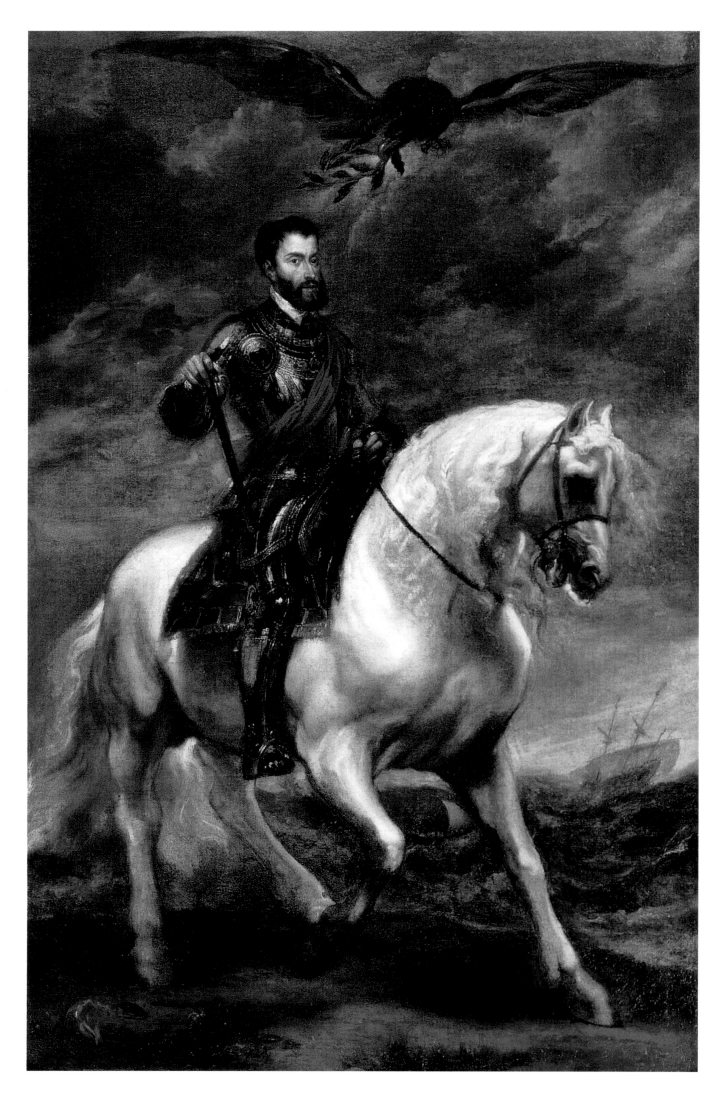

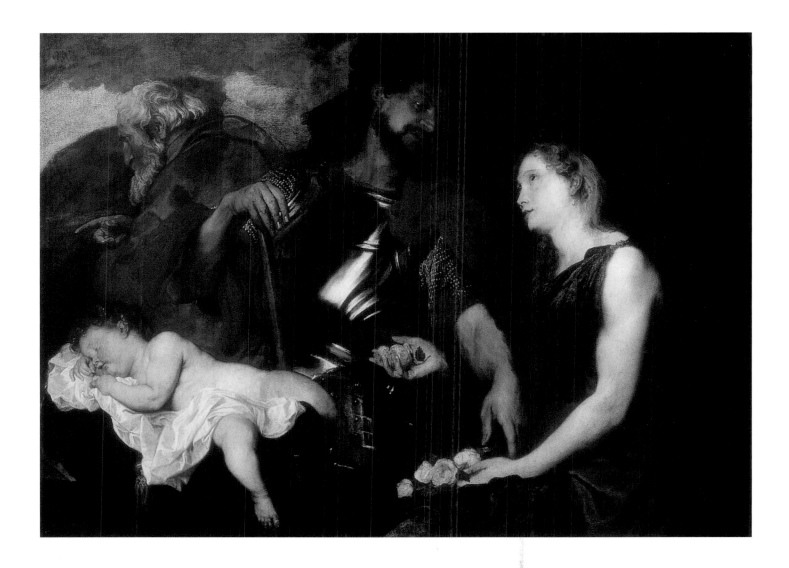

creatively active, spiritually rich individual – were further developed. These are portraits of his artist friends, Rome's intellectual elite. Two male portraits and a self-portrait in the Hermitage belong to this type.

The male portrait, painted in 1622 or 1623, is one of the artist's unquestioned masterpieces. It is characterized by an exceptional outward austerity and simplicity. The artist is not interested in either the subject's clothing or his surroundings – only in the man himself, in the movements of his soul, in his emotional world. And attention is focused on the most important things – the subject's face and hands, picked out by the light. The man is not posing. He seems to have been captured during an argument. He is passionately pointing out something to somebody, underlining his words with a gesture. Van Dyck is here employing a new, original technique – the exposition of a man's inner impulses and spiritual tension through external action. The keen glance thrown at his unseen interlocutor, the jerky posture, the animated fingers, all allow the artist to bring out the subject's inner essence and temperament. The portrait contains no bright colours, only contrasts of black and white.

54. *Charles V on Horseback*, Galleria degli Uffizi, Florence.

55. *The Four Ages of Man*, ca. 1625, Museo Civico, Vicenza.

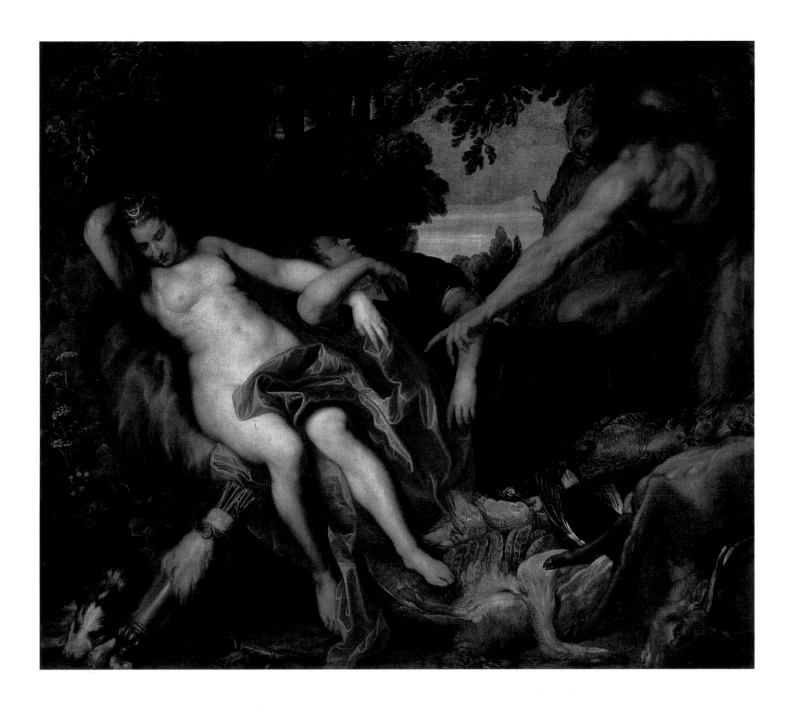

But by employing such laconic methods Van Dyck achieves an impression of exceptional tonal richness. The deep, dark colours are saturated with hot reddish hues, which seem to reflect the subject's ardency, his passionate fit of emotion. This type of colouring – warm and rich, as if radiating an inner light – once again testifies to Van Dyck's study of the Venetian painters, particularly Titian. Visitors to Van Dyck's Antwerp studio were later able to admire a room in his house full of the great Venetian's pictures and copies of his works by the Flemish portraitist.

56. *Diana and Endymion Surprised by a Satyr*, 1626, Prado, Madrid.

57. *Polyxena Spinola, Marchesa de Leganes*, Prado, Madrid.

There have been several attempts to establish the identity of the model in *Portrait of a Man*. On the basis of the inscription on the engraving by Sébastien Barras in the nineteenth-century edition of Van Dyck's *Iconography*, this portrait was for a long time thought to show the Antwerp doctor Lazarus Maharkyzus (1571–1647). Moreover, in line with this attribution, the portrait was ascribed to

70

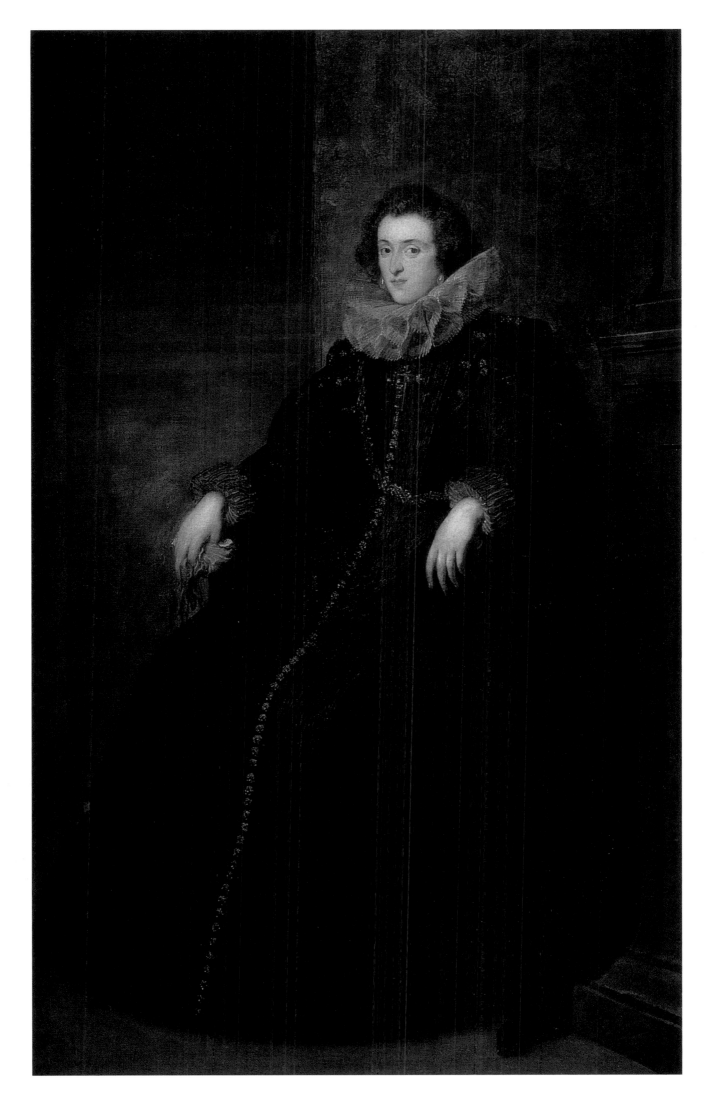

Van Dyck's Second Antwerp Period. However, the dynamism of the image, the attempt to convey a fleeting moment, and the strong echoes of Venetian art in the tonality, and to some extent in the turn of the figure,[14] force us to date the portrait to the artist's sojourn in Italy. Radiological research carried out in the Hermitage's laboratory has helped to establish a more precise date for the portrait's execution.[15] An X-ray has revealed a sketch for the famous portrait of Cardinal Guido Bentivoglio (Galleria Patti, Florence), executed by Van Dyck in Rome in 1622 or 1623, underneath the top layer of paint.

The face in the Hermitage portrait has at different times been identified as that of the painter Jean Leclerc from Lorraine or an unknown Roman cleric from the circle of Cardinal Bentivoglio.[16] But an entirely plausible hypothesis, recently proposed, identifies the subject as Virginio Cesarini, favourite, protégé, and chamberlain of Maffeo Barberini (Pope Urban VIII).[17]

Cesarini, author of elegant poems in Italian and Latin, member of the Accademia dei Lincei, publisher and protector of Galileo, was one of the central figures in Roman cultural and intellectual life in the late 1610s and early 1620s. This hypothesis is supported by the similarity of the features to the sculptured portrait on Cesarini's tomb in the Sala dei Capitani (Museo Capitolino, Rome), by his clothes, which reveal him to be a member of the clergy and, last but by no means least, by his pallid, sickly face, flushed with fever (Cesarini probably died from tuberculosis, in April 1624).

A fondness for Titian's work is also evident in the Hermitage's second *Portrait of a Man*, which according to some sources shows the Lyons banker and art lover Marc-Antoine Lumagne.[18] The portrait displays a grandeur of image, a monumental "wholeness" of silhouette, a deep, warm background, and a free and unfettered technique that are positively Titianesque. But here, too, the artist's main concern is the subject's intellectual energy and inner passion. In this portrait, as in the previous one, the man is shown at a moment in his life which the artist seems to have come across quite by chance. He has been reading a letter, which he still holds in his hand, but has looked up from it for a minute. And his flabby face has become transformed and animated by a thought...

In portraits like these, Van Dyck was attempting to extend the traditional boundaries of the genre, to imbue the image with movement and passion, almost with dramatic action. In Italy Van Dyck perfected the idiom of his art and enriched his compositional techniques and palette. His tonality, having lost its former brightness and multiplicity of colours and restricted now to only a small number of tones, acquired a particular depth and resonance. His art became more free and flexible in its methods and displayed a new power of expression.

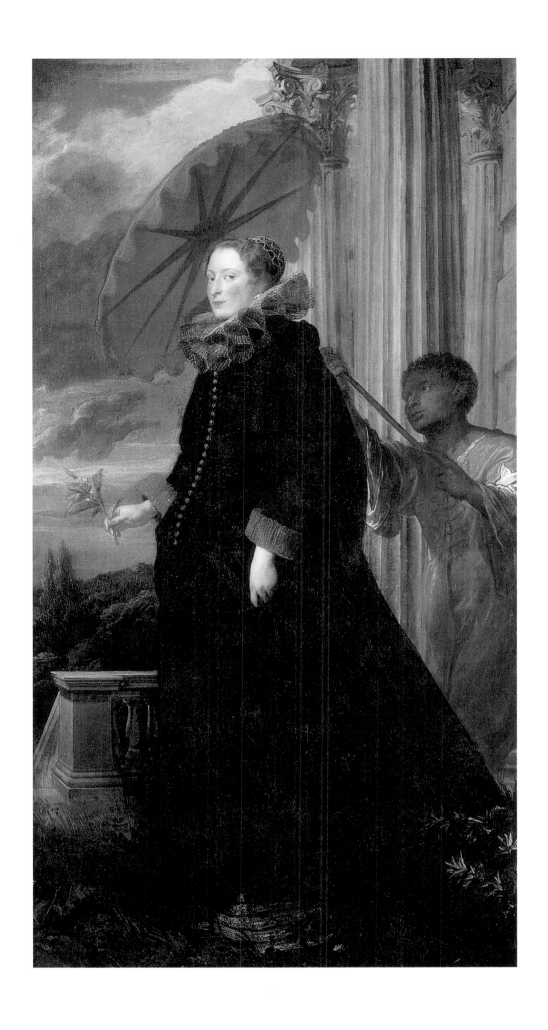

58. *Elena Grimaldi, Marchesa Cattaneo, with
a* Negro *Servant*, 1623,
National Gallery of Art, Washington.

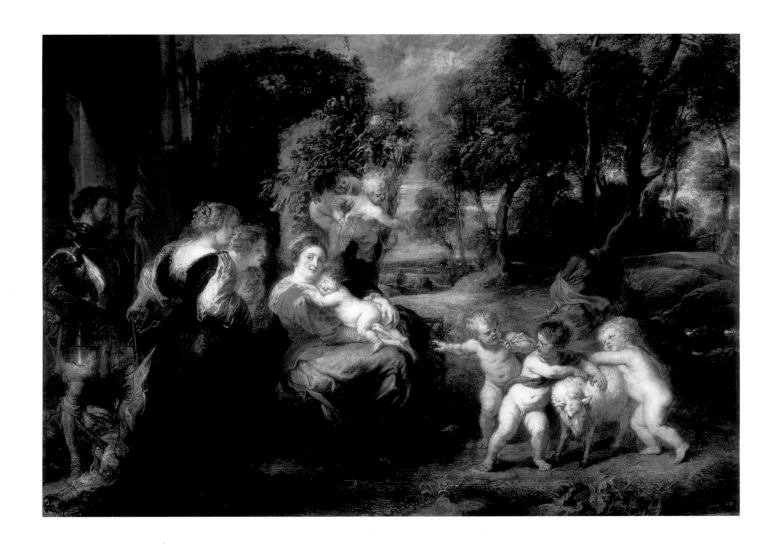

The visual and technical refinement of Van Dyck's mature art reached its apogee in the Hermitage *Self-Portrait* painted possibly in Rome in 1622 or 1623, the finest of the artist's self-depictions known to us.

Here Van Dyck paints himself in the bloom of youth, as a slender, elegantly dressed gallant, nonchalantly leaning against the pedestal of a broken column and fixing the observer with a dreamy, slightly enigmatic look. His grace of posture, his aristocratically slender, long-fingered, lithe hands, and the magnificence of his black-silk costume all vividly bear out the impression Van Dyck was said to have made in Rome on his fellow artists, who nicknamed him *il pittore cavalieresco* (the gentleman-artist) for his taste for the high society way of life. Not for nothing did the artist's biographer Giovanni Pietro Bellori write that Van Dyck's manners were more those of an aristocrat than of an artist. Likewise his sumptuous clothing and taste for wearing fine fabrics, feathered hats, and ribbons betrayed the young Fleming's attraction to the titled aristocracy, whose portraitist he became from the first months of his residence in Italy.

59. Peter Paul Rubens, *Landscape with Madonna and Child.*

The idea of man's innate nobility and of his spiritual and intellectual supremacy in the world, expressed in the Hermitage *Self-*

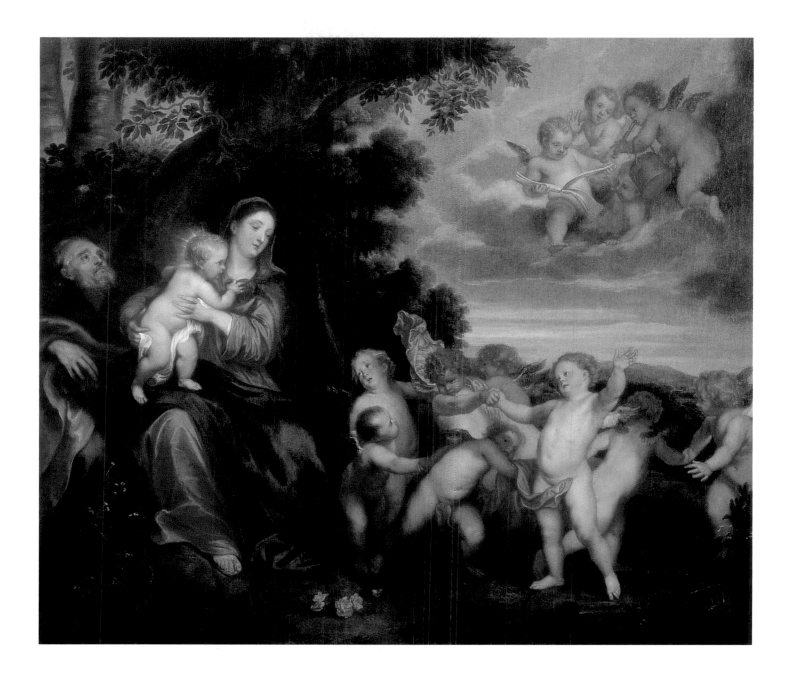

Portrait, finds its closest analogy in Italian Renaissance art. Researchers have suggested that the artist's posture in the portrait, his proud bearing, the free turn of the figure and the intricate silhouette of his costume, with its luxuriant puffed sleeves, were inspired by Raphael's *Portrait of a Young Man* (present whereabouts unknown; formerly in the Czartoryski Collection, Krakow), of which Van Dyck made a sketch on a page of his *Italian Sketchbook* (British Museum, London).[19]

The style of the portrait – a three-quarter-length figure leaning against the pedestal of a column – follows a Venetian prototype, more specifically that of Titian (see, for example, his *Portrait of Benedetto Varchi*, Kunsthistorisches Museum, Vienna). Several pages of the *Italian Sketchbook* are devoted to copies of Titian's portraits. The artist's refined and aristocratic appearance in *Self-Portrait* is echoed in the equally refined execution. Van Dyck has succeeded in retaining all the freshness of the spontaneous sketch,

60. *The Rest on the Flight into Egypt (The Holy Family with Angels)*, Palazzo Pitti, Florence.

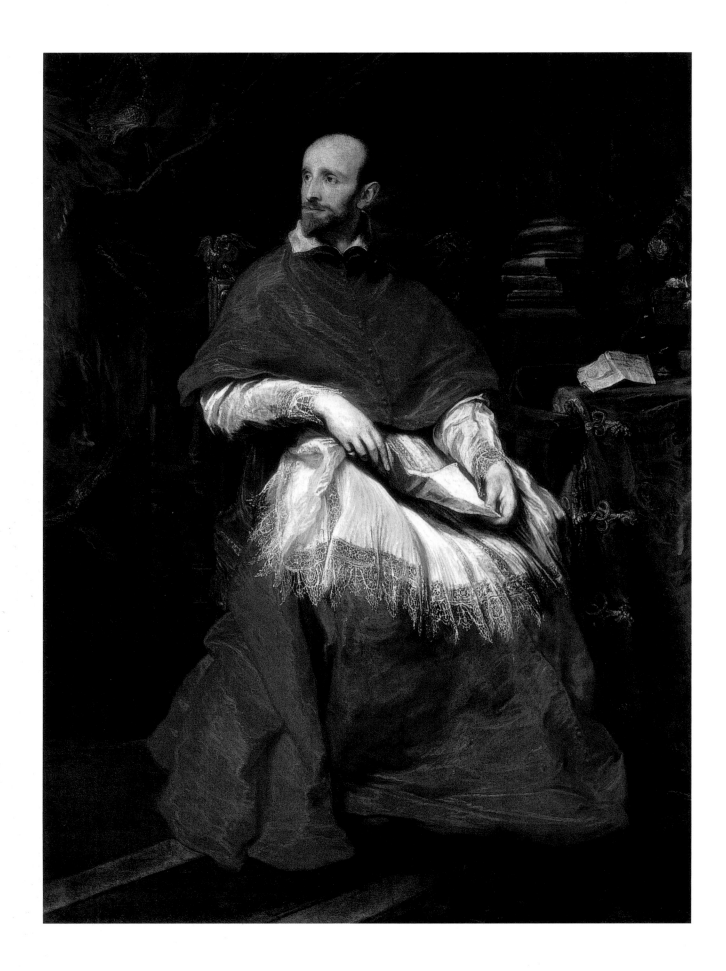

61. *Cardinal Bentivoglio,* 1622 or 1623,
 Galleria Pitti, Florence.

62. *Portrait of a Genoese Noblewoman with
 her Son,* ca. 1626,
 National Gallery of Art, Washington.

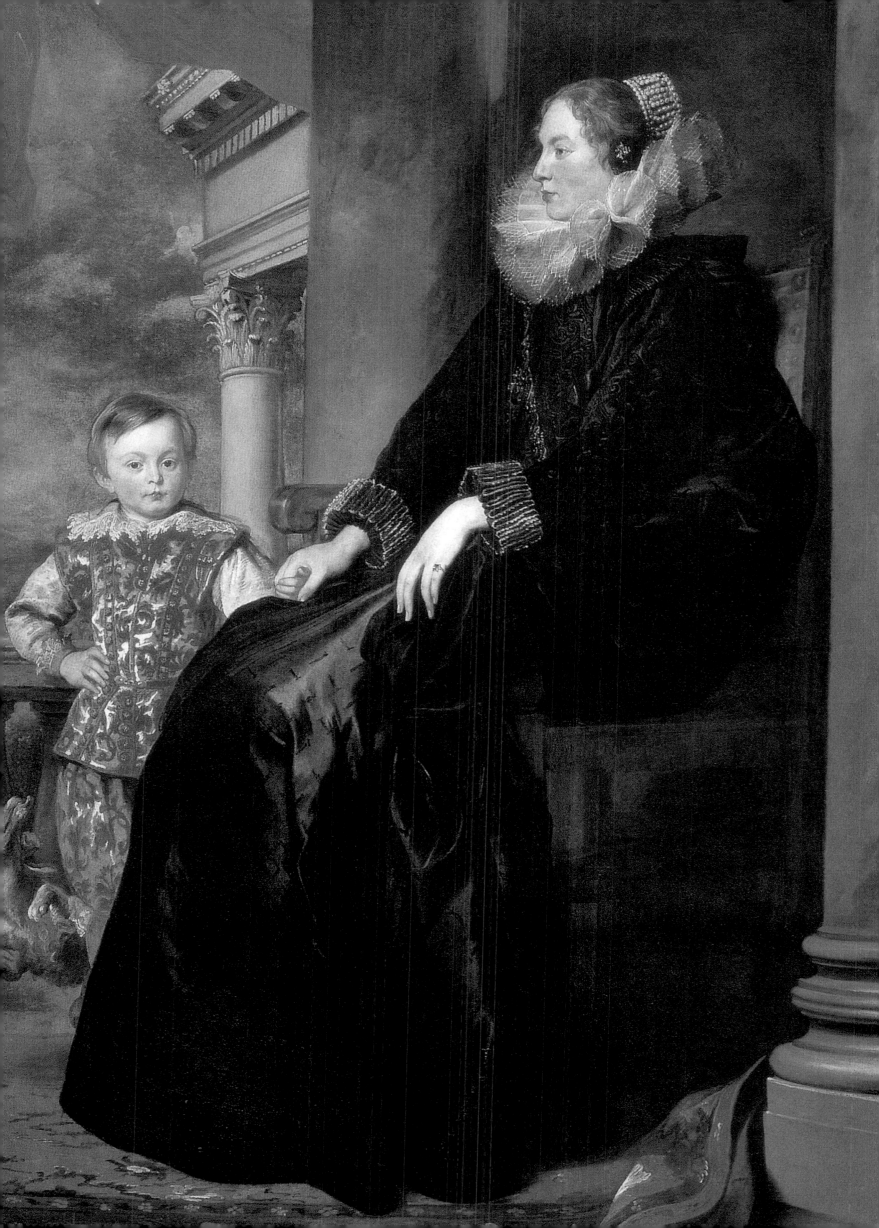

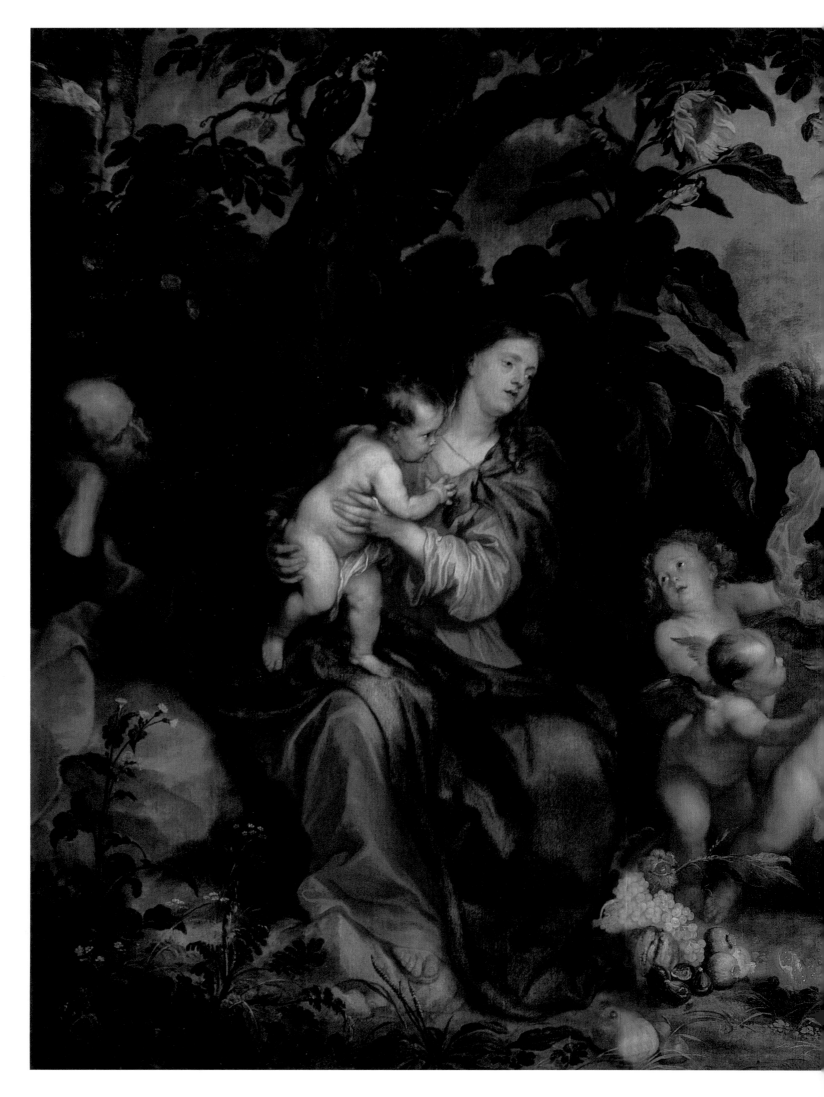

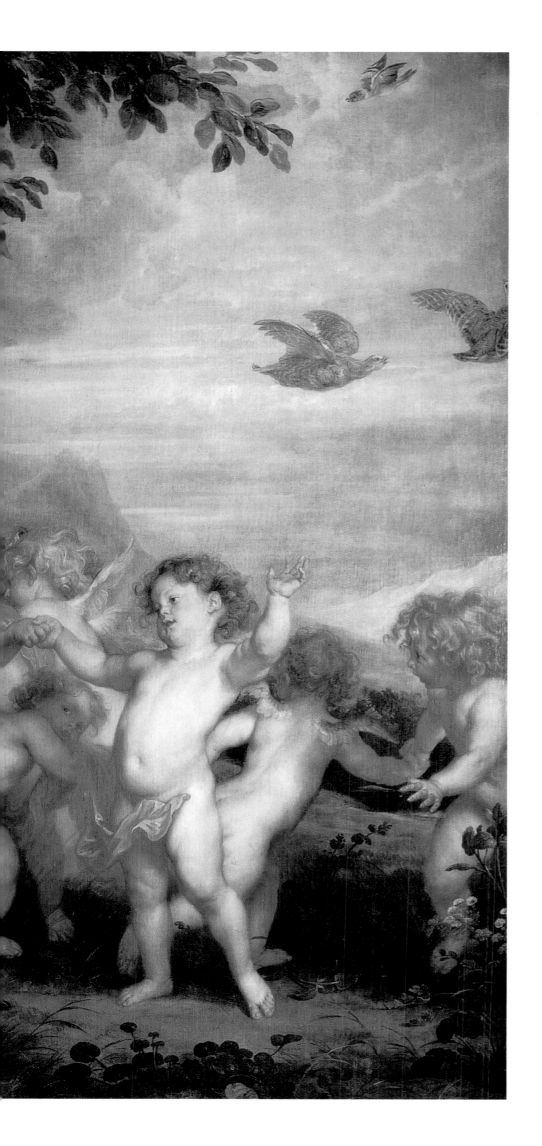

63. *The Rest on the Flight into Egypt* (*The Virgin of the Partridges*), early 1630s, The Hermitage, St Petersburg.

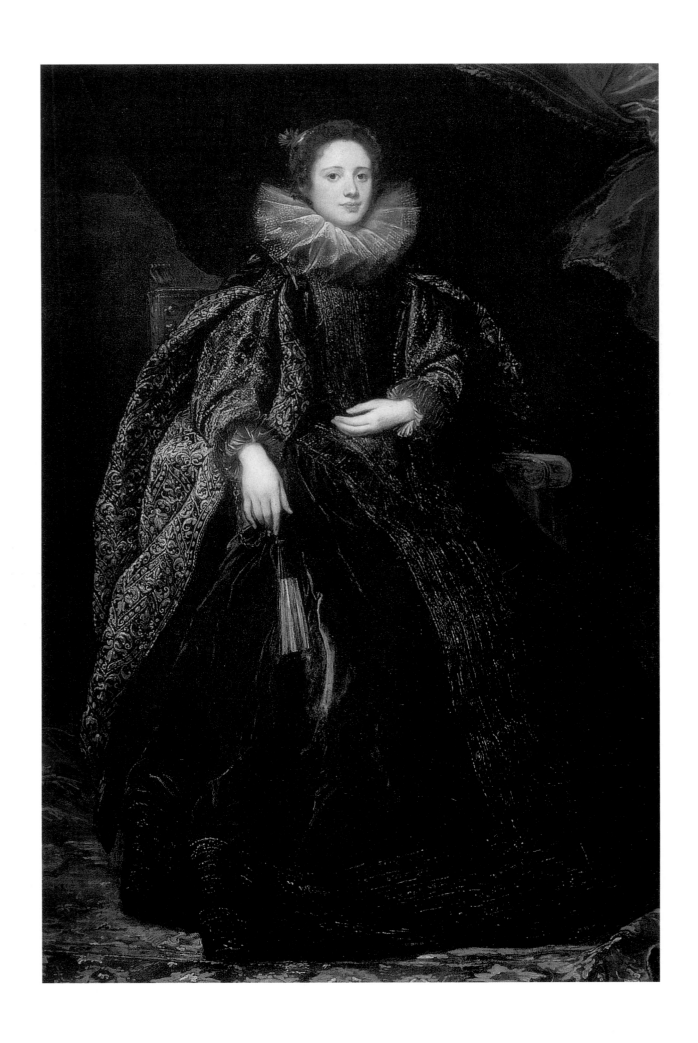

64. *Portrait of Marchesa Balbi*,
 late 1621 - early 1622,
 National Gallery of Art, Washington.

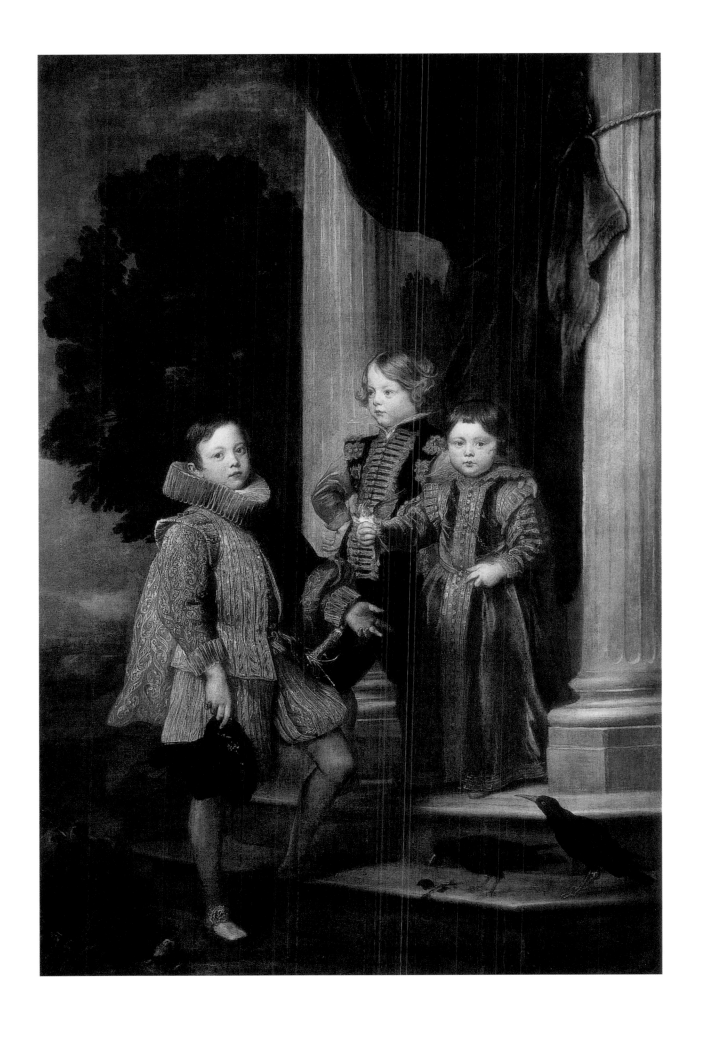

65. *The Balbi Children*, 1625-27,
The Trustees of the National Gallery,
London.

66. Raphael, *Portrait of a Young Man*,
 drawing from the *Italian Sketchbook*,
 1622, pen and ink on paper, British
 Museum, London.

67. Sketches for the painting *The Rest on
 the Flight into Egypt* (now in the Alte
 Pinakothek, Munich), ca. 1632,
 The Hermitage, St Petersburg.

lending the work a special persuasiveness. This portrait embodies the concept of the artist as *artiste*, virtuoso, someone in touch with the sublime world of beauty and harmony. In his portraits of artists, scholars, patrons, and collectors, Van Dyck always strove to stress the spiritual inspiration and eliteness of a human nature close to his ideal of the beautiful individual (*Lucas van Uffelen*, The Metropolitan Museum of Art, New York).

The same features characterize the *Iconography*, for which Van Dyck created drawings and grisailles and sixteen of his own etchings. This series of engraved portraits of the master's contemporaries was only published after his death, and in its final form included 190 engravings. The artist started work on it on his return to his homeland from Italy – in his Second Antwerp Period.

53. Peter Paul Rubens, *Statue of Ceres*, ca. 1615, The Hermitage, St Petersburg.

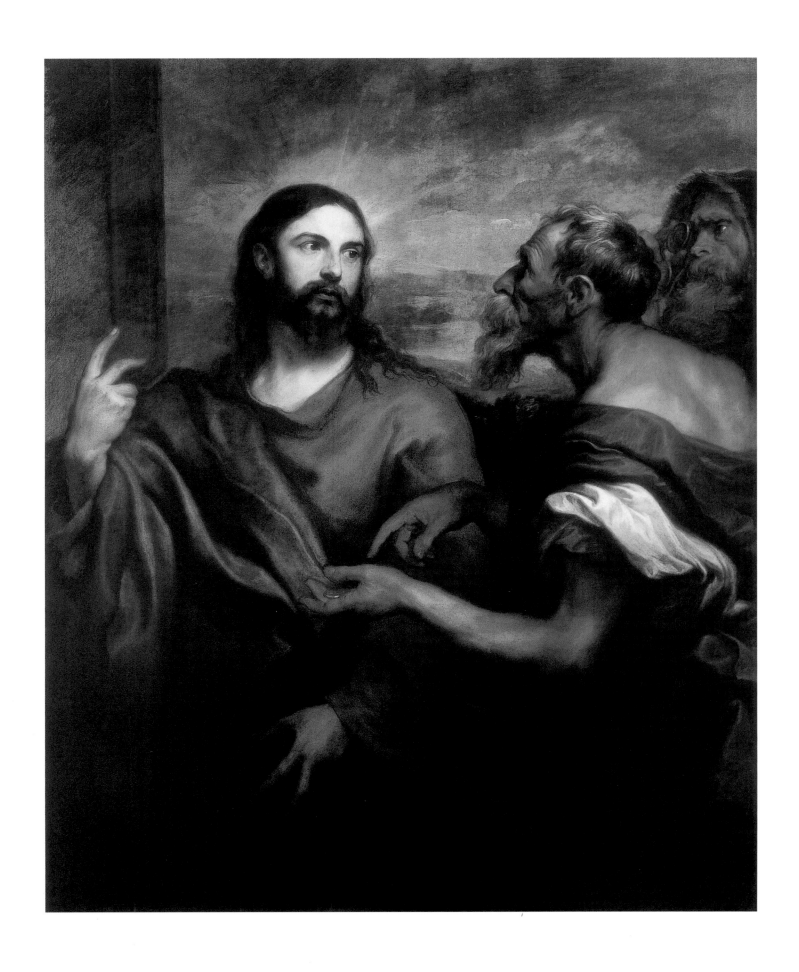

69. *Christ with Money*, ca. 1625,
National Gallery, London.

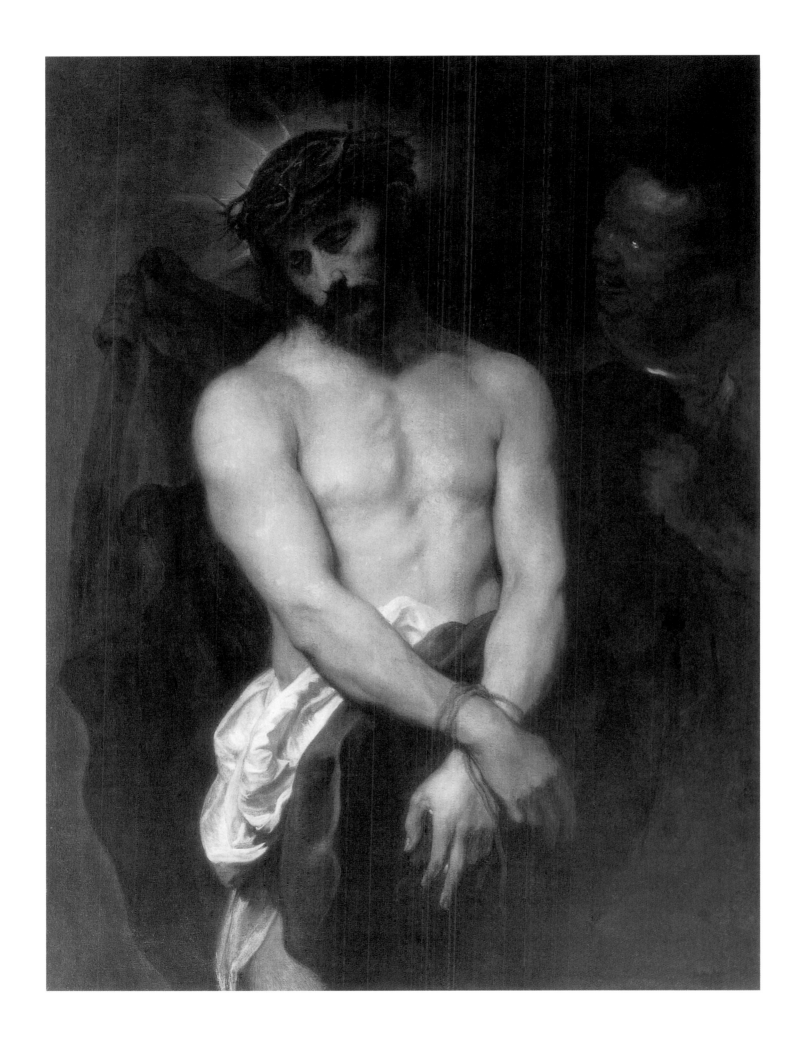

70. *Ecce Homo*, 1625-26,
The Trustees of the Barber Institute of
Fine Arts, The University of Birmingham.

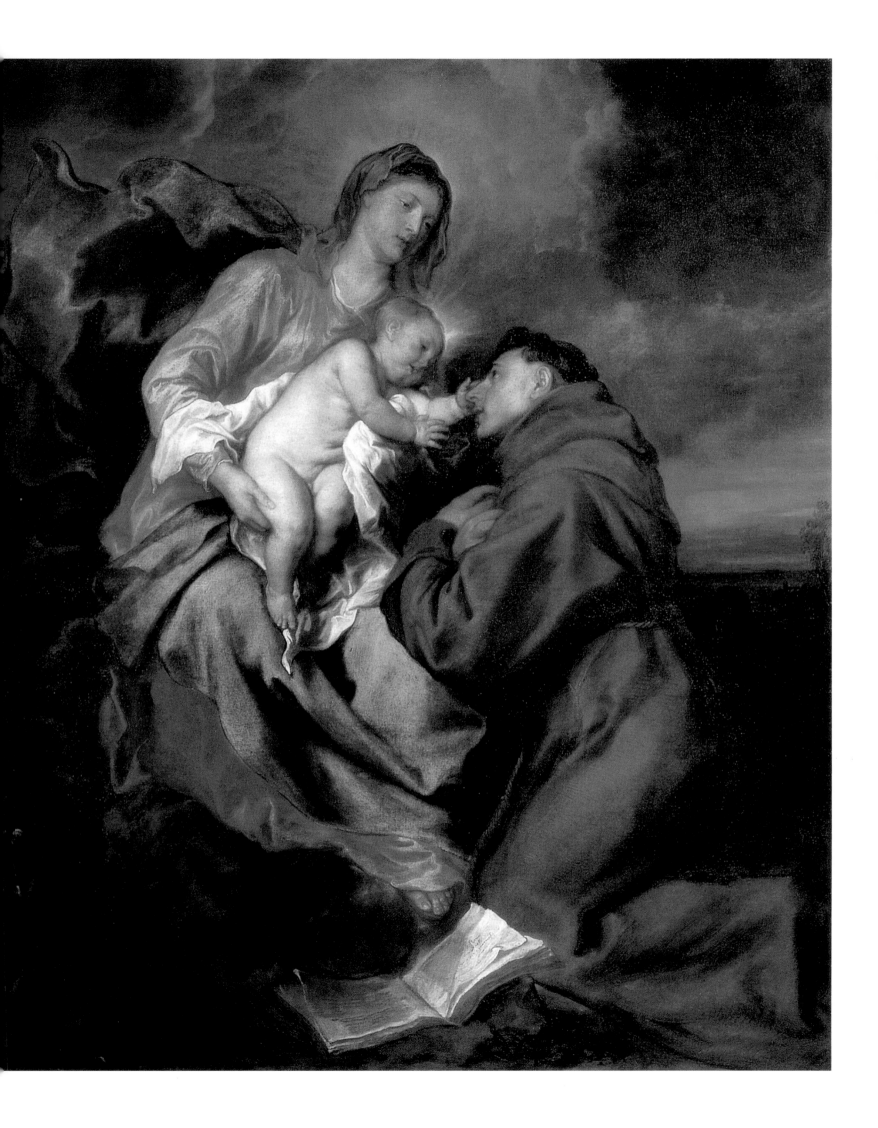

SECOND ANTWERP PERIOD

1628-1632

Van Dyck's portraits from the Second Antwerp Period are also characterized by the refinement of their artistic idiom. They seem to mark the artist's return to the traditional Netherlandish type of half-length or three-quarter representation, with its characteristic austerity and simplicity of composition (*Portrait of Jan van den Wouwer*, Pushkin Museum of Fine Arts, Moscow).

In many of the portraits from this time we no longer find any gorgeous draperies, and the setting is now reduced to a minimum, acquiring an almost symbolic character. For example, in the portrait of Adriaen Stevens from 1629 (Pushkin Museum of Fine Arts, Moscow) only the column in the background bearing a family coat of arms and the coin-filled plate on the table – an attribute of the model's profession – testify to the high social standing of the subject: he was the Treasurer of Antwerp and in charge of the City Council's charitable activities. The background in the companion portrait of Stevens' wife, Maria Bosschaerts (Pushkin Museum of Fine Arts, Moscow), is equally modest. She is depicted sitting in a huge armchair looking at her husband. The portraits display neither striking poses, nor picturesque costumes, nor bright colours. Their tonality is characterized by a cool, refined range of sober colours. Only the sonorous patches of heraldic emblems impinge on this restrained palette, endowing it with notes from a higher register.

Along with such modest and refined portraits of the respectable bourgeoisie, Van Dyck created other works, similar to

71. *The Vision of St Anthony,* 1629, Pinacoteca di Brera, Milan.

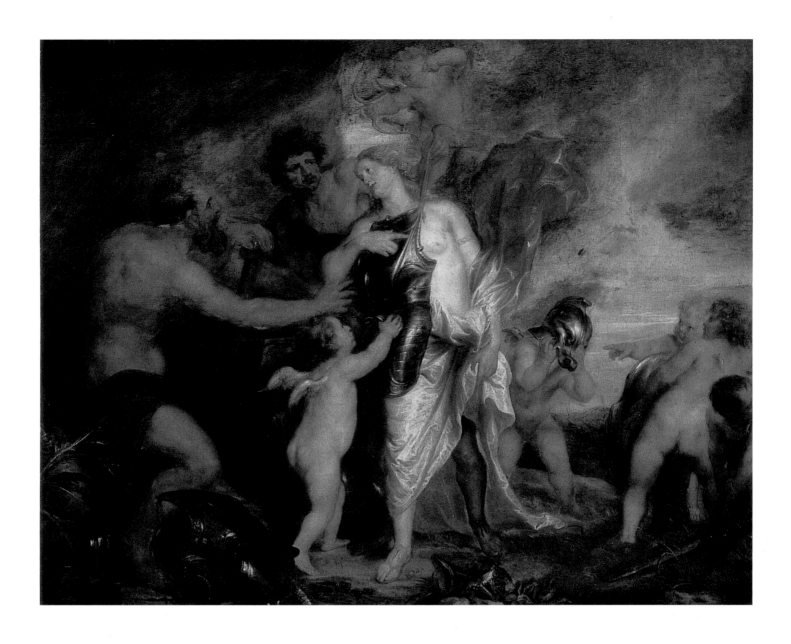

his Genoese portraits in their stunning appearance – the grandezza (grandeur) type. A good example is his *Portrait of Maria Luigia de Tassis* (Collection of the Princes of Liechtenstein, Vaduz), one of the artist's undisputed masterpieces. This wonderful portrait (a depiction of the only daughter of Canon Antonio de Tassis of Antwerp's Cathedral of Our Lady), in which outward ostentation combines harmoniously with the vivacity and spontaneity of the subject's character, was evidently commissioned by the Canon as a companion to Van Dyck's portrait of the clergyman himself (Collection of the Princes of Liechtenstein, Vaduz). Antonio de Tassis was a friend of the artist, and his engraved portrait can be found in Van Dyck's *Iconography*.

The *Iconography* also contains a portrait of Jan van den Wouwer, the humanist and diplomat, friend of Rubens, and publisher of the works of Seneca and Tacitus; the painted version is now in Moscow's Pushkin Museum of Fine Arts. Both of these works – the portrait of the Canon and the portrait of Van den Wouwer – are distinguished by Van Dyck's characteristic combination of refinement of execution and verisimilitude of image.

72. *Venus in the Forge of Vulcan*, 1630-32, Kunsthistorisches Museum, Vienna.

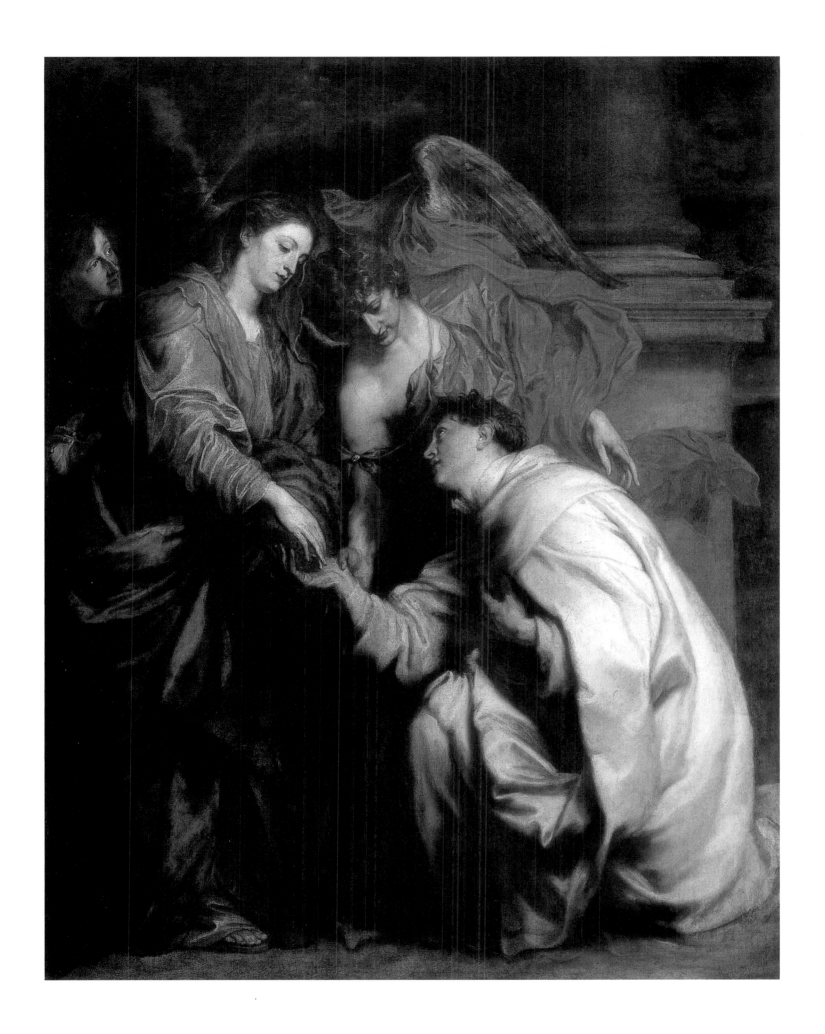

73. *Vision of the Blessed Herman Joseph,*
1630, Kunsthistorisches Museum,
Vienna.

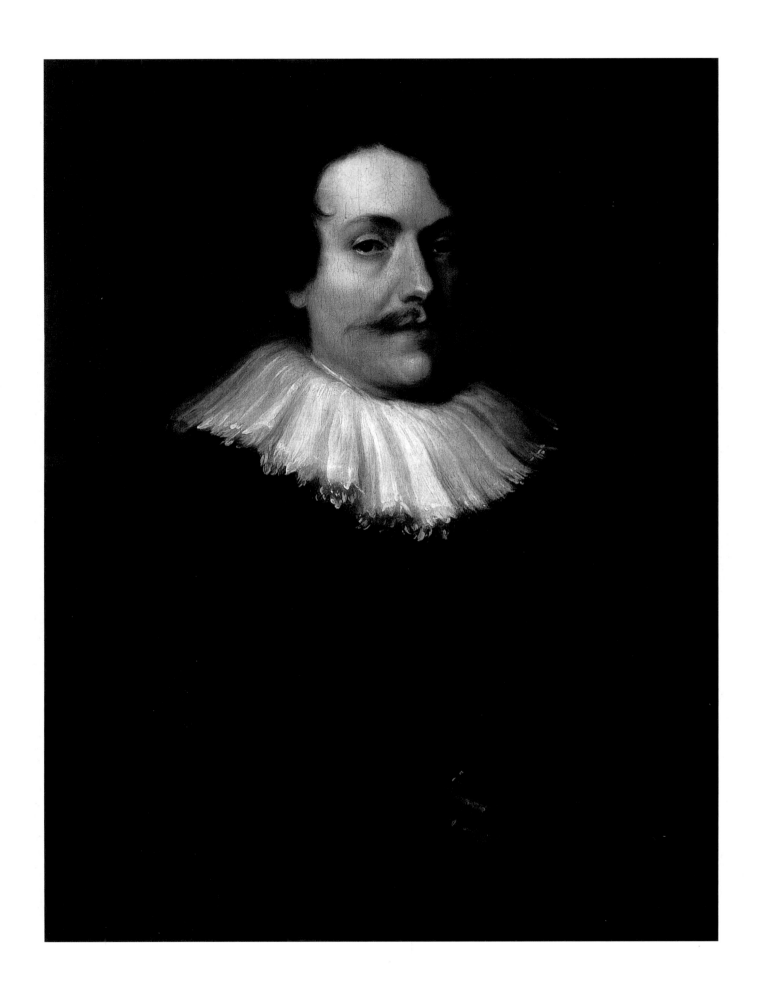

74. *Man in Black,* ca. 1630,
Museum of Western and Oriental Art,
Kiev.

90

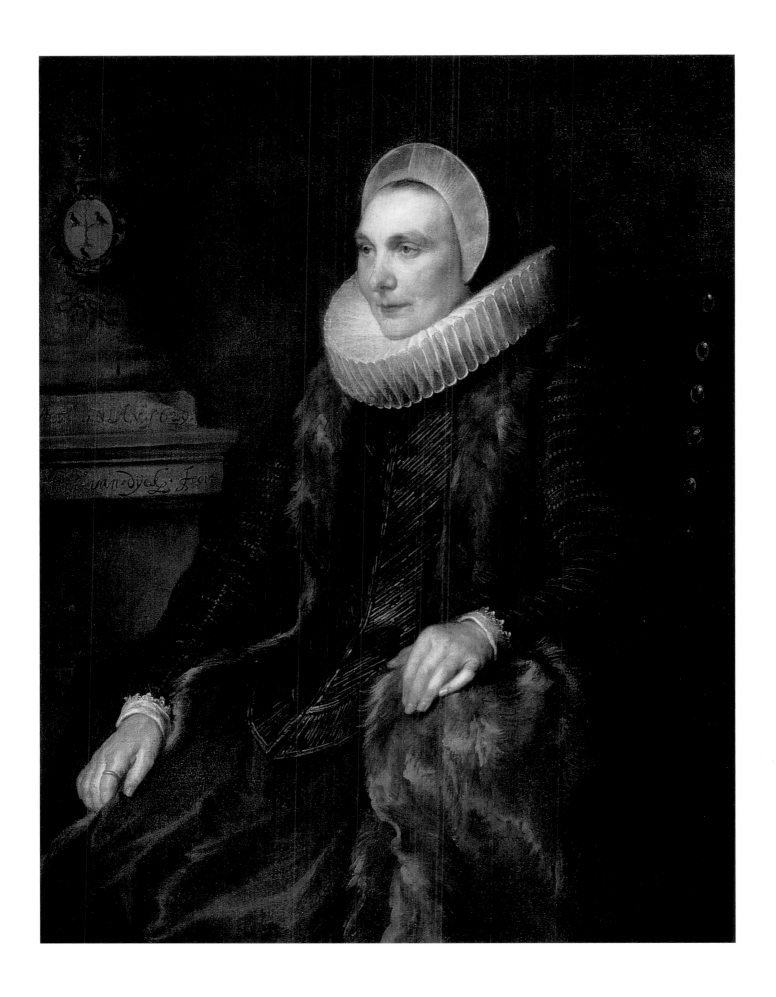

75. *Maria Bosschaerts, Wife of Adriaen Stevens*, 1629,
The Pushkin Museum of Fine Arts,
Moscow.

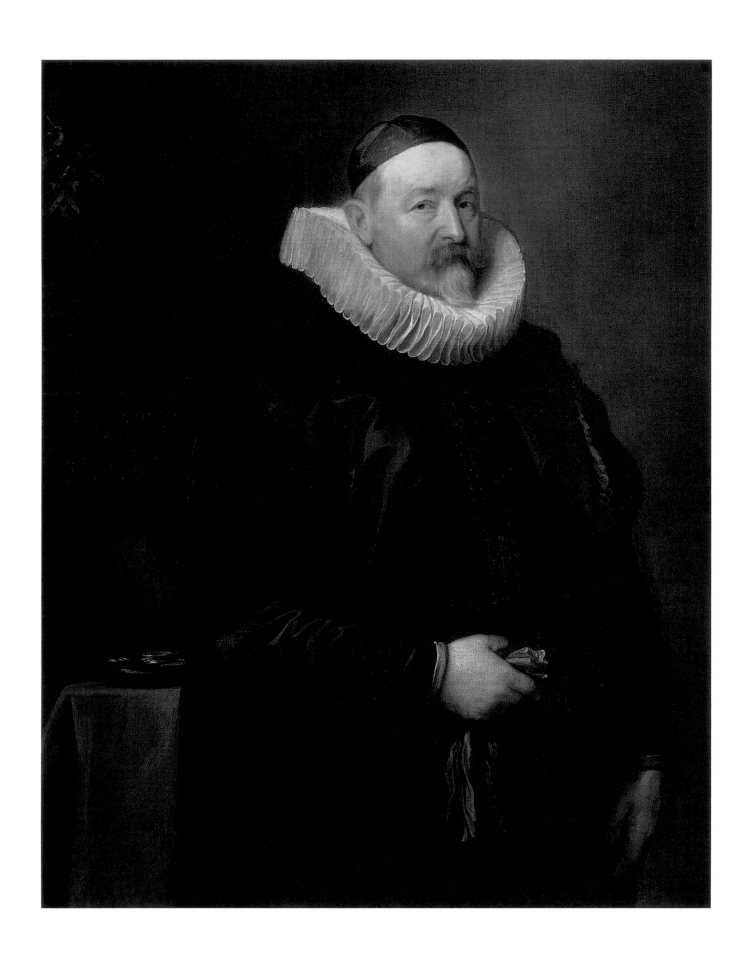

76. *Adriaen Stevens,* 1629,
The Pushkin Museum of Fine Arts,
Moscow.

Van Dyck's portraits stood out from those produced by his contemporaries. There were many portraitists in Antwerp, yet none of them was able to compete with Van Dyck in nobility and fineness of execution. Not for nothing did the celebrated artist, engraver, critic, art theorist, and leader of the French "Rubenists"

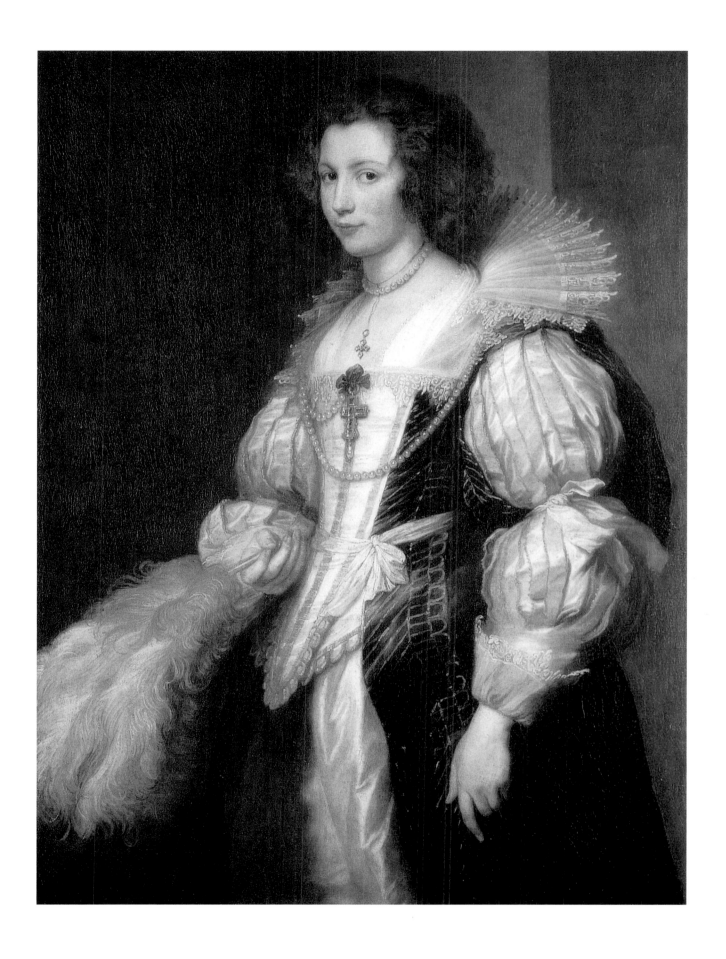

Roger de Piles (1635–1709) write of the Flemish master: "Many painters created portraits as lifelike, well painted, and felicitous in their colouring as Van Dyck's; however, being incapable of distributing the light with as much skill and fine understanding of chiaroscuro, they were unable to achieve the sense of refinement,

77. *Portrait of Maria Luigia de Tassis*, 1629, Collection of the Princes of Liechtenstein, Vaduz.

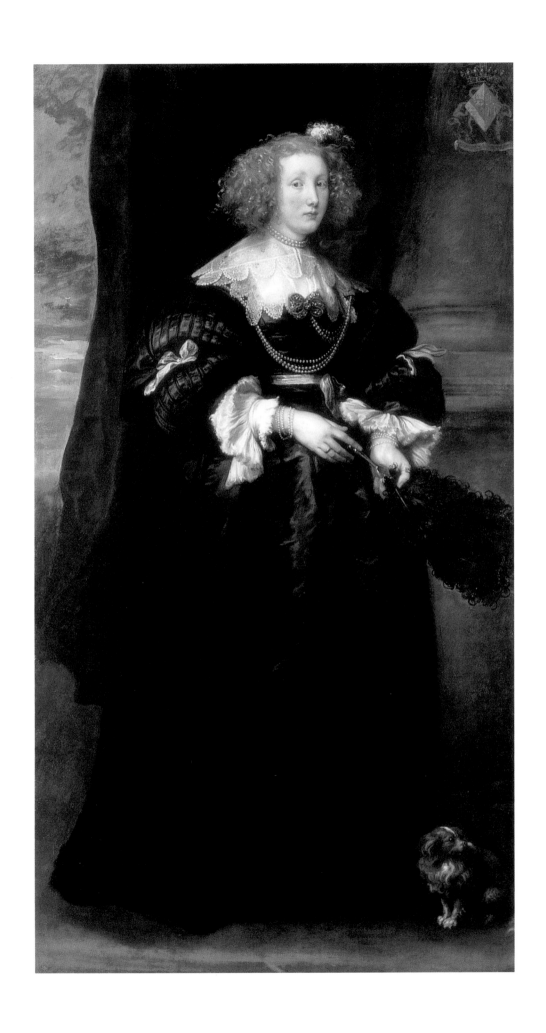

78. *Marie de Raet, Wife of Philippe Le Roy*,
1631,
The Wallace Collection, London.

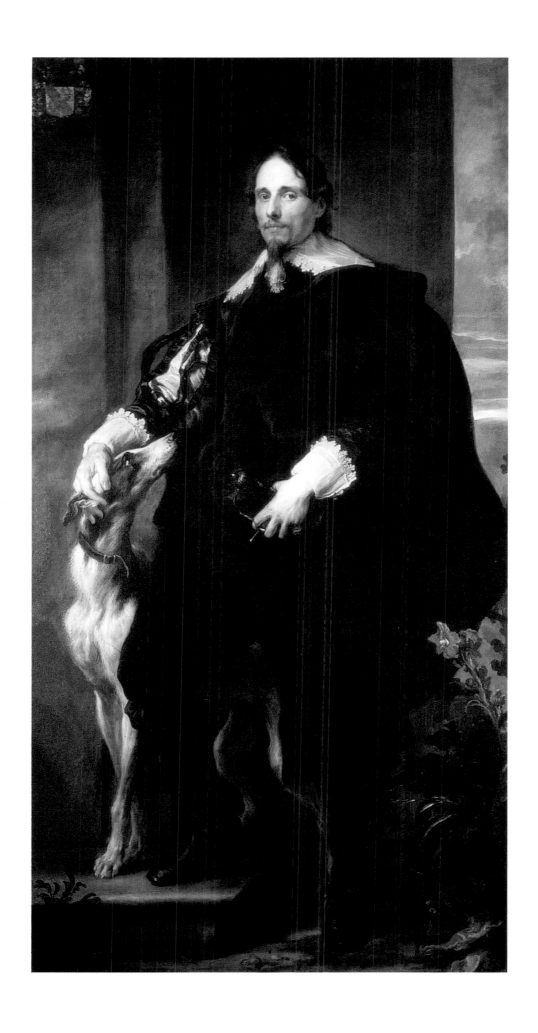

79. *Philippe Le Roy, Seigneur de Ravels,* 1630,
The Wallace Collection, London.

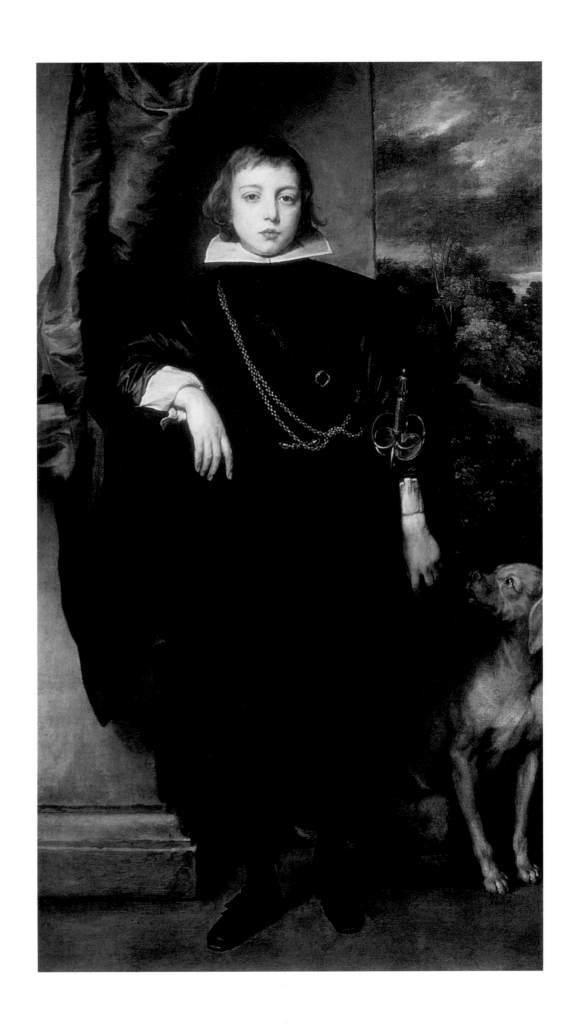

80. *Prince Rupert of the Palatinate*,
 1631-32,
 Kunsthistorisches Museum, Vienna.

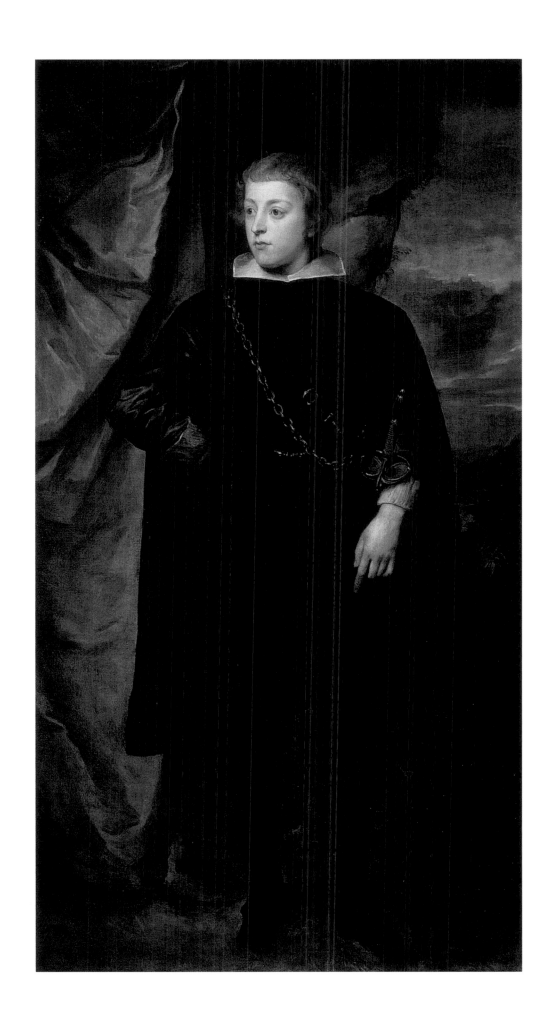

81. *Prince Charles Louis of the Palatinate*,
 ca. 1632,
 Kunsthistorisches Museum, Vienna.

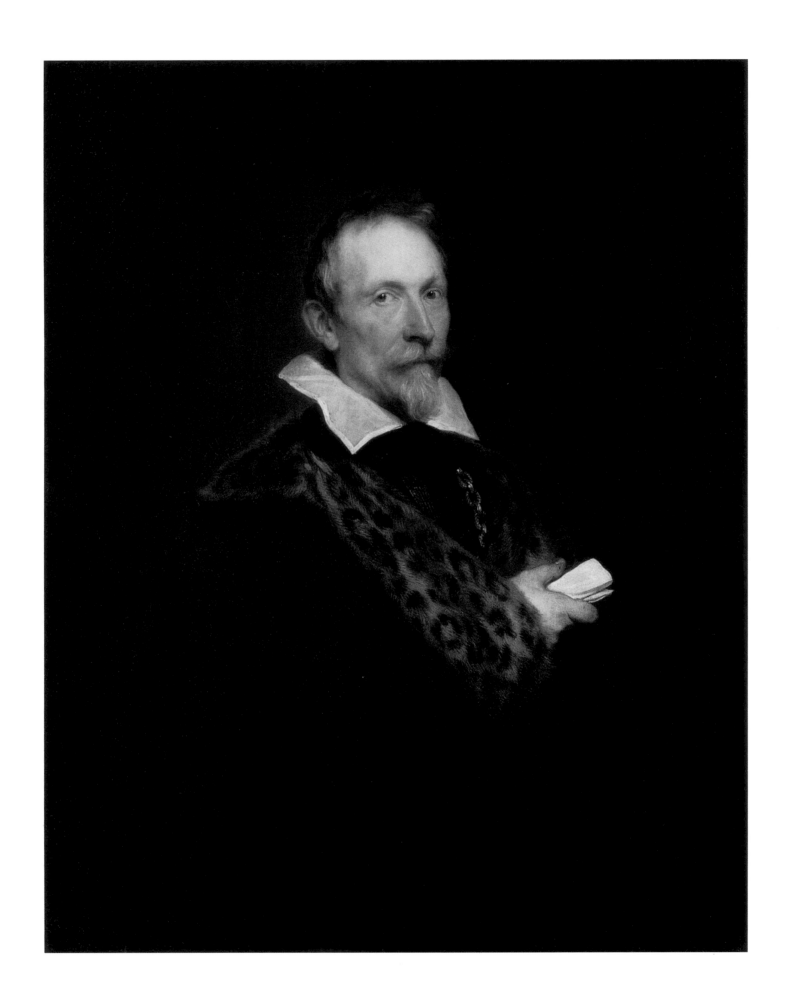

82. *Jan van den Wouwer*, ca. 1632,
The Pushkin Museum of Fine Arts,
Moscow.

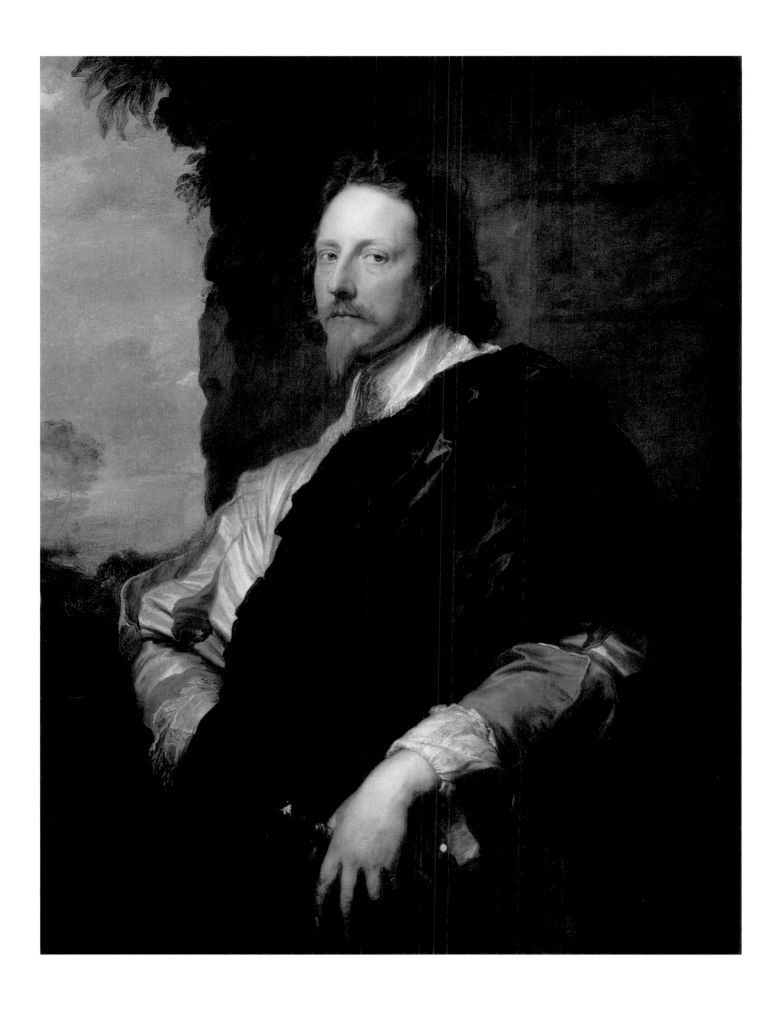

83. *Nicholas Lanier*, 1628,
Kunsthistorisches Museum, Vienna.

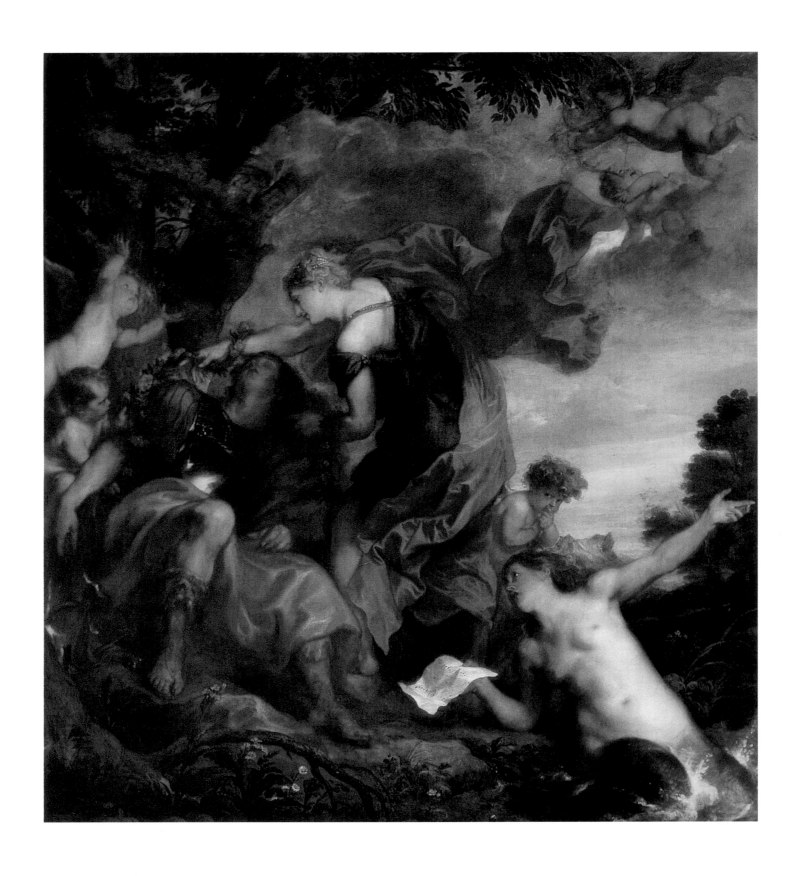

wonder, and extraordinariness inherent in his works".[20] The subtlety of execution that so delighted many of Van Dyck's contemporaries was also a hallmark of his religious paintings from the Second Antwerp Period.

One of the best is the Hermitage's *The Rest on the Flight into Egypt* (*The Virgin of the Partridges*). This picture was painted in the early 1630s, probably for the Confraternity of Bachelors – a lay brotherhood under Jesuit direction, dedicated to the Virgin Mary,

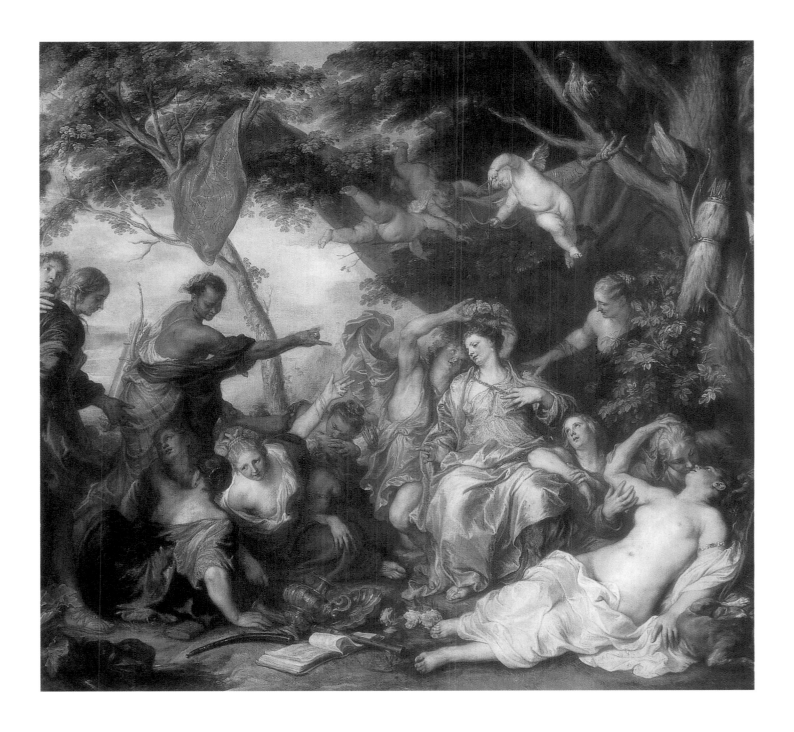

which Van Dyck joined in 1628. It is no accident that the symbolism of the most important parts of the composition is linked in one way or another with the Marian cult.[21] For example, the sunflower towering above Mary in the centre is not merely a part of the landscape, but an indication of the inner meaning of the whole image – the divine essence of Mary as the Immaculate Virgin.

Another symbol of Mary's purity, employed by Netherlandish painters from the fifteenth century onwards, was the parrot, shown in Van Dyck's picture sitting on a branch to the left of the Virgin. The partridges (a symbol of one of the seven deadly sins – lust) are depicted flying away, indicating that Mary's purity puts all that is sinful to flight. The Holy Family is sitting under a fruit-laden apple tree (just like in Rubens' *The Holy Family Under an*

85. *Amaryllis and Mirtillo*, 1631-32, Graf von Schönborn Collection, Pommersfelden.

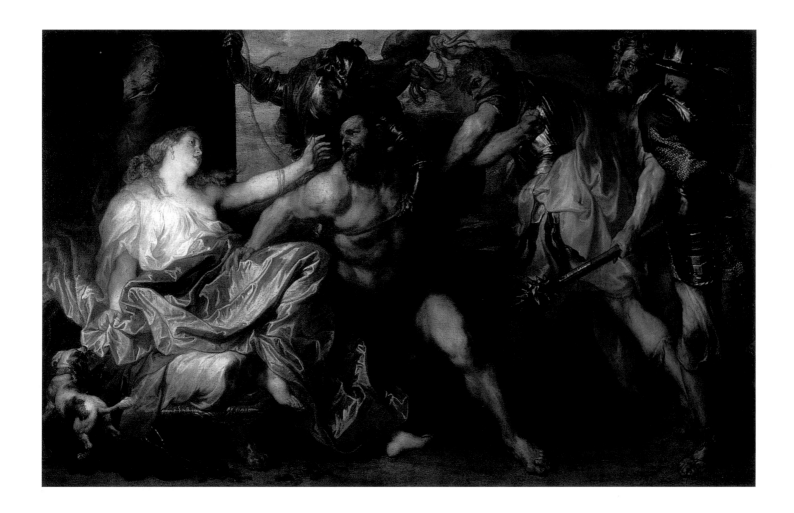

Apple Tree on the outer wings of the "Ildefonso Altarpiece", Kunsthistorisches Museum, Vienna), which symbolizes Mary's conquest of Original Sin. The white roses visible behind the apple tree are also an attribute of the Virgin: they stand for virginal purity, beauty, love, and joy. *The Virgin of the Partridges* again has echoes of Titian: in the noble, stately outlines of the figure of Mary, in the painting's broad, flowing, undulating rhythm. The artist has placed the main group of characters – Mary with Child on her lap and Joseph – over to the left. The greater part of the canvas – almost its central part – is taken up with a merry group of child-angels playing a kind of round-dance. The Baby Jesus is reaching out to them. Van Dyck skilfully conveys the spontaneity of these lovable little figures. But their movements are slow and perhaps slightly intentionally graceful. This restrained grace, and especially the gentle damping and refinement of the tonality, anticipates the art of the eighteenth century with its cultivated style.

In 1630 Van Dyck was accorded the title of Court Painter to the Infanta Isabel, the Spanish regent in the South Netherlands. Even though the Infanta resided in Brussels, Van Dyck continued living in Antwerp, which was the true centre of artistic life in the

86. *Samson and Delilah,* ca. 1628-30, Kunsthistorisches Museum, Vienna.

87. *St Augustine in Ecstasy,* 1628, Koninklijk Museum voor Schone Kunsten, Antwerp.

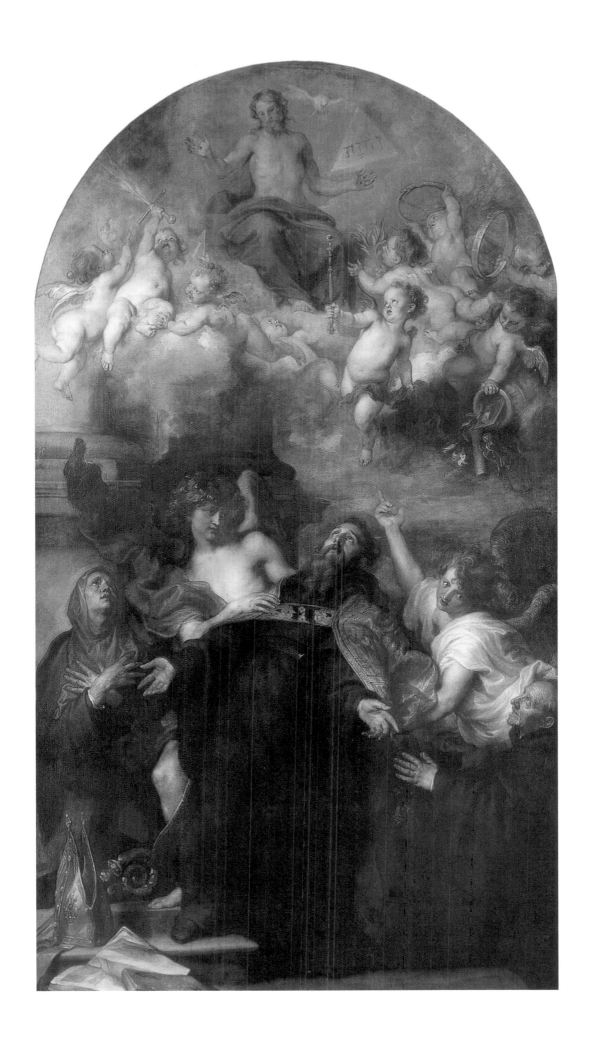

103

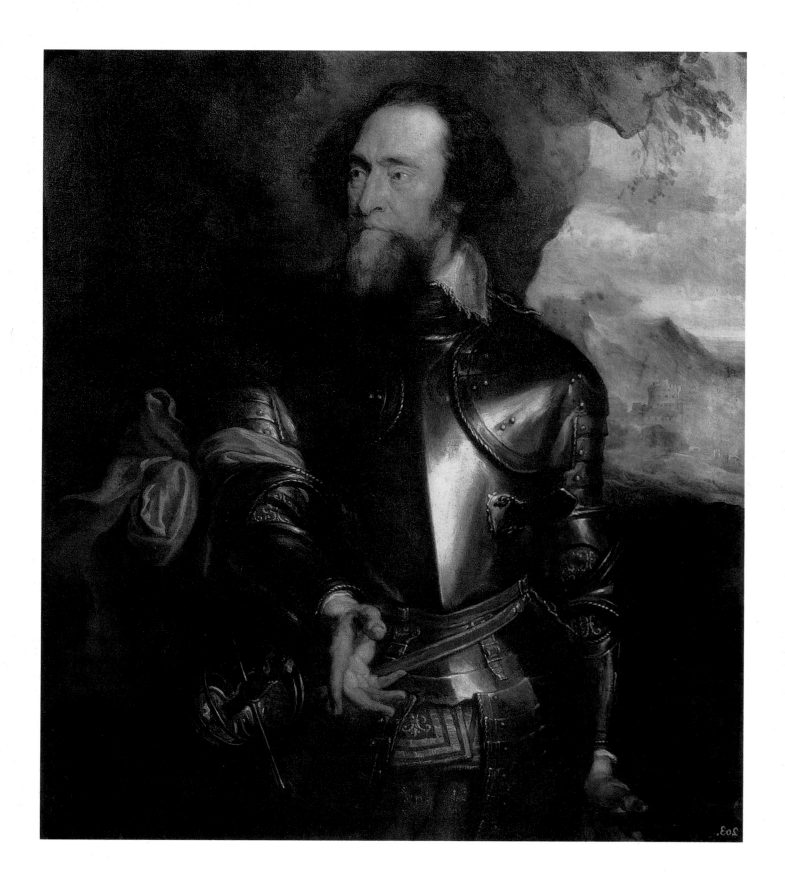

88. *Hendrick van der Bergh*, 1629-32, Prado, Madrid.

89. *Martin Rijckaert*, Prado, Madrid.

Spanish Netherlands. Alongside Rubens, he enjoyed the widespread recognition of his compatriots as one of the leading masters of the Antwerp School. Van Dyck's name was also well known outside Flanders. In the autumn of 1630, Maria de Medici visited his studio in Antwerp. The Fleming spent the winter of 1630–31 in The Hague, working at the court of Frederick Henry and Amalia van Solms, the Prince and Princess of Orange.

104

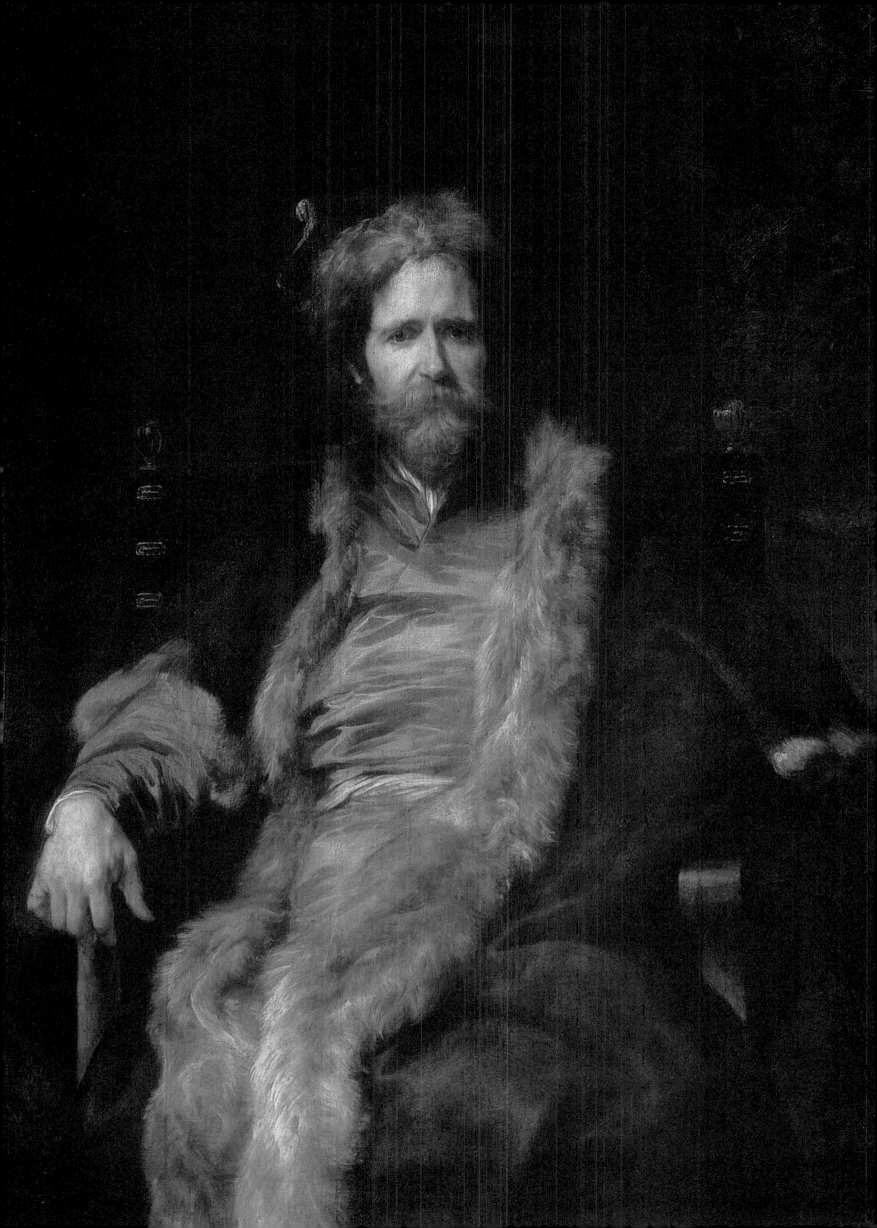

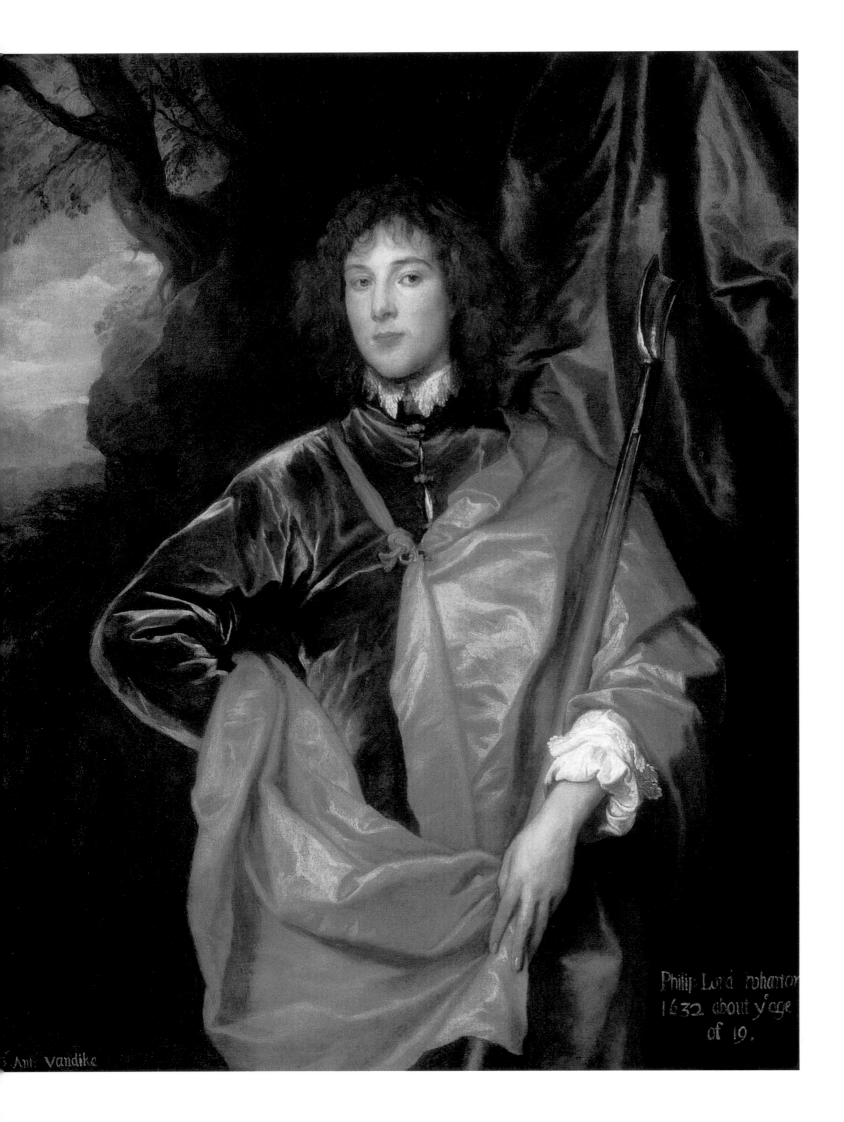

Philip Lord wharton
1632 about y^e age
of 19.

S Ant: vandike

THE ENGLISH PERIOD

1632-1641

In late 1632, invited by Charles I to work at the English court, Van Dyck left for London and remained in England, with short interruptions, until his death. He took up residence in Blackfriars, where he was frequently visited by the King, and was assigned summer apartments at Eitham Palace in Kent.

In England Van Dyck worked exclusively on portraits. He immediately occupied a pre-eminent position among the country's artists and became the favourite portraitist of the English aristocracy. In the artist's work, the ideal of the spiritually superior individual whose inner nobility is merely confirmed by his aristocratic extraction, an idea fully formed in English high society, received its consummate incarnation. His portraits invariably emphasize the elegant spontaneity of posture, the proud bearing, the nobility of features, and the inner refinement of his subjects, irrespective of whether or not they themselves possessed these qualities.

This can be fully appreciated in the Hermitage collection, in which Van Dyck's brief final period is particularly extensively represented. Most of the museum's portraits from this time came from the Wharton family gallery in Winchendon. Eighteenth-century sources testify that around 1637–39 Philip, fourth Lord Wharton (1613–1696; his portrait, dated 1632, was once in the Hermitage), at that time close to the King, commissioned from Van Dyck a series of portraits of members of his family. To display them he built a special gallery in the new house on his

90. *Philip, 4th Lord Wharton*, 1632,
 Nationa Gallery of Art, Washington.

107

91. *Henry Danvers, Earl of Danby*, drawing,
British Museum, London.

Winchendon estate in Buckinghamshire, which also contained portraits of the King and Queen – a gift from Charles I – and later (probably from 1656) a portrait of the Archbishop of Canterbury, William Laud.[22]

Around 1725, a sizeable part of Philip Wharton's collection – eleven portraits – was acquired by Robert Walpole from Wharton's heirs. One of the portraits, depicting Arthur Goodwin (1593/4–1643), the father of Philip Wharton's second wife, was given by Walpole to the Duke of Devonshire and is now at Chatsworth. Apart from the Hermitage's seven portraits from the Wharton collection (four full-length and three half-length) and these paintings of Philip Wharton and Arthur Goodwin, we know of only another three full-length portraits which were once part of the collection of the fourth Lord Wharton. These are the portraits of Jane Goodwin, Lady Wharton (1618–1658), the second wife of Lord Philip; Margaret Smith, Mrs. Thomas Carey (later Lady Herbert), the wife of Philip Wharton's maternal uncle (both in the collection of Major Malcolm Munthe); and Anne Cavendish, Lady

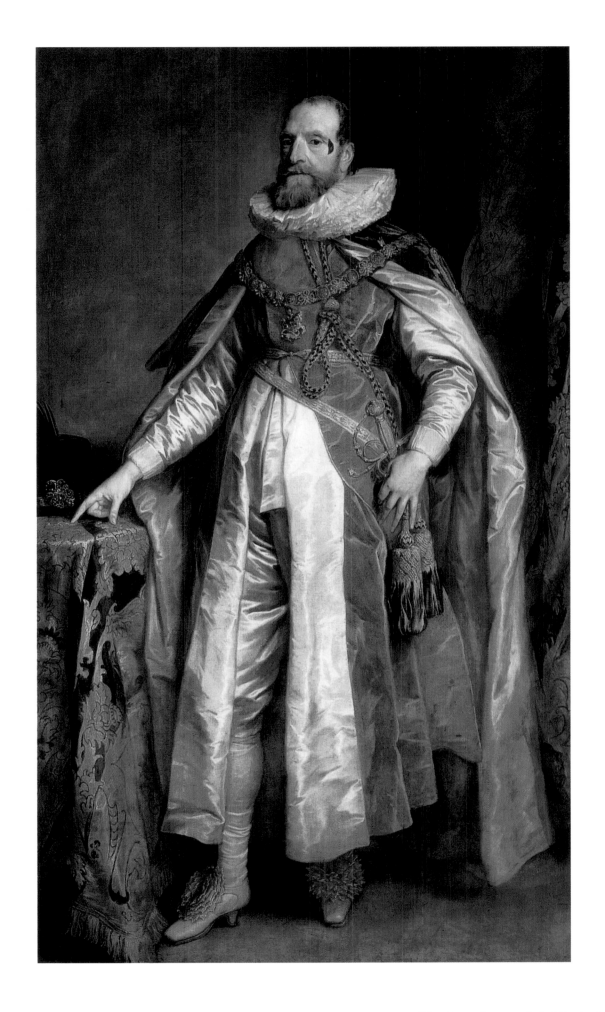

92. *Henry Danvers, Earl of Danby, in the Costume of the Order of the Garter* (full-length), late 1630s, The Hermitage, St Petersburg.

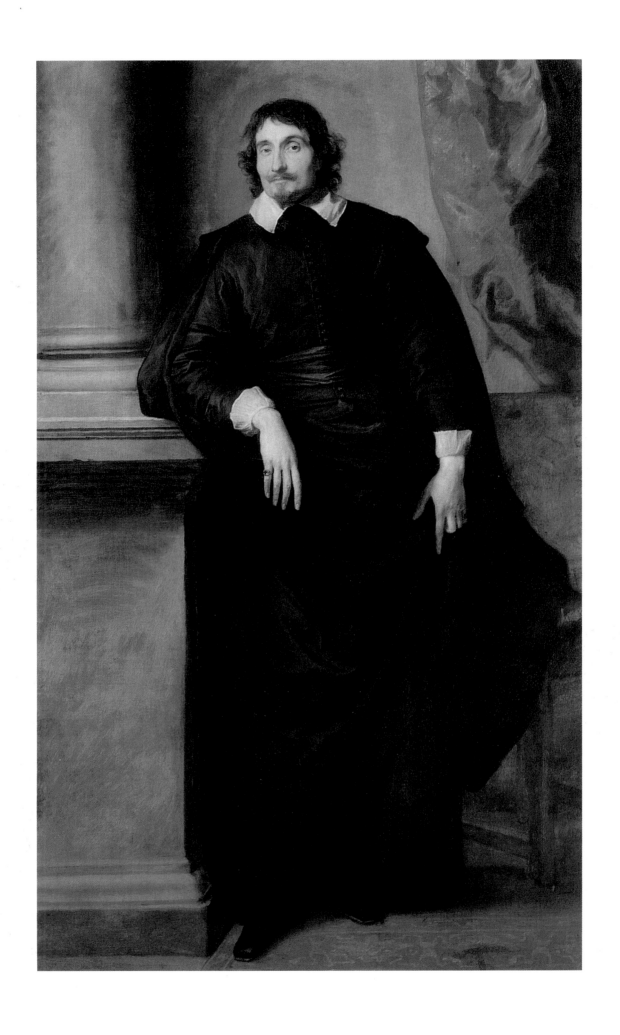

93. *Cesare Alessandro Scaglia, Abbot of Stafford and Mandanici*, 1634, Collection of Viscount Cumrose.

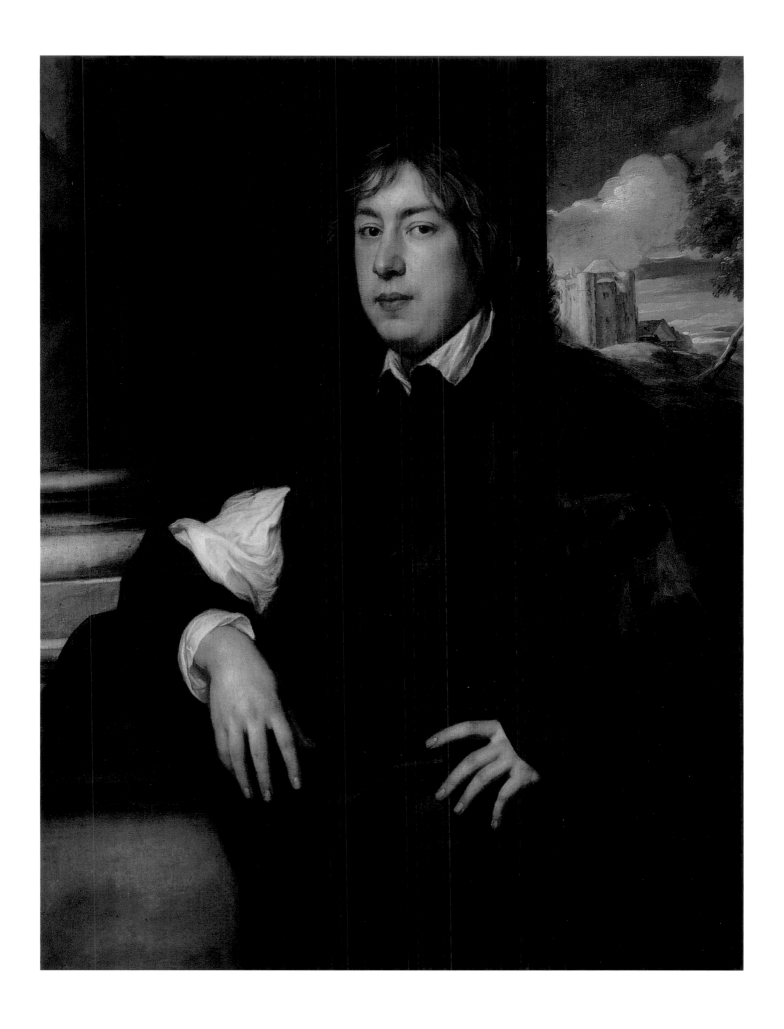

94. *Portrait of Everhard Jabach,* 1636-37,
The Hermitage, St Petersburg.

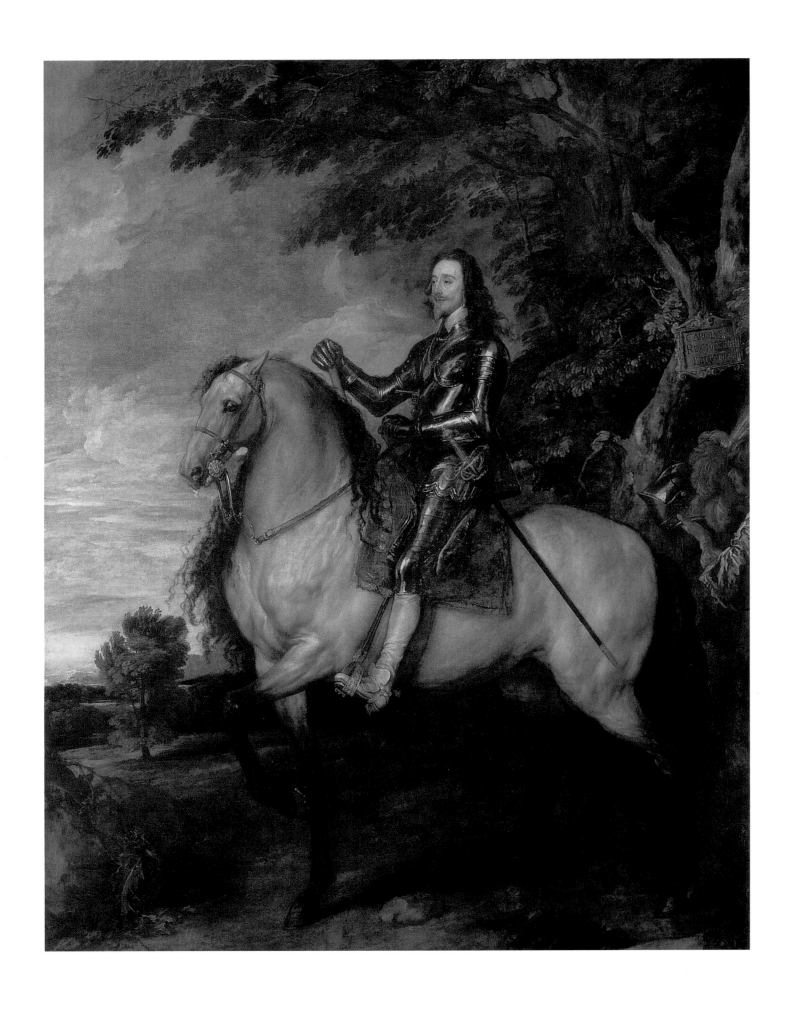

95. *Charles I on Horseback*, ca. 1637,
National Gallery, London.

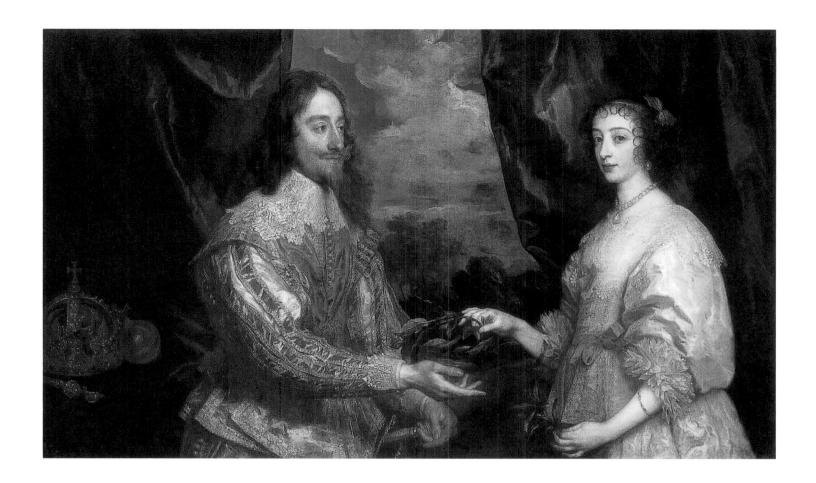

Rich (1612–1638), unrelated to the Wharton family, the wife of Robert Rich, third Earl of Warwick (in a private collection). These three portraits differ from the others in that they are inscribed (in the bottom left-hand or right-hand corner), in identical lettering, with information on the subjects: name, rank, age, and date of the portrait's execution (sometimes with the note "circa").

There are reasonable grounds for supposing that these inscriptions were made in Philip Wharton's lifetime, since they are present only on the pictures from his portrait gallery. These works allow us to form only an incomplete picture of Lord Wharton's collection, which was evidently added to in later years. In any case, information on the number of items in the collection is contradictory: Arnold Houbraken (1660–1719), the well-known Dutch painter, engraver, and art historian, speaks in his collection of artists' biographies *De Groote Schouburgh der Nederlandsche Kunstschilders en Schilderessen* (1718) of thirty-two Van Dyck portraits at Winchendon (including fourteen full-length),[23] while the English engraver and antiquarian George Vertue (1684–1756), often called the father of English art history, remarks in his notebook that by the time of its sale Philip Wharton's collection numbered eighteen portraits by Van Dyck: six half-length and twelve full-length. Vertue judged them to be good pictures, "not the most curious or finisht, but done in a free masterly manner, not studied nor labour'd [in] many parts". The "loosely done" parts of the paintings "appear well at a distance".[24]

95. *King Charles I and Henrietta Maria*, 1632.

113

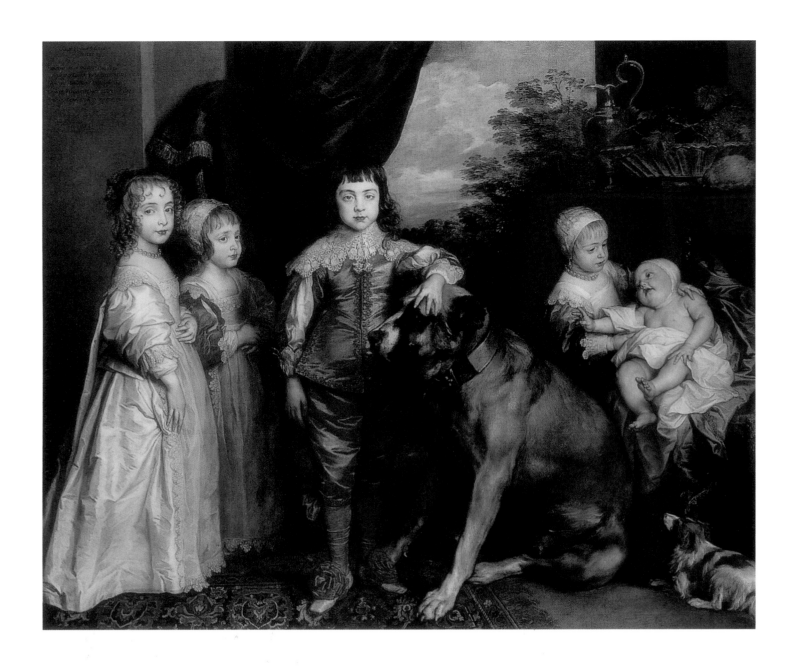

97. *Five Children of Charles I,* 1637,
Royal Collection, Windsor Castle.

In fact, Van Dyck painted all the portraits in Wharton's collection with artistic brilliance, though the involvement of the artist's assistants cannot be discounted in the execution of the background and costume details. It was undoubtedly one of them who committed an error – unnoticed by Van Dyck – in the painting of the armour for the portrait of Charles I: both gauntlets – one on the King's hand, the other lying at his feet – are for the right hand. It seems that the participation of the master's studio in the painting of portraits of the King and Queen was provoked by their relatively low price, which Van Dyck himself refers to in a memorandum he presented to Charles I in late 1638.[25] Nevertheless, both of these portraits are also characterized by the elegant spontaneity so typical of Van Dyck.

Queen Henrietta Maria (1609–1669) is depicted in the portrait not only as a stately ruler, but as a tall, slender, beautiful woman. Her contemporary Princess Sophia, the King's niece and later Electress of Hanover, wrote of her, recalling an encounter with

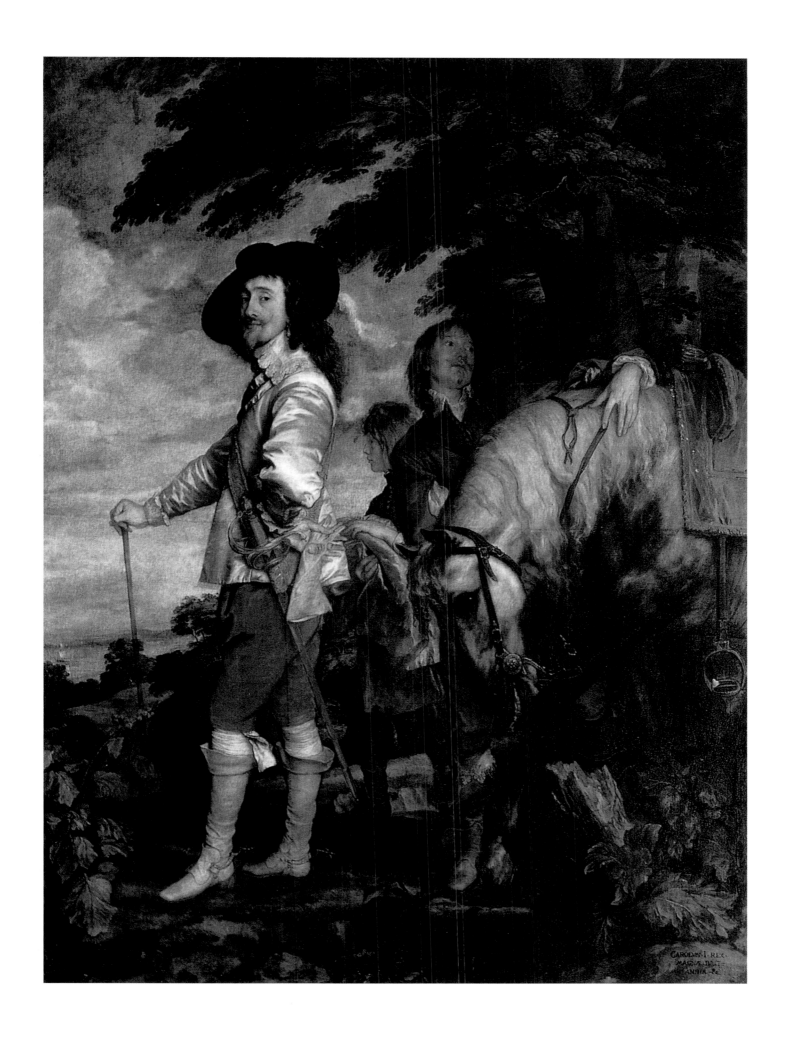

98. *Poi à la Chasse*, 1635,
Louvre, Paris.

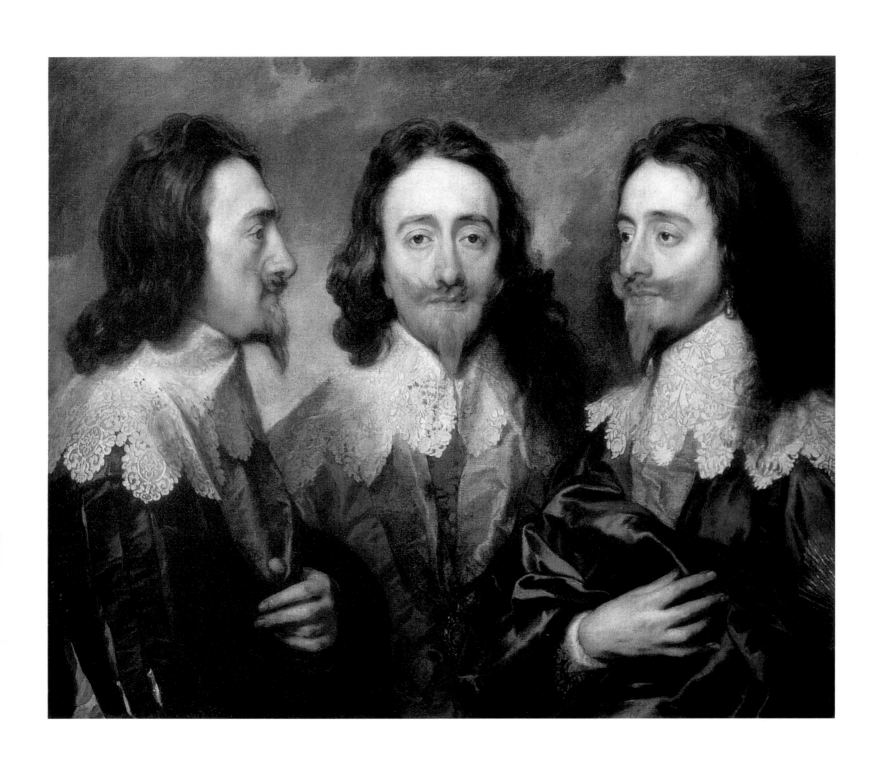

99. *Charles I in Three Positions*, 1635-36,
Royal Collection, Windsor Castle.

Henrietta Maria in The Hague in 1641: "Van Dyck's marvellous portraits had instilled in me such an exalted notion of what all English ladies were like that I was surprised when I saw the Queen, who had seemed so beautiful in her portraits; she was a short woman, with long, dry hands, uneven shoulders, and teeth sticking out of her mouth like fangs." However, the Princess went on to note that closer inspection revealed the Queen to have "very beautiful eyes, a regular nose, and a delightful colouring in her face".[26]

To show Henrietta Maria in a favourable light, Van Dyck employed the entire artistic box of tricks he had developed for the ceremonial portrait while still in Genoa. It is not only the royal clothes and attributes, testifying to the sitter's high social rank (the diamond crown on the table), that helped the artist to achieve the desired effect. By lengthening the figure and selecting a narrow vertical format he makes her seem slender, and by employing a point of view slightly from below and presenting her as if raised on an invisible pedestal, he achieves the impression of solemnity.

However, an important aspect of Van Dyck's skill lies in the fact that, even when idealizing his sitter, he never betrayed the truth of the living image: his figures could not look less like beautiful mannequins. And most of the time the idealization in the artist's portraits consists not so much in the embellishment of the features as in his ability to set the face in beautiful surroundings.

Van Dyck was especially precise in communicating individual character in his male portraits. Thus the artist adds not the slightest embellishment to his rendition of the square face of Henry Danvers, Earl of Danby (1573–1644), a celebrated soldier, who served in Ireland and the South Netherlands, fought bravely in the army of the French King Henry IV (Danvers's left temple bears a large, plaster-covered battle scar), and in 1633 became a Knight of the Garter.

For skill of composition and fineness of execution, this is one of the best works from Van Dyck's English Period. Danvers is shown standing upright, in his red-and-white Garter robes and a dark-blue cloak with white lining. The headdress of the order lies on the table where he leans his hand. The scarlet and pale blue of the costume shimmer with a soft light, and harmonize effortlessly with the gold-embroidered black draperies and tablecloth.

Van Dyck was no less truthful in his depiction of Charles I in the Hermitage portrait, which was executed, as we have already noted, with the assistance of the artist's studio. Here the words of the seventeenth-century Italian sculptor Giovanni Lorenzo Bernini (1598–1680) particularly attest to Van Dyck's perception. He once remarked that Van Dyck had succeeded in depicting the King's face ("there was something unfortunate in the countenance of Charles"[27]), as if he could foresee the monarch's wretched fate –

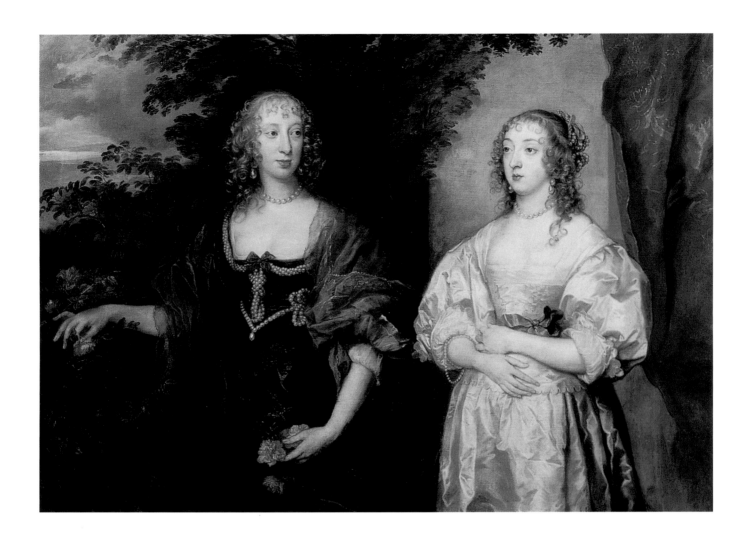

execution by beheading. In the portrait Charles I appears before us in knightly robes wearing a gold medallion, the Lesser George – a depiction of St George fighting the dragon. This is one of the insignia of the Order of the Garter, of which the King was head. Charles I always wore the Lesser George; for the monarch that Christian saint represented the ideal of chivalry and was the embodiment of what a king should be.

According to his sympathetic contemporaries, the King was a sovereign filled with kindness and justice, for his actions attested that immoderate desires and despotic propensities were totally alien to him. At the court of Charles I "men of learning and ingenuity in all arts were in esteem". The King himself "was a most excellent judge and a great lover of paintings, carvings, engravings, and many other ingenuities".[28] Perhaps this is why Van Dyck's best depiction of Charles (in the brilliance of technique, boldness of composition, and originality of design) – Roi à la Chasse (1635; Louvre, Paris) – portrays him as an elegant and relaxed man of the world, the true incarnation of the Renaissance concept of the *corteggiano* (courtier), and not as a sovereign.

Charles – in a wide-brimmed hat, camisole, and elegant high boots – has evidently stopped during a leisurely ride (the artist

100. *Countess Portland (?) and Lady d'Aubigny*,
The Pushkin Museum of Fine Arts,
Moscow.

118

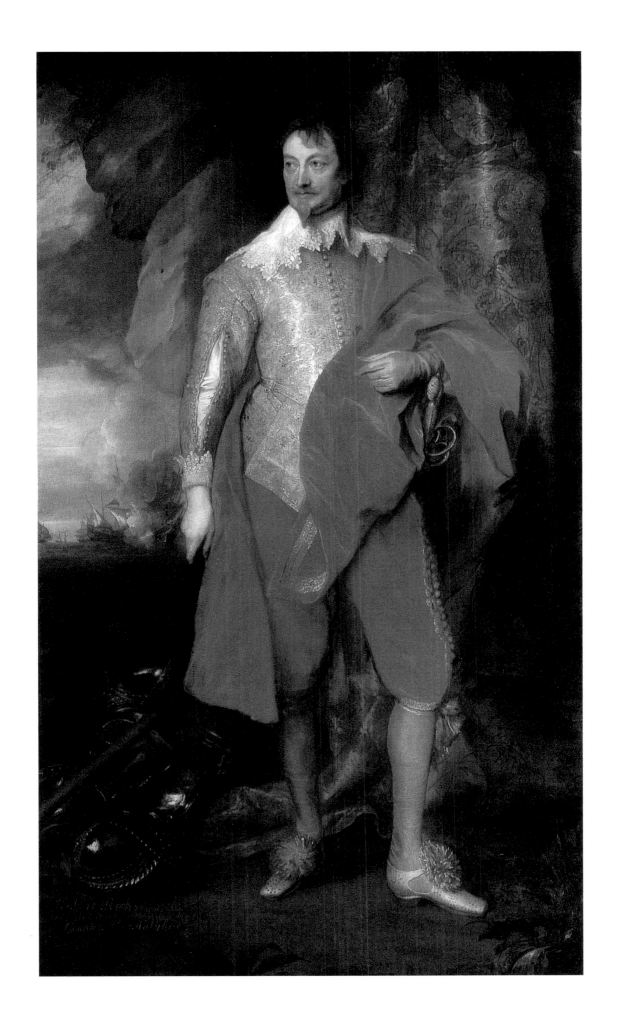

101. *Robert Rich, 2nd Earl of Warwick*, 1634,
The Metropolitan Museum of Art,
New York.

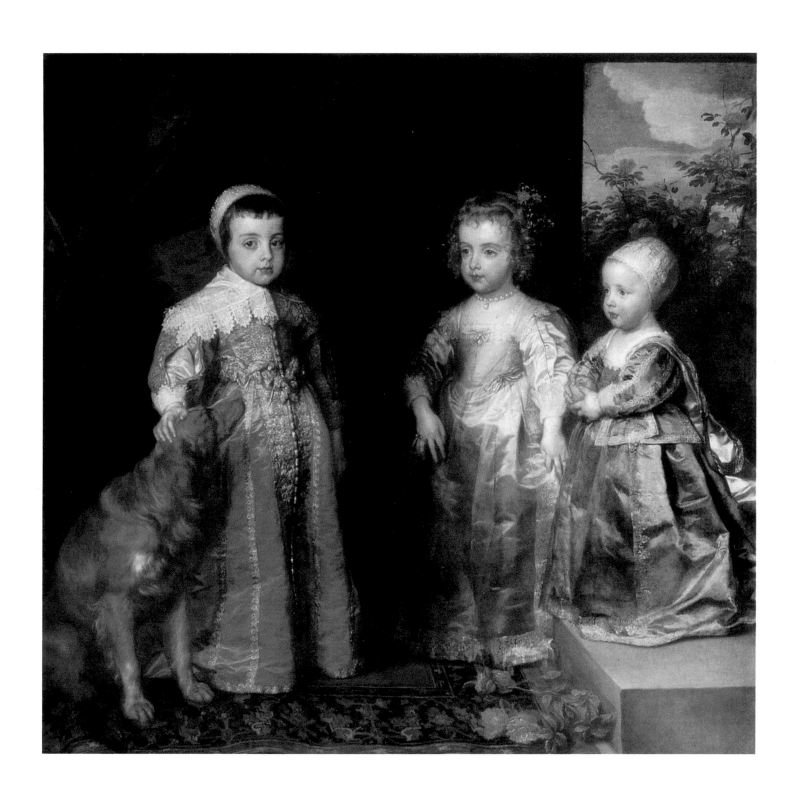

102. *The Three Eldest Children of Charles I,*
1635,
Galleria Sabauda, Turin.

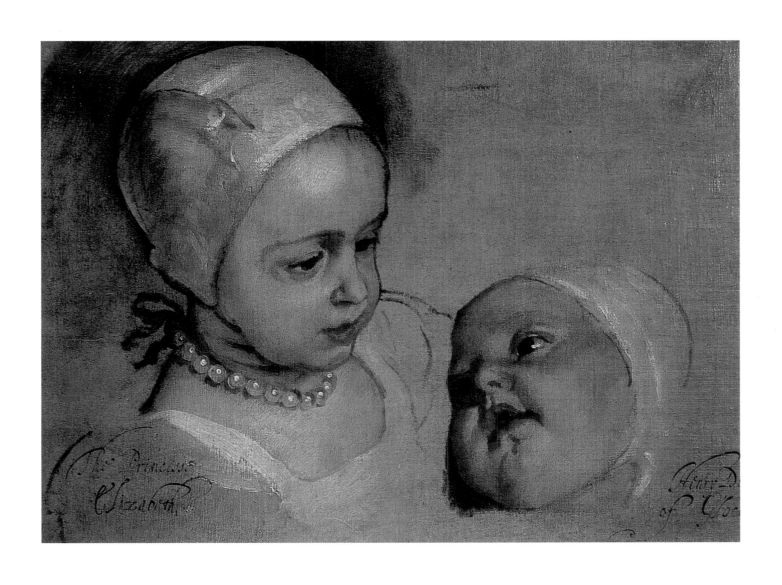

103. *Princess Elizabeth I and Princess Anne*,
study for the painting *Five Children of
Charles I*, ca. 1637,
British Rail Pension Fund.

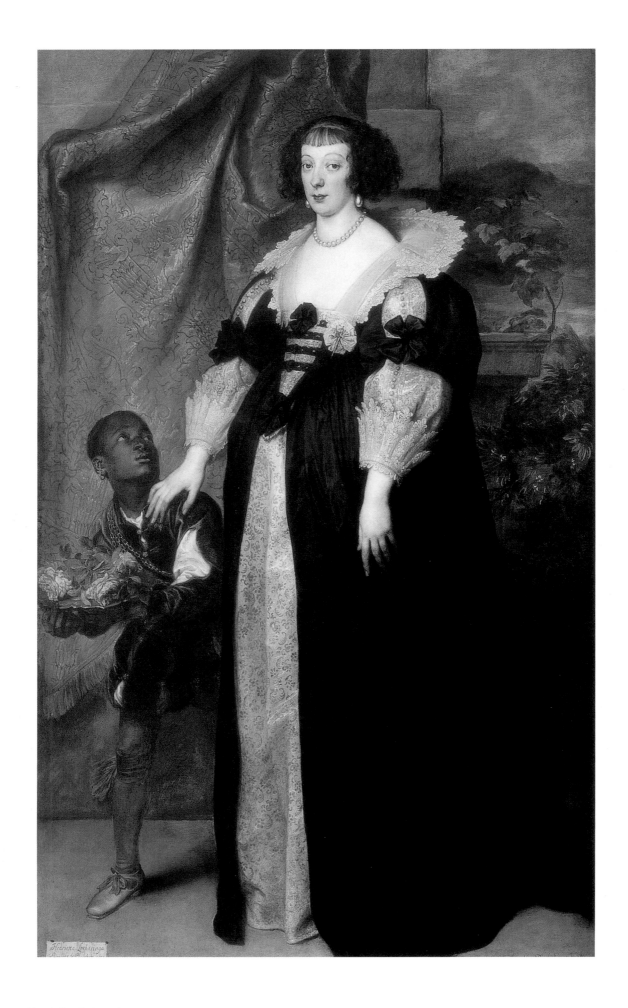

104. *Princess Henriette de Lorraine*
Accompanied by a Page, 1634, English
Heritage (The Iveagh Bequest),
Kenwood.

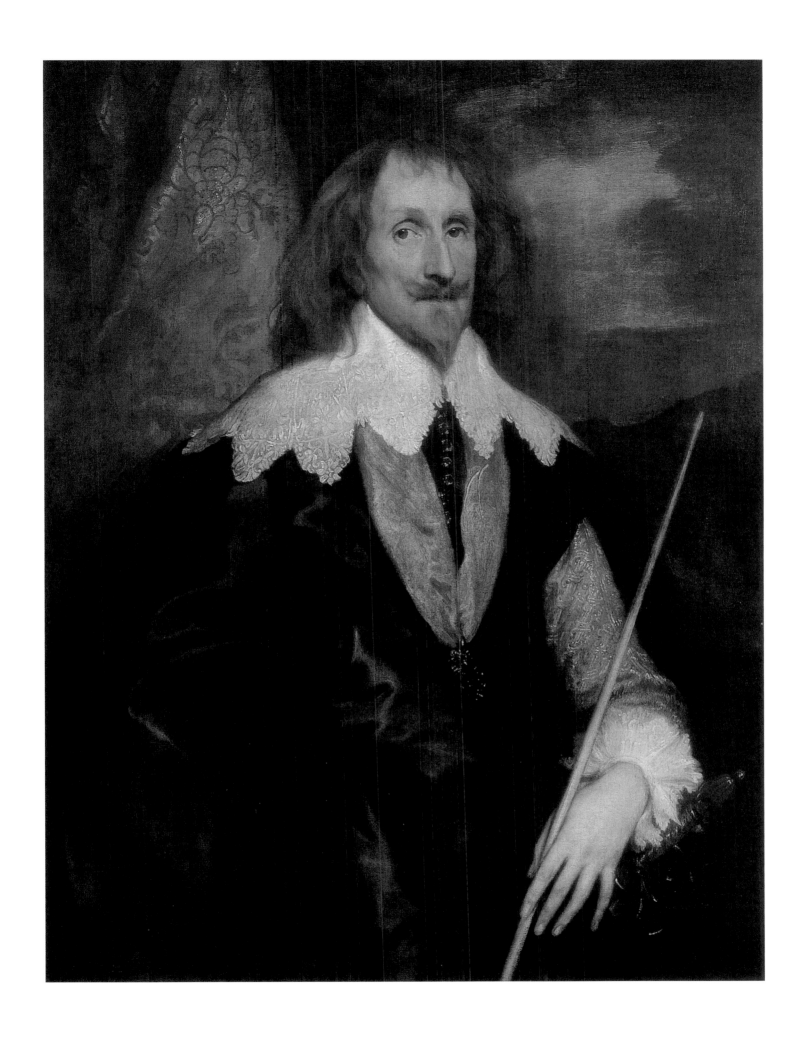

105. *Philip Herbert, 4th Count of Pembroke*,
ca. 1634,
National Gallery of Victoria, Melbourne.

achieves this impression by moving the figure to the left of the composition's central axis). With one hand he is leaning on a walking stick, while holding a kid glove in the other. The King seems completely absorbed in his thoughts and remote from his surroundings – nature, the distant sea, and his accompanying servants: his page and the groom who is holding his horse. The artist's portrait subtly reveals that Charles was, as contemporaries stated, "temperate and chaste and serious", "more disposed to melancholy than joviality".[29]

There is no great variety to the compositional devices employed by Van Dyck in his English portraits. Moreover, once Van Dyck had found a successful approach, he often used it in several different pictures. Nevertheless, he was always unfailingly able (and this is the strength of his skill!) to see and accentuate the sometimes barely perceptible individual features of his subjects' outer and inner natures, which allowed him to create a different image every time, even within the confines of the already developed scheme.

106. *Inigo Jones,* 1632-36, drawing.
Devonshire Collection, Chatsworth.

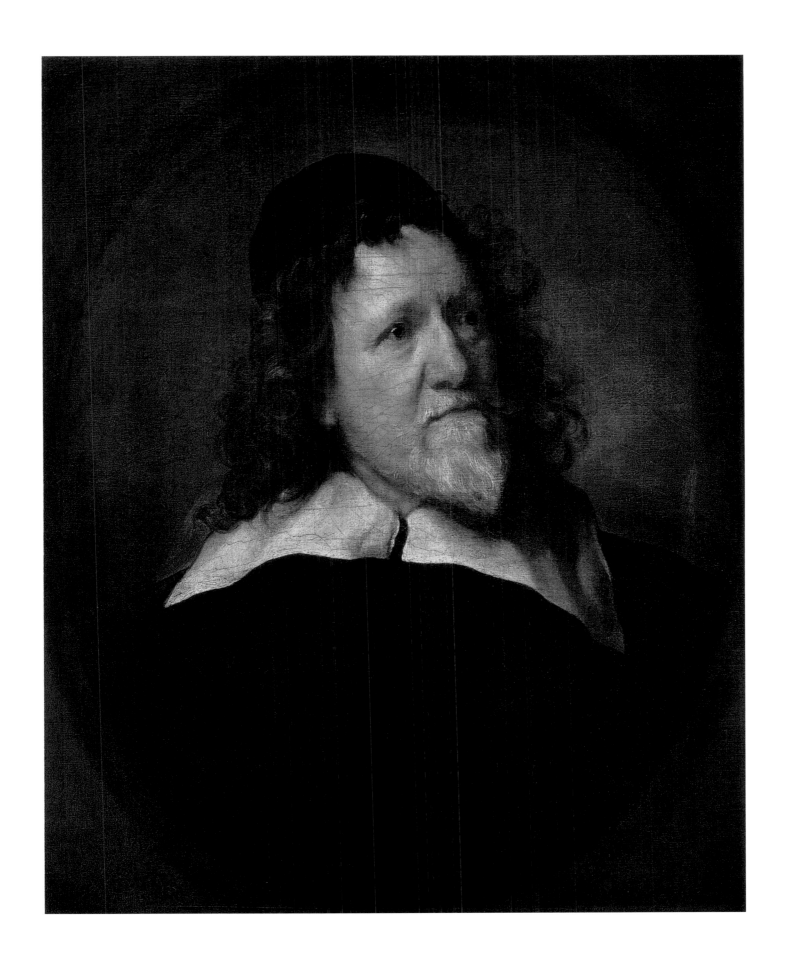

107 *Inigo Jones,* early 1630s,
(oval inscribed in a rectangle),
The Hermitage, St Petersburg.

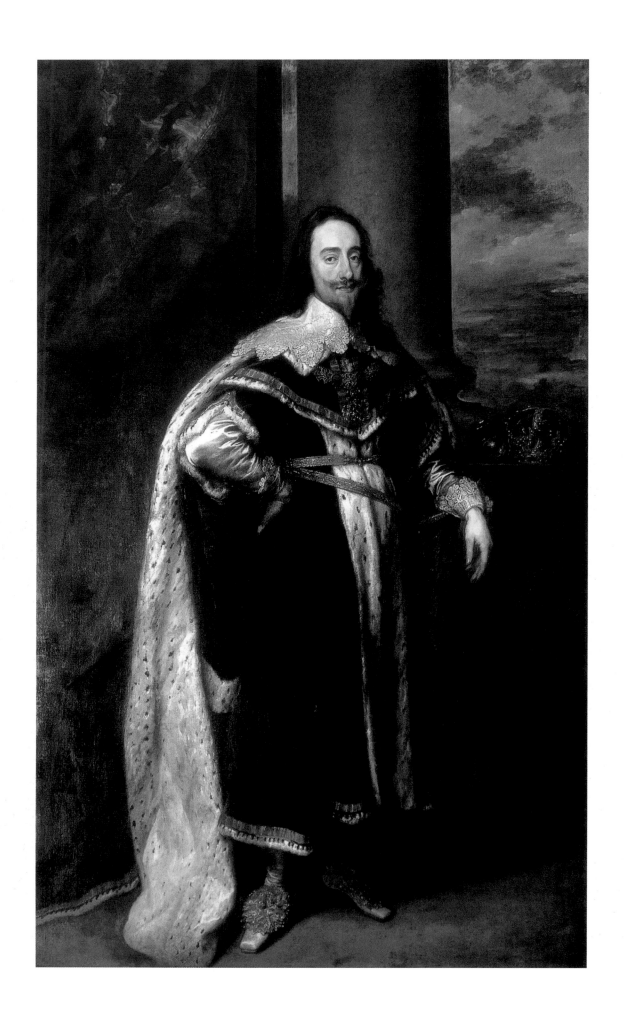

108. *Charles I*, ca. 1636.

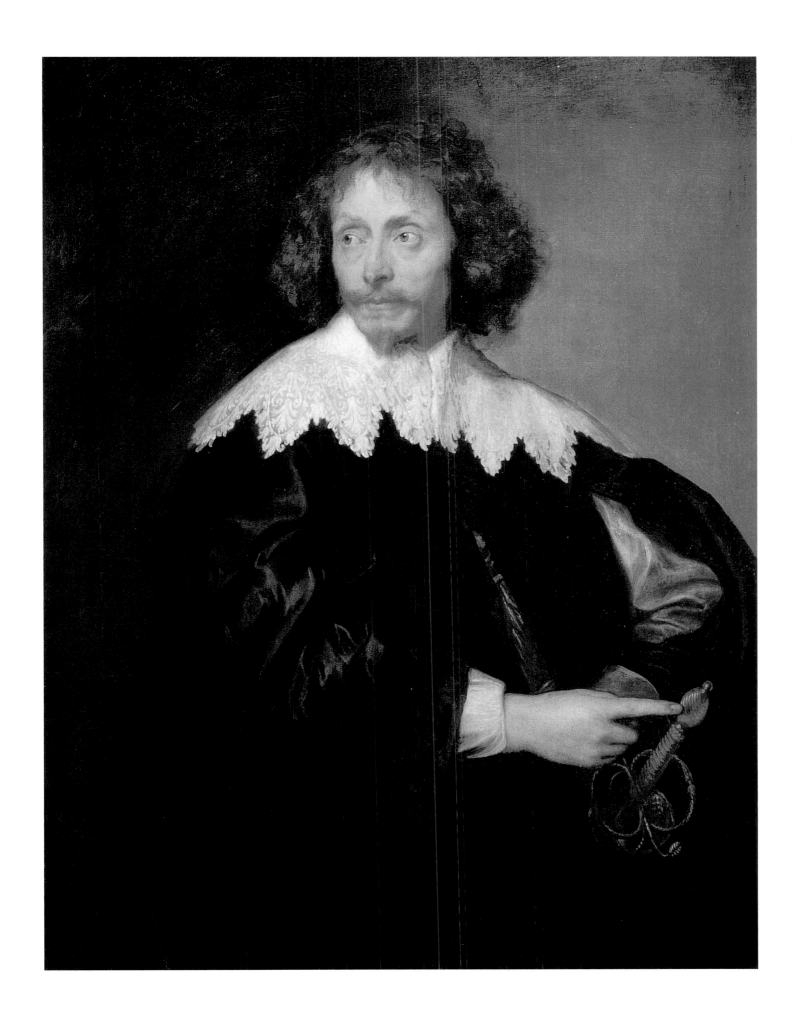

109. *Sir Thomas Chaloner*, ca. 1637,
The Hermitage, St Petersburg.

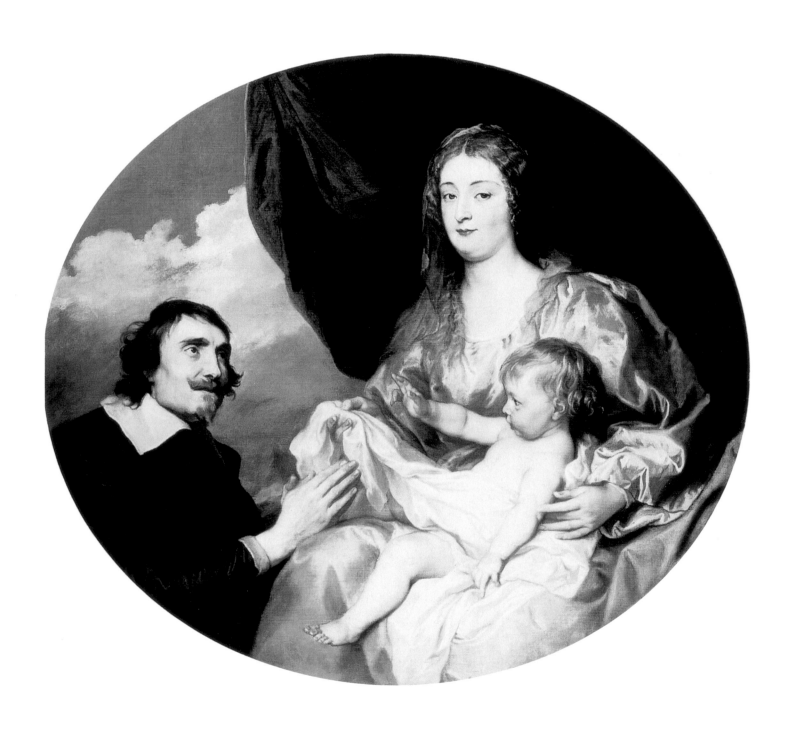

110. *The Abbé Scaglia Adoring the Virgin and Child,* 1634-35,
 National Gallery, London.

In his portrait of the Cologne banker and collector Everhard Jabach (1610–1695) Van Dyck repeated the composition of his *Self-Portrait* (Hermitage). However, the artist enriched the portrait with a depiction of a specific corner of England – the Ypres Tower, a remnant of the twelfth-century Norman citadel in the port of Rye, Sussex. In general, Van Dyck made great use of landscape backgrounds in his English portraits (*Portrait of Sir Thomas Wharton, Knight of Bath, Portrait of Lady Jane Goodwin*; all in the Hermitage).

The colouring in the artist's English portraits acquired a new brightness in comparison to the works from his Italian and Second Antwerp periods. He shunned gaudiness, however, displaying a taste and sense of proportion that never deserted him. In one of his most colourful portraits from the late 1630s, *Ladies-in-Waiting Ann Dalkeith, Countess of Morion (?), and Ann Kirke*, Van Dyck achieves an astounding harmony, strikingly yet subtly combining the silvery whites and delicate lilacs in the fabrics of his characters' dresses with the cherry-reds, and the blacks with the whites. The sonorous splendour of the foreground is further emphasized by the gold-embroidered black draperies in the background and the distant twilit landscape. Not one spot leaps out from the portrait's general colour scheme; every tone has its echo, blending into a unified harmony of colour.

In England Van Dyck was overloaded with commissions, and was forced to work on several portraits simultaneously. His contemporaries were astounded at how quickly he worked. Jabach, who posed for the artist on several occasions, once touched on this subject during a discussion with Van Dyck. Jabach's account of this discussion was included in Roger de Piles's book *Cours de Peinture par Principes*, which remains the only detailed account of Van Dyck's working practices. In England, according to de Piles, he was so swamped with work on portraits of the royal family and grandees that he had no time to write his memoirs, and he therefore left no technical treatise in which he might have formulated his artistic method.

When Jabach questioned the painter about the speed at which he worked, Van Dyck replied that "at the beginning he worked long and hard on his paintings to gain his reputation and in order to learn how to paint them quickly".

Jabach then described his working practice: "[The artist] made appointments with his sitters and never worked more than an hour at a time on each portrait, either when sketching it out or when finishing it. When his clock indicated that the time was up, he rose, thanked the sitter kindly, indicating that that was enough for one day and arranged another appointment. After which his servant came to clean his brush and bring him another palette whilst he [Van Dyck] welcomed the next sitter, with whom he had made an appointment. In this way he worked on several portraits in the same day with extraordinary speed.

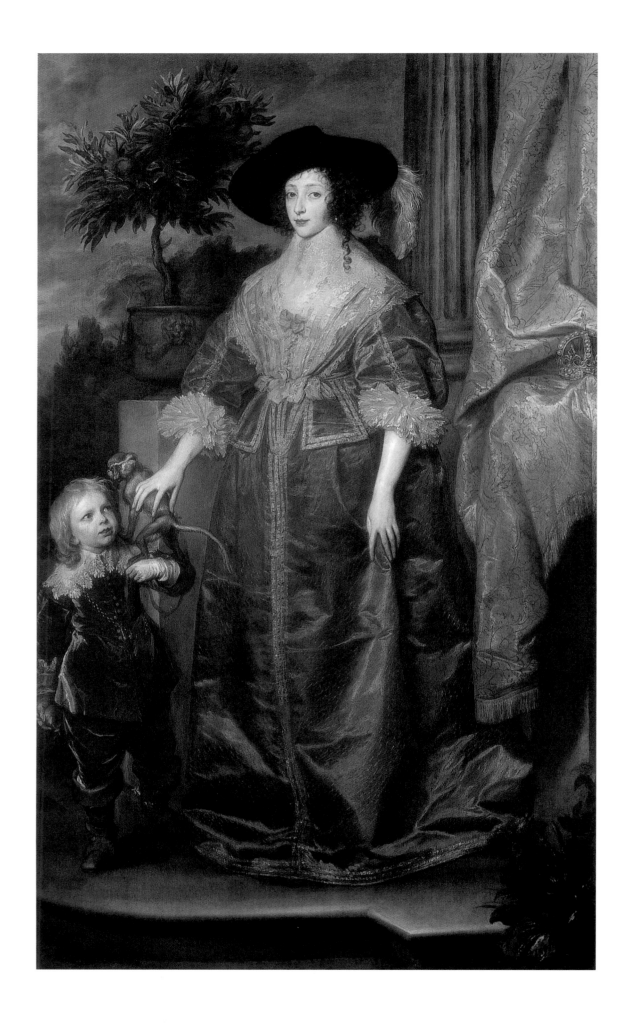

111. *Henrietta Maria, with her Dwarf Sir Jeffrey Hudson,* 1633,
National Gallery of Art, Washington.

130

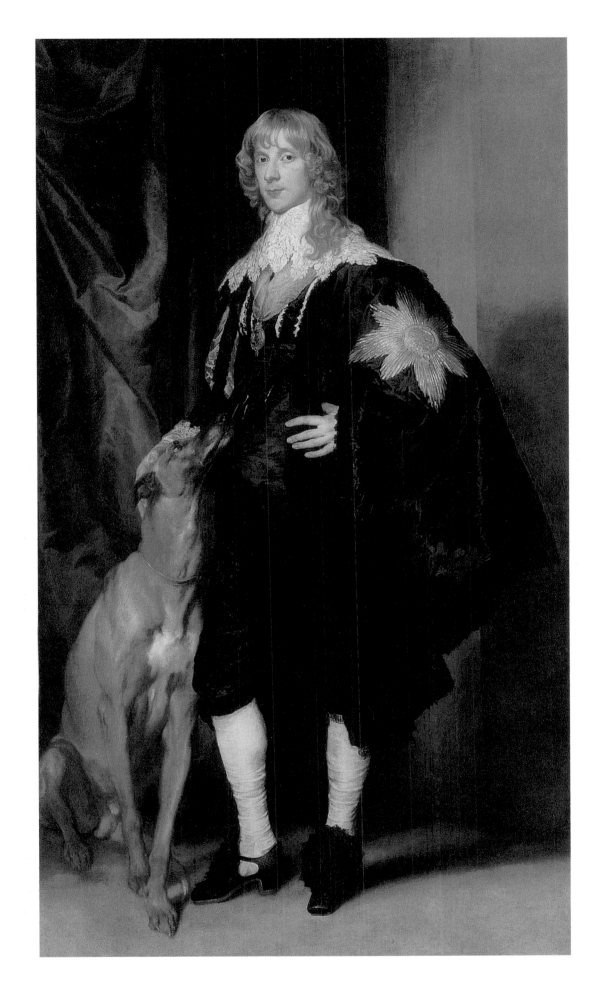

112. *James Stuart, Duke of Lennox and Richmond,* 1633,
The Metropolitan Museum of Art,
New York.

Having lightly sketched out a portrait, he arranged the sitter in a pose that he had thought out beforehand. Then with his grey paper and black and white chalks, he drew the figure and clothes with a great flourish and exquisite taste for about a quarter of an hour. He then gave these drawings to his skilful assistants for them to paint the sitter in the clothes which had been sent at the special request of Van Dyck. His pupils having done all they could from the life with the drapery, he passed his brush lightly and quickly over what they had done and with his talent gave it the art and truth that we admire in his work. As far as the hands are concerned, he had in his studio people in his employ of both sexes who served as models."[30]

This method of working with assistants sometimes led to an uneven quality of work. For example, in his portrait of the young daughters of Lord Philip Wharton, Philadelphia and Elizabeth (Hermitage), we are struck by the jarring discrepancy between the figures and the background, the cold and expressionless execution of which leaves us in no doubt as to the involvement of the artist's assistants. The figures themselves, though, were painted by Van Dyck and are among the finest he created in England. The children's portraits reveal yet another facet of his art. Van Dyck was a consummate master of the child portrait. In his renderings of children he never lapses into sugary, doll-like depictions, but subtly emphasizes the peculiarities of the child's view of the world (*Three Eldest Children of Charles I*, Galleria Sabauda, Turin; *Three Children of Charles I* and *Five Children of Charles I*, both in the Royal Collection, Windsor Castle).

Both of the girls in the Hermitage portrait, dressed and coiffed like ladies of the court, are posing for the artist. Yet while trying to preserve the earnestness of adults they behave with all the spontaneity of children taking a somewhat sly pleasure in acting out their roles. The refinement of the cool colour range and the finely honed elegance of the silvery tone, which characterize many of Van Dyck's English portraits, including this one, were taken up and developed by later English painters.

Van Dyck can be said to be the father of the English national school of portraiture which flourished in the eighteenth century. Such prominent painters as Thomas Gainsborough (1727–1788) and Joshua Reynolds (1723–1792) drew considerable inspiration from his works. The Flemish master therefore belongs as much to the history of English art as to Flemish. In England Van Dyck painted several portraits of English cultural figures. Among the works of this type was a depiction of Inigo Jones (Hermitage), executed in the early 1630s. Jones, an eminent architect, theatre decorator and innovator nicknamed "the English Vitruvius", built the Banqueting House of London's Whitehall Palace, whose ceiling paintings were created by Rubens. In the Hermitage portrait of the architect, Van Dyck, returning to a theme of his early work,

113. *François Langlois*, ca. 1637, Collection of the Viscount Cowdray.

133

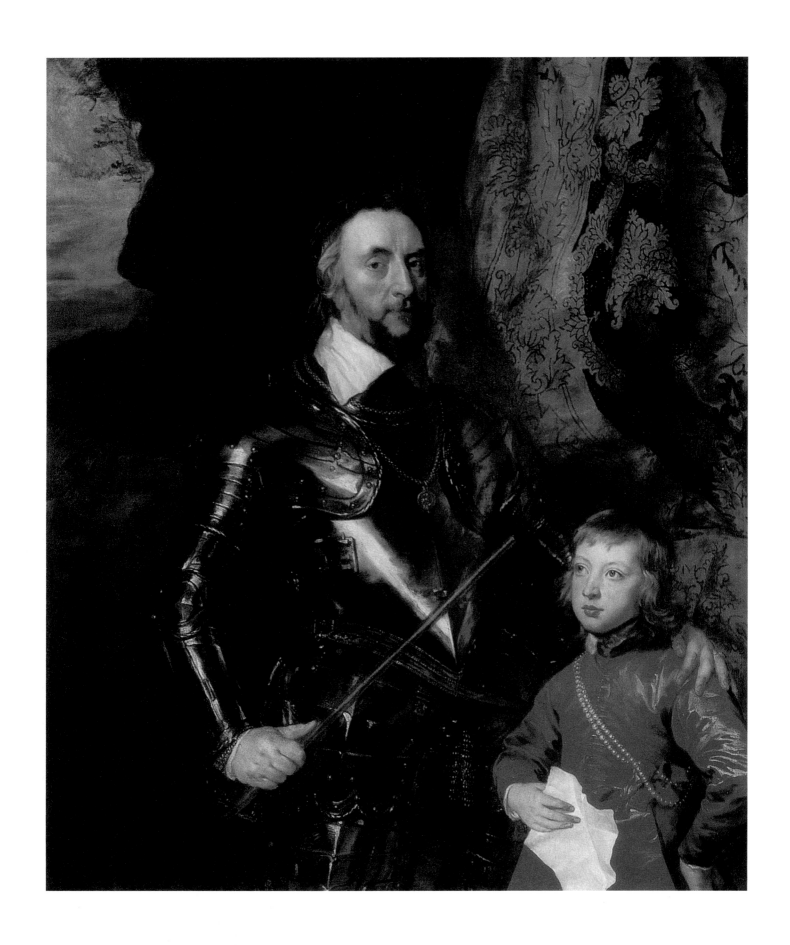

114. *Thomas Howard, Earl of Arundel, and his Grandson, Lord Maltravers*,
ca. 1636, Collection of the Duke of Norfolk, Arundel Castle, Sussex.

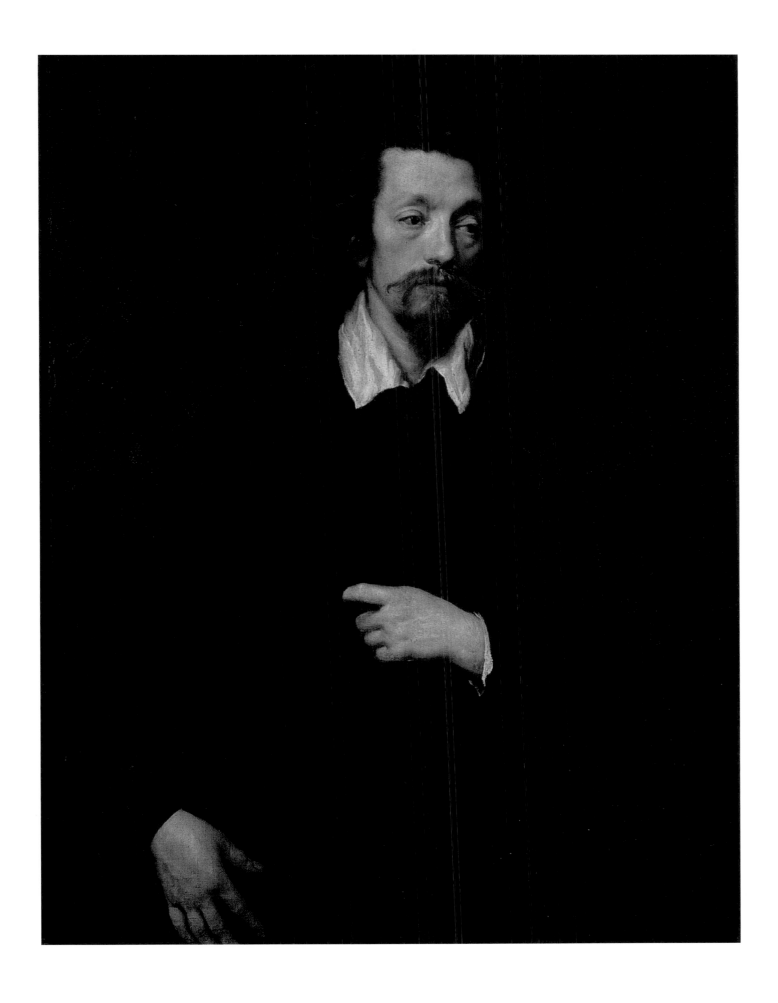

115. *Jacques de Cachiopin*, 1634-35,
Kunsthistorisches Museum, Vienna.

sparingly and laconically creates a vibrant, memorable image of a man at a moment of mental strain and emotional impulse.

Van Dyck's art retained its brilliance to the end of his days. In England the painter's skill reached new heights. This can be seen in his fine portrait, painted in the late 1630s and now in the Hermitage, of Sir Thomas Chaloner (1595–1661), one of those who later signed Charles I's death warrant. Without the slightest idealization the artist shows the face of a man already past his youth, with flabby skin and reddened eyelids. But the energetic, imperious turn of the head, the quivering nostrils, the firmly clenched mouth, and especially the eyes, bright and penetrating, allow us to sense the dynamics of this man's inner life.

116. Peter Paul Rubens, *Fur Coat* (*Portrait of Helena Fourment*), late 1630s, Kunsthistorisches Museum, Vienna.

117. *Andromeda Chained to the Rock*, 1638-39, County Museum of Art, Los Angeles.

The strained emotionalism that permeates the portrait seems to reflect the whole atmosphere of English society on the eve of the Civil War. Chaloner's portrait is painted with such lightness and ease that it seems to have been executed in one sitting. Van Dyck applies the paint in short strokes, thinly and delicately, to fashion the face and the hand, pointing imperiously at a sword (an

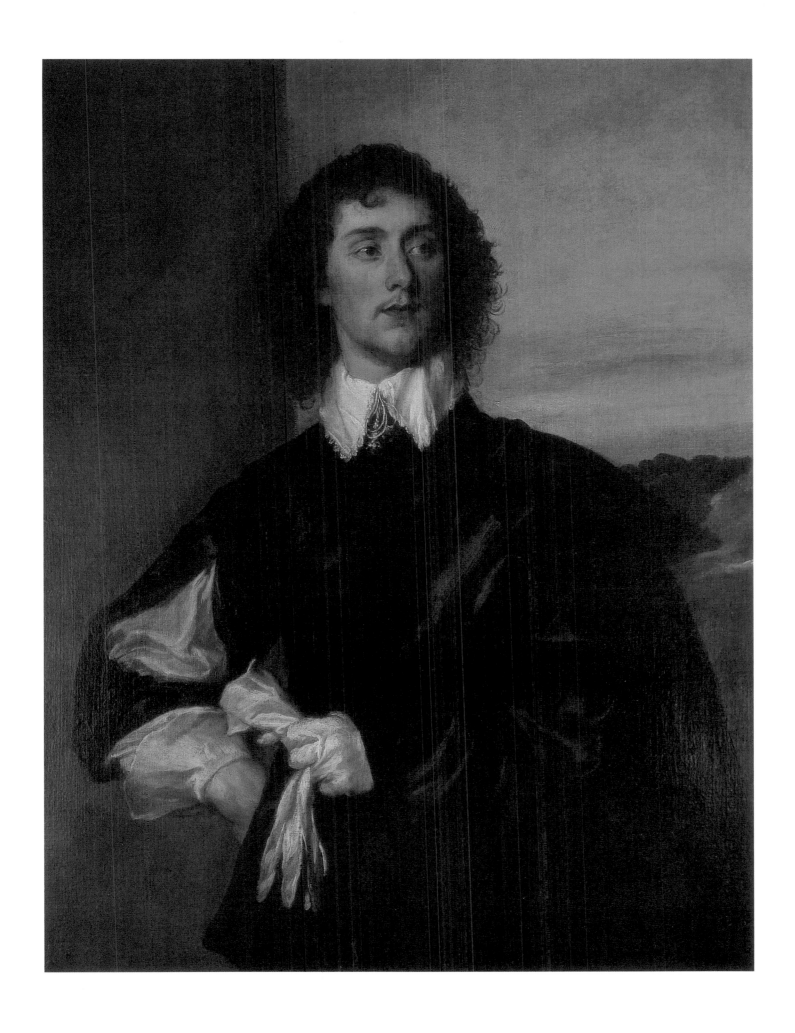

118. *Sir Thomas Hammer*, ca. 1638,
The Weston Park Foundation.

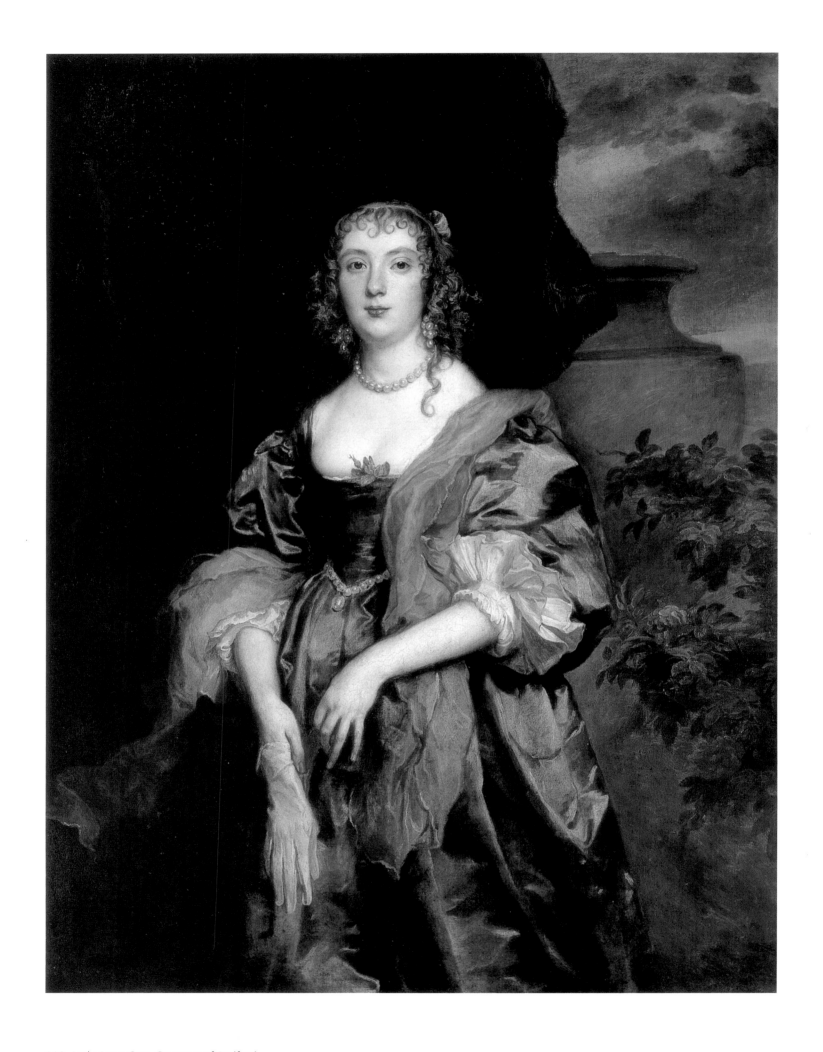

119. *Lady Anne Carr, Countess of Bedford,*
 ca. 1638.

138

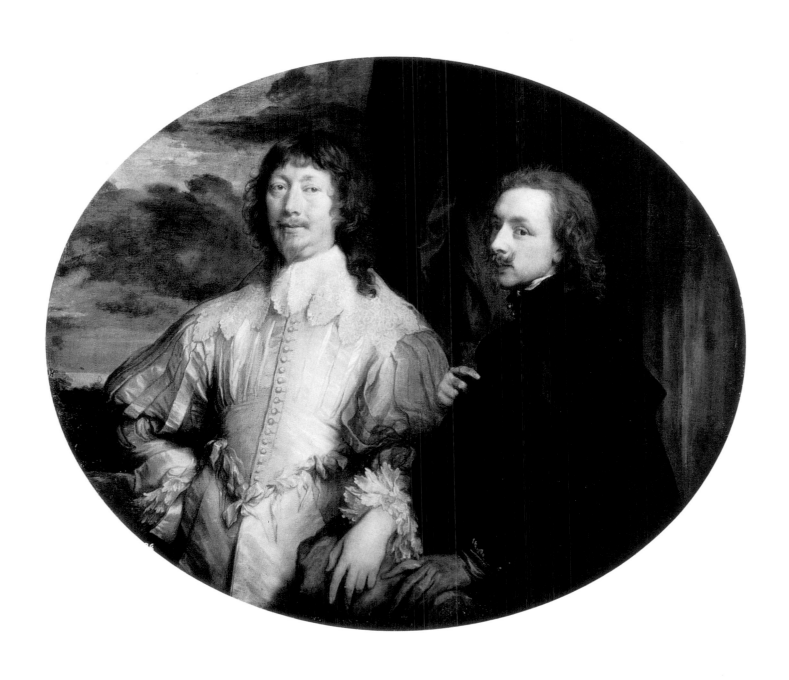

120. *Self-Portrait with Endymion Porter*,
ca. 1635,
Prado, Madrid.

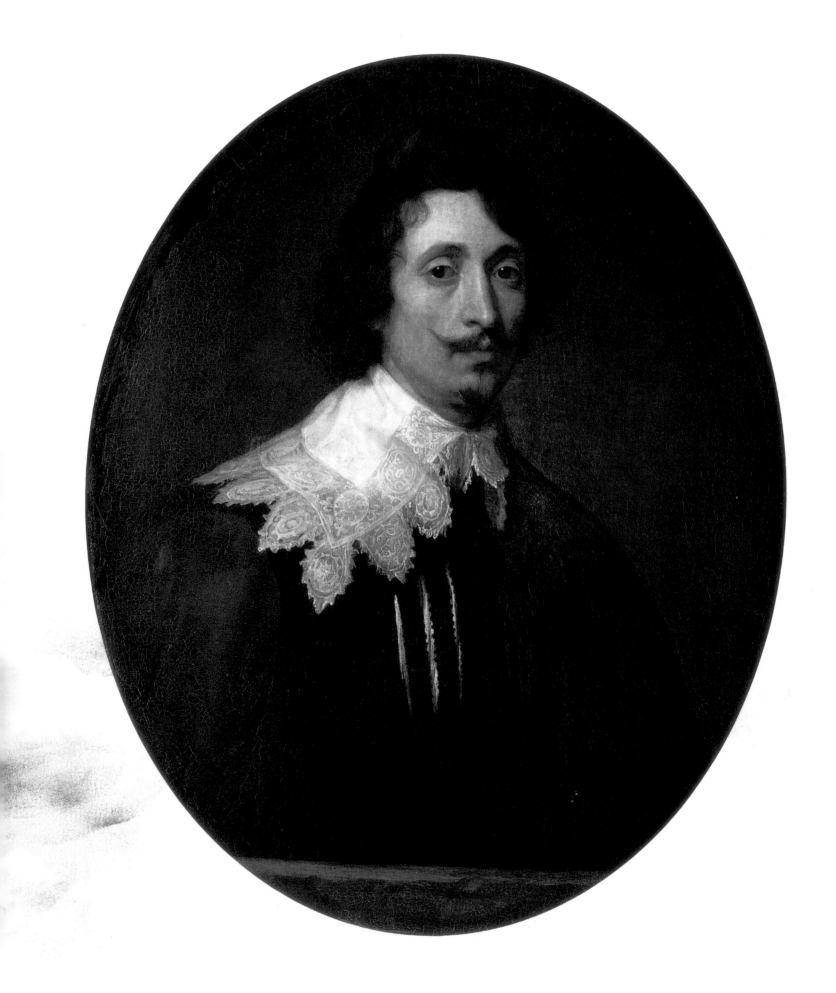

attribute of a nobleman); he uses long, meandering, flowing strokes to convey the shifting tints of the black silk of the costume, the play of the light on the folds. The portrait's colour range is extremely narrow, almost monochrome, but its laconic brevity serves to underline the refinement of the image.

Another work among the finest from Van Dyck's English Period is his *Portrait of Philip, Fourth Lord Wharton* (National Gallery of Art, Washington), which the artist evidently painted on the occasion of the nineteen-year-old lord's marriage to Elizabeth, the daughter of Sir Roland Wensford (whose portrait is in the Hermitage), in September 1632. This event seems to have supplied the painter with the pretext to paint the young man in the dress of an Arcadian shepherd, holding a crook - a theme which at that time enjoyed great popularity at court, and which often figured in the various productions ("masques") of the court theatre. The young lord's pensive look, the refined grace of his posture, the elegance of his costume, the understated colours of which are subtly set off by the green curtain and somewhat theatrical rocky landscape vanishing into the distant haze – everything about this wonderful portrait helps to create an image that is at once poetic and memorable. The portrait is filled with harmony, gentleness, and tenderness, and is imbued with a fondness for the subject that is rare for Van Dyck.

During his years in England, Van Dyck worked almost exclusively on portraits. However, he obviously found the framework of the portrait genre too narrow. His artistic interests continued to display their former breadth. In his final years, for example, he devoted a good deal of time to the depiction of nature. Although Van Dyck produced no actual landscape works (apart from some drawings), the landscape backgrounds in his portraits played a significant role in the later development of Western European (particularly English) landscape painting.

But Van Dyck's strongest aspiration was to become a painter of historical works. He gladly accepted the commission for a series of decorations for the walls of the Banqueting House in Whitehall Palace to illustrate The History of the Order of the Garter. However, he was not destined to carry out this work. Menacing political developments were brewing in England, and the King was no longer able to spend large sums of money on artistic commissions. Having made a few sketches, Van Dyck was forced to abandon this cherished project.

The Flemish master's penchant for historical painting occasionally revealed itself in his creation of works of an unusual type, a cross between the portrait and the "historical picture". One example is the painting *The Abbé Scaglia Adoring the Virgin and Child* (National Gallery, London), in which the Virgin bears the features of the French Christina of Savoy, the wife of Victor Amadeus I, Duke of Savoy, and sister of the English Queen Henrietta Maria,

121. *Portrait of a Young Man*, 1634-35, The Hermitage, St Petersburg.

141

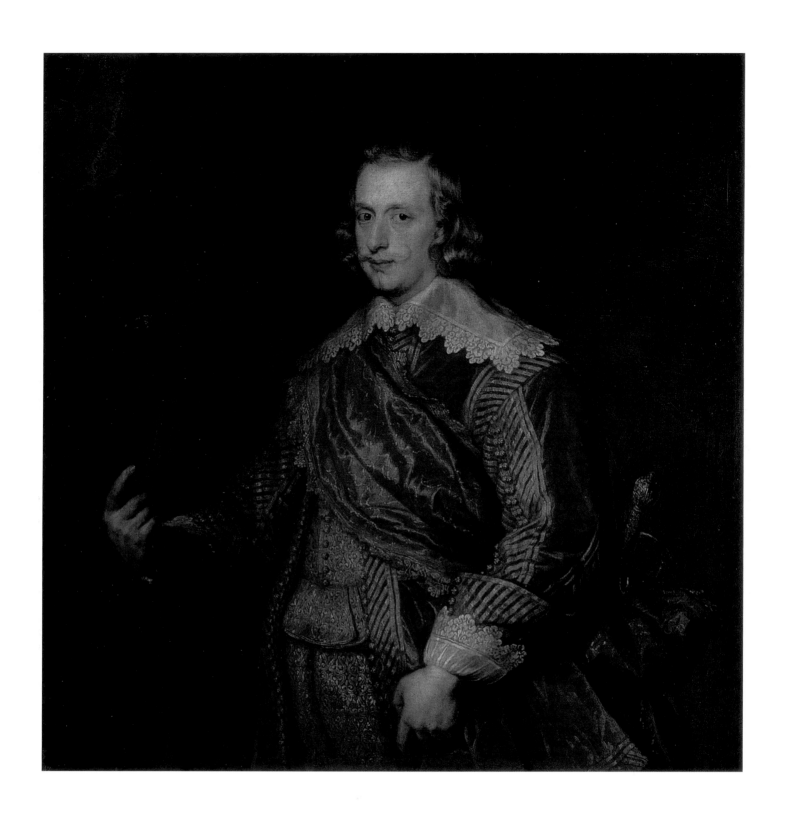

122. *Cardinal Infante Ferdinand,* 1634,
Prado, Madrid.

while the Christ Child sitting in her lap seems to have been modelled on Francis Hyacinth, her eldest son and the heir to the throne of Savoy. The Abbé Scaglia, who commissioned the painting, it seems, as a present to the Duke, was obviously hoping with this gesture to regain the favour of the House of Savoy. He had served it many years as a diplomat, and had been forced to leave for Flanders when he lost his position. This picture, which is notable for its striking compositional harmony – the classically austere group of figures is skilfully inserted into an oval – is one of Van Dyck's most mature works, not only with regard to the fineness of the execution, but also in the depth of the inner substance.

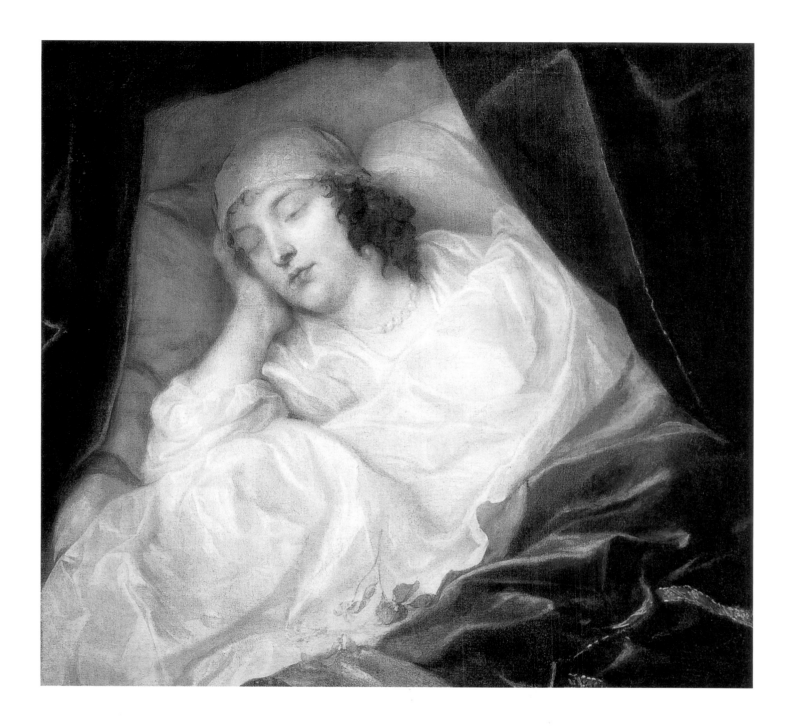

A work of the same type, but different in character, is *Andromeda Chained to the Rock* (County Museum of Art, Los Angeles). At first sight this is a mythological composition, but it is in fact a portrait of Margaret Lemon, Van Dyck's mistress, in the guise of Andromeda. For the artist, the mythological subject of this extensive canvas (215.3 x 132.1 cm), with the large naked figure, whose pallor is strikingly offset by the silvery-blue draperies flapping in the wind, moved out to the foreground, is merely an excuse to show "ideal nudity". For this picture Van Dyck drew, with his own creative adaptations, not only on Titian's famous *Perseus and Andromeda* (Wallace Collection, London), but also on such celebrated portraits as Titian's *Lady in a Fur Cloak* (Kunsthistorisches Museum, Vienna) and *Portrait of a Young Woman* (Hermitage, St Petersburg) and Rubens's *Fur Coat* (Kunsthistorisches Museum, Vienna).

123. *Venetia, Lady Digby on her Deathbed*, 1633,
The Trustees of Dulwich Picture Gallery, London.

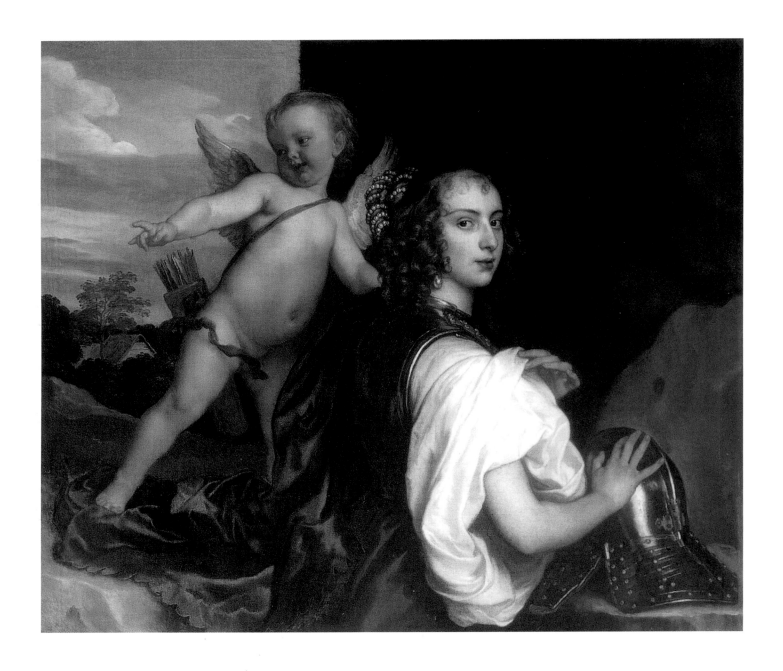

124. *Portrait of a Girl as Erminia Accompanied by Cupid,* Collection of the Duke of Marlborough, Blenheim Palace, Oxfordshire.

Although Van Dyck enjoyed great success in England, and was accorded the highest esteem (the King knighted him, invested him with the title of "principalle Paynter in ordinary to their Majesties", and arranged his marriage to one of the Queen's ladies-in-waiting), he never became fully assimilated. The artist was always being dragged back to his mother country by various business interests, ties of friendship, and family obligations. His brother and sisters lived in Antwerp, as did his illegitimate daughter Maria Theresia, whom he supported. It was an Antwerp publisher who brought out Van Dyck's collection of engraved portraits of his famous contemporaries.

Van Dyck returned to Flanders three times in 1634. It seems the artist was then planning to remain in his mother country. Everything points to this: he acquired a plot of land near Antwerp; he set to work on a commission of great public importance – a group portrait of the members of Brussels City Council for the Town Hall (lost; a sketch can be found in the Ecole des Beaux-Arts,

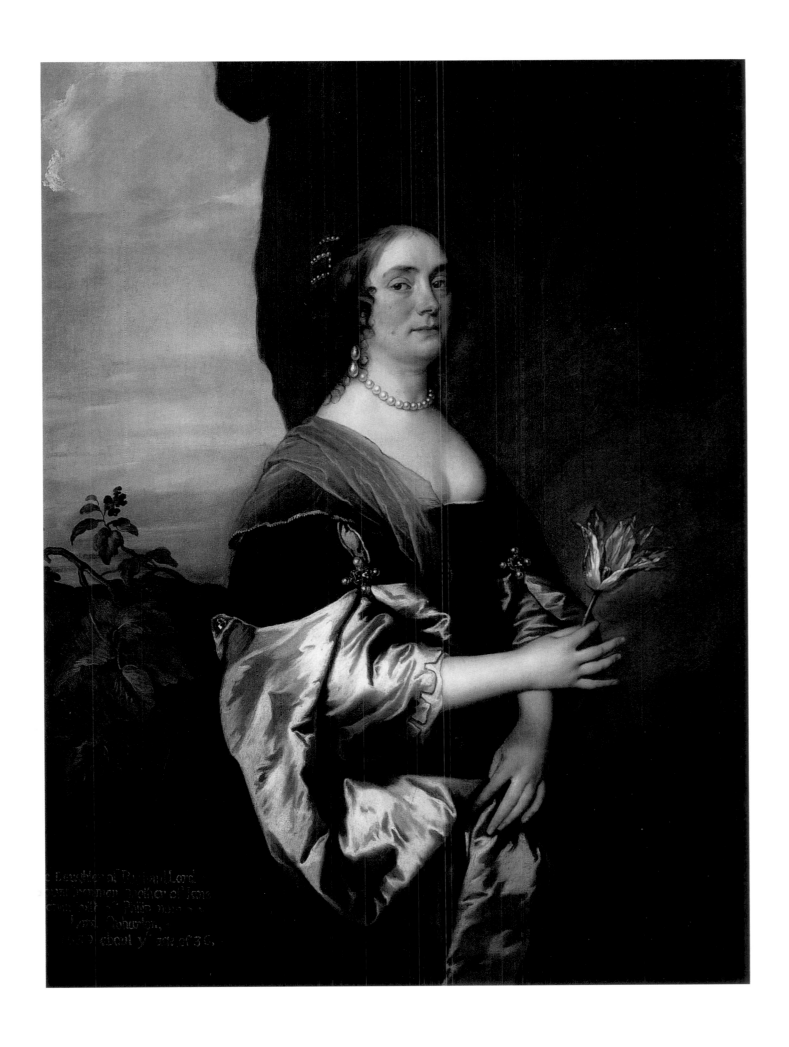

125. *Lady Jane Goodwin*, 1639,
The Hermitage, St Petersburg.

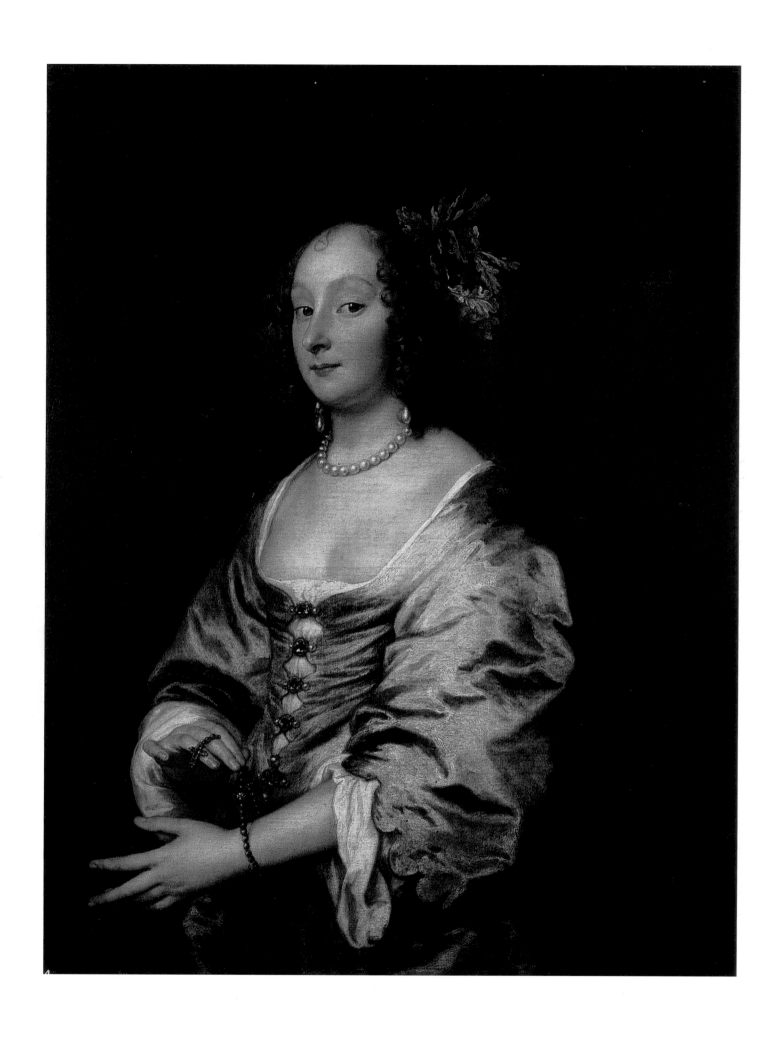

126. *Mary Ruthven*, ca. 1639,
Prado, Madrid.

146

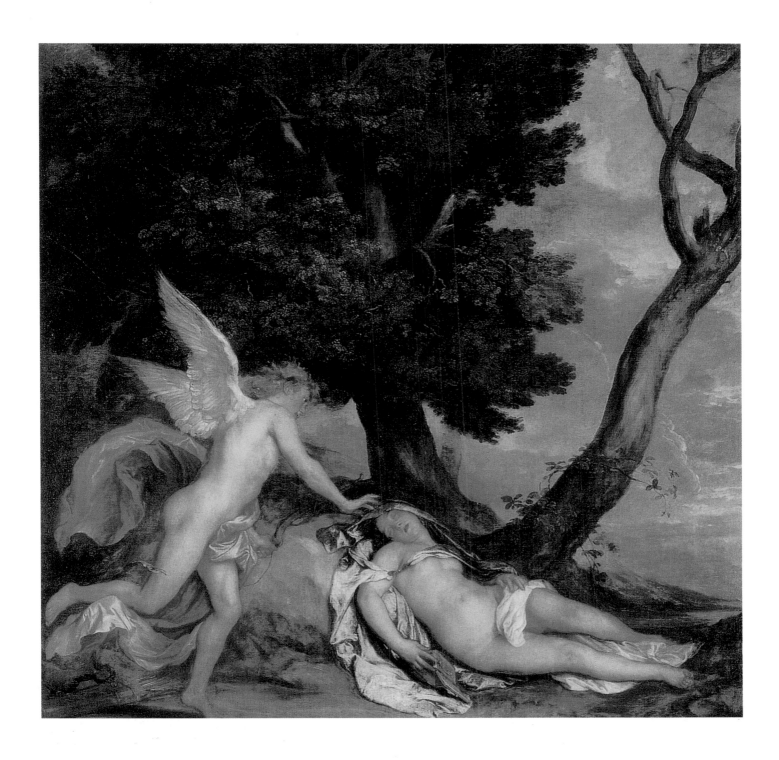

Paris); and in October 1634 his fellow artists elected him Honorary Dean of the Guild of St Luke – an honour which had previously been bestowed only on Rubens. Unfinished work back in London, however, forced Van Dyck to return to England.

Van Dyck's last trip to the continent took place in the spring of 1641, when he and his wife set out for Paris, hoping to be awarded the commission for the decoration of the Louvre. Thwarted in his ambitions (the project was awarded to Nicolas Poussin), he returned again to London, where he fell ill and passed away in December 1641 at the age of forty-two. The artist-knight was given a solemn burial in the choir of St Paul's Cathedral in the heart of London.

127. *Cupid and Psyche*. ca. 1638, Royal Collection, Kensington Palace, London.

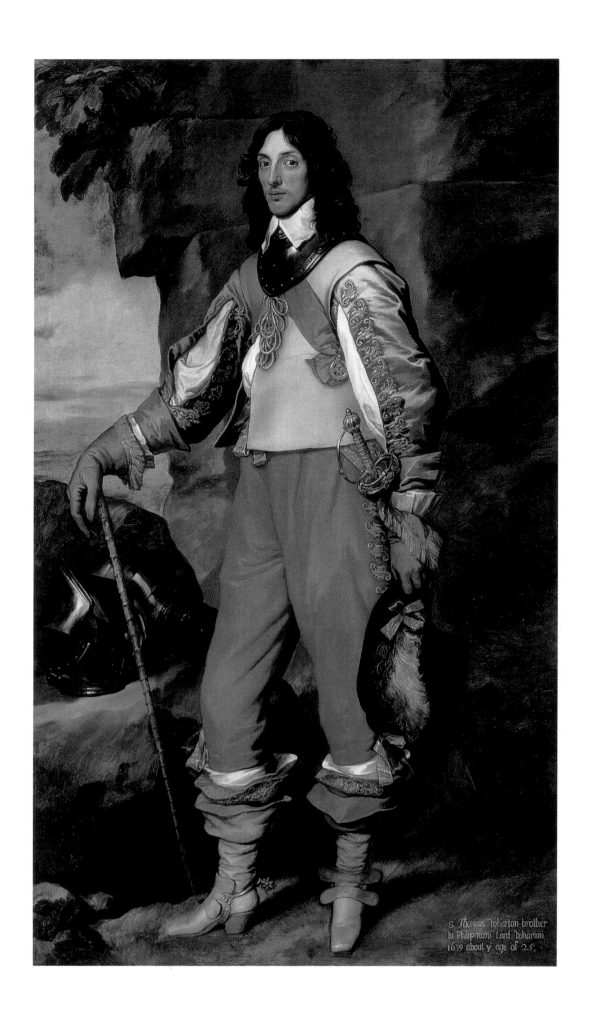

128. *Sir Thomas Wharton,* 1639,
 The Hermitage, St Petersburg.

148

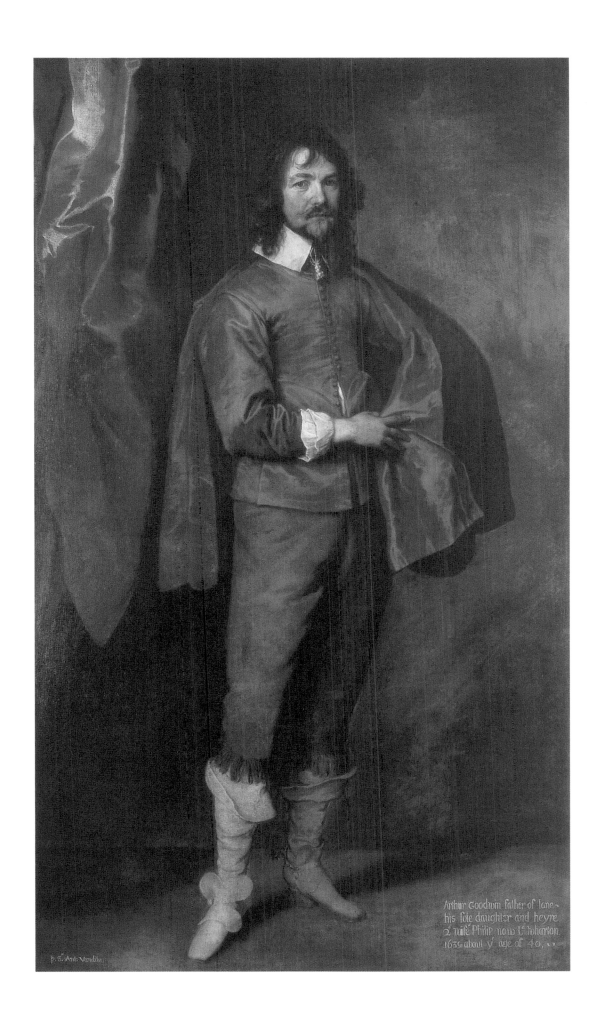

129. *Arthur Goodwin,* 1639.

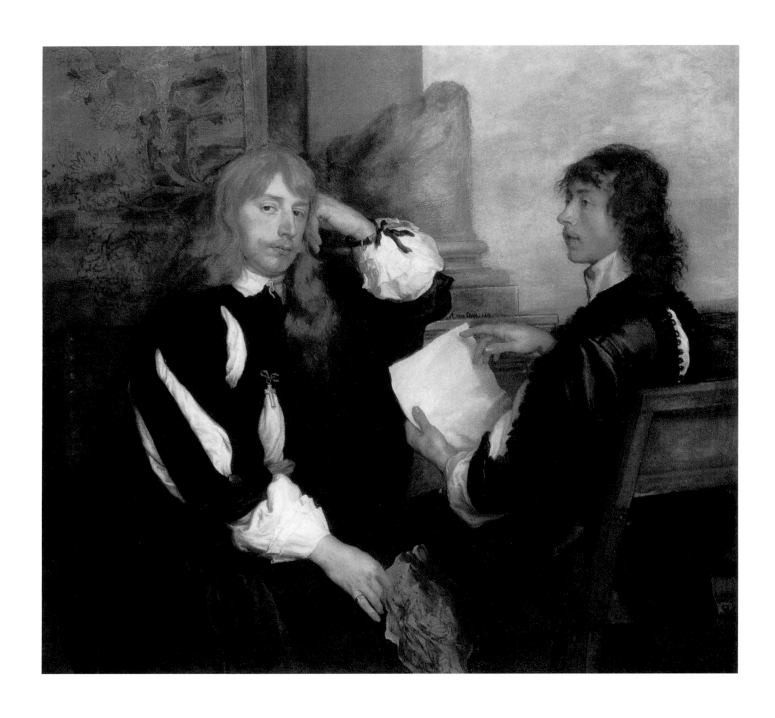

130. *Thomas Killigrew and William, Lord Crofts*
(?), 1638,
Royal Collection, Windsor Castle.

Van Dyck's work paved the way to the future, and assisted in the creation of the English school of portraiture of the eighteenth century. It is difficult to imagine the later development of the English portrait without the Flemish painter's inspiring example. The landscape backgrounds in Van Dyck's portraits, and his landscape drawings (*Landscape with Trees and Sailing Vessels*, Barber Institute, Birmingham University), did not go unnoticed by English painters (particularly Thomas Gainsborough in the eighteenth century), either. Van Dyck was one of the first European artists successfully to convey the richness and complexity of man's inner world, and made a huge contribution to the creation of the psychological portrait, which was to reach its seventeenth-century zenith in the work of Rembrandt.

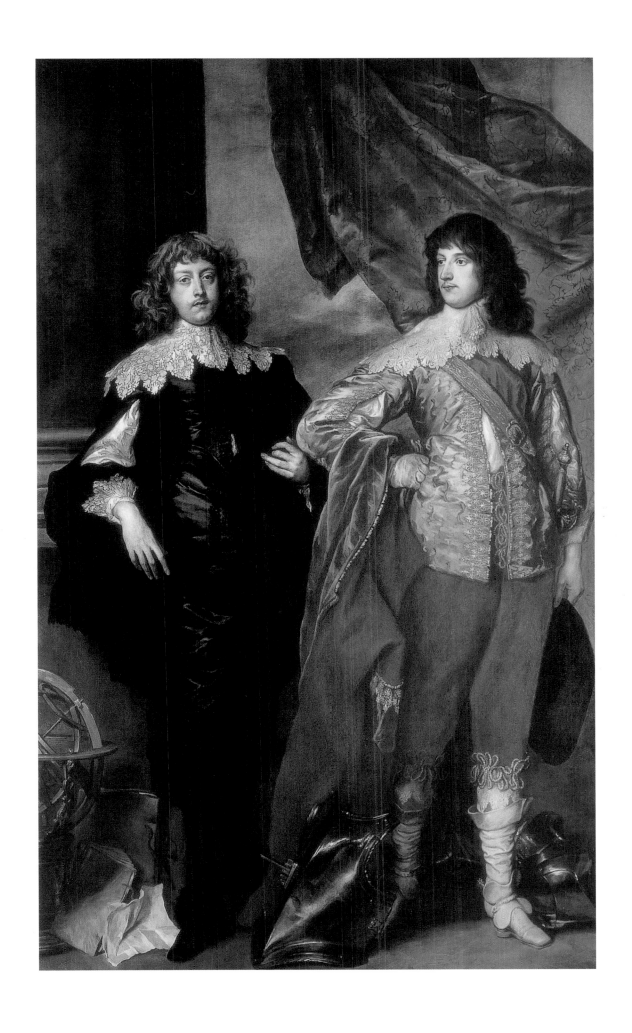

131. *George, Lord Digby, and William, Lord Russell,* ca. 1637 or before, Althorp Park.

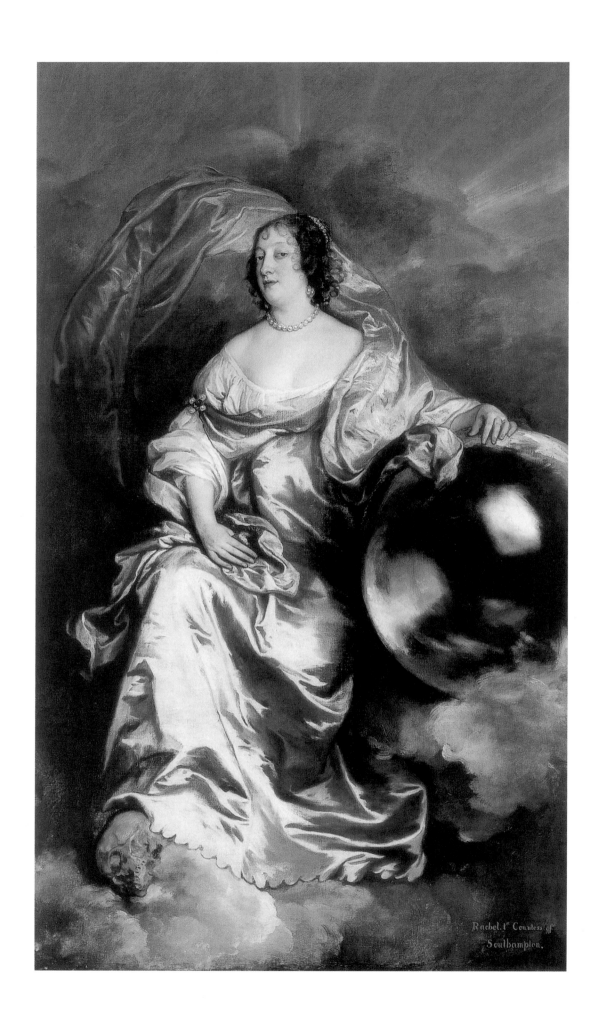

132. *Rachel de Ruvigny, Countess of*
Southampton as Destiny, ca. 1640,
National Gallery of Victoria, Melbourne.

Notes

1 *The Imperial Hermitage: Catalogue of the Picture Gallery*. Compiled by A. Somov. Part 2: Netherlandish and German Painting, St Petersburg, 1902, p. 187 (in Russian).

2 A collection of paintings and drawings gathered by the prominent art connoisseur and collector, the French financier Pierre Crozat (1665–1740). After his death, part of the collection was sold off, and part, including around 400 pictures, was left to his nephew Louis Francois Crozat, Marquis du Châtel (1691–1750), and after the latter's death to his brother Josephe-Antoine Crozat, Baron de Tugny (1696–1751), who added many of the pictures to his collection. The collection of Josephe-Antoine Crozat was inherited, in its turn, by his youngest brother Louis Antoine Crozat, Baron de Thiers (1699–1770), who in 1755 published a catalogue of his collection (see Bibliography). This collection was acquired by Catherine the Great in 1772.

3 This picture gallery, collected by the English Prime Minister Robert Walpole (1676–1745), was acquired by Catherine the Great in 1779 from the latter's heirs. Its catalogue was compiled by Sir Robert's youngest son, the famous writer and art connoisseur Horace Walpole (see Bibliography).

4 Three portraits – of Adriaen Stevens and its pendant, of his wife, Maria Bosschaerts, along with the portrait of Jan van den Wouwer – now belong to Moscow's Pushkin Museum of Fine Arts; the portrait of Pieter Brueghel the Younger ("Hell Brueghel") is now thought to be the work of Van Dyck's studio, while the Hermitage's 1981 catalogue attributes the portrait of Count Johann Tilly (see Bibliography) to an unknown 17th-century Flemish artist (p. 55).

5 The painting *The Penitent Apostle Peter*, which entered the Hermitage some time between 1763 and 1774, comes from the collection of the Portuguese ambassador in Paris, Count Cuevas; Van Dyck's *Family Portrait*, which entered the Hermitage before 1774, comes from the collection of the Parisian collector La Live de Jully.

6 These are the portraits of the Antwerp burgomaster Nicolaes Rockox and of Baltazarina van Linick and her son.

7 W. Hogarth, *The Analysis of Beauty* (1753), Oxford, 1955.

8 Quoted from: Fierens-Gevaert, Van Dyck, Paris, [s.a.], p. 11.

9 In Antwerp the word "cabinet" was used to describe private collections of various rarities (for example, seashells), including works of fine art.

10 Rubens' letter to Sir Dudley Carleton of 28 April 1618. Quoted from: *The Letters of Peter Paul Rubens*, translated and edited by R.S. Magum, Cambridge (Mass.), 1971, p. 61.

11 For more detail see: G. Martin, *National Gallery Catalogue: The Flemish School c. 1600 – c. 1800*, London, 1970, p. 31.

12 Letter from Francesco Vercellini (?) to the Earl of Arundel of 17 July 1620. Quoted in: *Peter Paul Rubens: Letters. Documents. Judgements of his Contemporaries*, selection, introduction, and notes by K.S. Yegorova, Moscow, 1977, p. 114 (in Russian).

13 G.P. Bellori, *Le vite de'pittori, scultori et architetti moderni*, Rome, 1672. Quoted in: C. Brown, *The Drawings of Anthony van Dyck*, Pierpont Morgan Library, New York, 1991, p. 17.

14 In the turn of the head of the model in the Hermitage portrait, and in the keen glance he is throwing to an unseen interlocutor, we can see echoes of the central figure in Titian's *Concert* (Galleria Palatina, Palazzo Pitti, Florence).

15 O.I. Panfilova, "Van Dyck's Sketch for the *Portrait of Cardinal Bentivoglio*", *Reports of the State Hermitage*, VII, 1955, pp. 36f (in Russian).

16 S. Barnes in the catalogue to the exhibition *Anthony van Dyck*. National Gallery of Art, Washington, 1990–1, pp. 164, 166.

17 D. Freedberg, "Van Dyck and Virginio Cesarini: A Contribution to the Study of Van Dyck's Roman Sojourns", in: S.J. Barnes and A.K. Wheelock, Jr., *Van Dyck 350*, National Gallery of Art, Washington, 1994, pp. 153–6.

18 For more detail see: *Abecedario de P.J. Mariette et autres notes inédites de cet auteur sur les arts et les artistes*, vol. 2, Paris, 1854, p. 205; M. Varshavskaya, *Van Dyck: Pictures in the Hermitage*, Leningrad, 1963, pp. 109f (in Russian).

19 S. Barnes in the catalogue to the exhibition *Anthony van Dyck*. National Gallery of Art, Washington, 1990–1, p. 168.

20 [R. de Piles], *Conversations sur la Connaissance de la Peinture et sur le jugement qu'on doit faire des tableaux*, Paris, 1677. Quoted in: *Peter Paul Rubens: Letters. Documents. Judgements of his Contemporaries*, selection, introduction, and notes by K.S. Yegorov, Moscow, 1977, p. 389 (in Russian).

21 M. Varshavskaya, *op. cit.*, pp. 112ff.

22 For more detail see: M. Jaffe. "Van Dyck Studies I: The Portrait of Archbishop Laud", *The Burlington Magazine*, No. 955, October 1982, p. 605.

23 A. Houbraken, *De Groote Schouburgh der Nederlandsche Kunstschilders en Schilderessen*, vol. 1, Amsterdam, 1718, p. 147.

24 *Vertue I. The Eighteenth Volume of the Walpole Society. 1929–1930. Vertue Note Books*, vol. 1, Oxford, 1930, p. 109.

25 See: W.H. Carpenter, *Pictorial Notices… collected from original documents*, London, 1844, pp. 67f; J.S. Held, "Le Roi à la chasse", *The Art Bulletin*, No. 2, June 1958, p. 140.

26 Quoted from: C. Brown, *Van Dyck*, Oxford, 1982, p. 177.

27 Quoted from: R. Strong, "Van Dyck. Charles I on Horseback", *Art in Context*, New York, 1972, p. 32.

28 L. Hutchinson, *Memoirs of the Life of Colonel Hutchinson* (ed. J. Sutherland); Oxford, 1974; quoted in: C. Brown, *Van Dyck*, Oxford, 1982, p. 140.

29 Quoted from: C. Brown, *Van Dyck*, Oxford, 1982, pp. 140, 164.

30 Roger de Piles, *Cours de Peinture par Principes*, Paris, 1708, pp. 291ff; quoted in: C. Brown, *The Drawings of Anthony van Dyck*, Pierpont Morgan Library, New York, 1991, pp. 34f.

Biographical Outline

ANTWERP. 1599–1620

2 March 1599:
> Birth of Anthony van Dyck, seventh child, into the family of the rich cloth merchant Frans van Dyck and his wife, Maria Cuypers.

17 April 1607:
> Death of Van Dyck's mother.

October 1609:
> Enrolls in the Guild of St Luke as the apprentice of Hendrick van Balen.

11 February 1618:
> Is registered as a Master of the Guild of St Luke.

29 March 1620:
> In a contract drawn up between Rubens and the Antwerp Jesuits for the creation of 39 ceiling paintings for the new Church of the Order, of all Rubens' assistants only Van Dyck gets mentioned by name.

LONDON. 1620–21

October 1620:
> Thomas Locke writes from London to William Trumbull, an Englishman resident in Brussels, about Van Dyck's arrival in the English capital.

25 November 1620:
> Toby Matthew writes in a letter to Sir Dudley Carleton, an English diplomat and well-known collector, that King James I has granted Van Dyck an annual stipend of £100.

ANTWERP. 1621

28 February 1621:
> Receives a passport and permission, signed by the Earl of Arundel, to take an eight-month leave of absence; returns to Antwerp.

ITALY. 1621–27

October – November 1621:
> Arrives in Genoa and takes up residence in the house of Cornelis and Lucas de Wael.

February – August 1622:
> Works on portraits in Rome.

August – October 1622:
> In Venice.

October 1622 – January 1623:
> Accompanies the Countess of Arundel to Turin, Milan and Mantua.

1 December 1622:
> Van Dyck's father dies in Antwerp.

March – October/November 1623:
> In Rome.

October/November 1623:
> Returns to Genoa.

April – September 1624:
> In Palermo.

September/October 1624 – July 1625:
> Again in Genoa.

July 1625:
> Journeys to Marseilles and Aix-en-Provence, where he meets Rubens' correspondent Peiresc, whose portrait is to be found in Van Dyck's *Iconography*.

ANTWERP. 1627–32

Autumn 1627 (?):
> Returns to Antwerp, where his sister Cornelia dies.

September 1628:
> Joins the Jesuit Confraternity of Bachelors, "Soldaliteit van
> de bejaerde Jongmans".

May 1630:
> Van Dyck calls himself "painter to Her Highness"
> ["schilder van Heure Hoocheyd", i.e. the Infanta Isabel];
> however, he continues to live in Antwerp and does not
> move to Brussels, where the Infanta has her residence.

4 September – 16 October 1630:
> The French Queen Maria de Medici visits Van Dyck's
> studio during her stay in Antwerp.

Winter 1631–32:
> Works in The Hague at the court of Frederick Hendrick
> and Amalia van Solms, Prince and Princess of Orange.

LONDON. 1632–34

1 April 1632:
> Arrives in London.

5 July 1632:
> Knighted and made "principalle Paynter in ordinary to
> their Majesties"; takes up residence in Blackfriars, and in
> summer stays at Eitham Palace in Kent.

ANTWERP – BRUSSELS. 1634–35

Winter 1634:
> Makes a journey from London to Flanders.

18 October 1634:
> Van Dyck is elected honorary dean of Antwerp's Guild of
> St Luke.

November – December 1634:
> Lives in Brussels.

LONDON. 1635–41

Spring 1635:
> Again in London.

1639:
> Marries Mary Ruthven, a lady-in-waiting to Queen
> Henrietta Maria.

October – November 1640 (?):
> In Paris he tries unsuccessfully to procure the commission
> for the decoration of the Grande Galérie in the Louvre;
> returns to London.

October 1641:
> In Antwerp.

16 November 1641:
> Arrives in Paris.

1 December 1641:
> Birth of his daughter Justiniana.

9 December 1641:
> Van Dyck dies in Blackfriars.

11 December 1641:
> Buried in the choir of St Paul's Cathedral in London (his
> tomb was destroyed in the Great Fire of London of 1666).

Bibliography

GIOVANNI PIETRO BELLORI, *Le vite de'pittori, scultori et architetti moderni*, Rome, 1672.

ROGER DE PILES, *Conversations sur la Connaissance de la Peinture et sur le jugement qu'on doit faire des tableaux, où par occasion, il est parlé de la vie de Rubens et de quelque-uns de ses plus beaux ouvrages*, Paris, 1677. *Le Cours de Peinture par Principes*, Paris, 1708.

ARNOLD HOUBRAKEN, *De Groote Schouburgh der Nederlandsche Kunstschilders en Schilderessen*, 3 vols, Amsterdam, 1718–21.

Aedes Walpolianae, or Description of the Collection of Pictures at Houghton Hall in Norfolk, the Seat of the R.H. Sir Robert Walpole, Earl of Oxford, 2nd ed. with additions, London, 1752.

Catalogue des tableaux du Cabinet de M. Crozat, Baron de Thiers, Paris, 1755.

Vertue I. The Eighteenth Volume of the Walpole Society, 1929–1930. Vertue Note Books, vol. 1, Oxford, 1930.

HORACE WALPOLE, *Anecdotes of Paintings in England*, 4 vols, London, 1765–71.

P.J. MARIETTE, *Abecedario et autres notes inédites de cet auteur sur les artistes.* Published by Ph. de Chennevières and A. de Montaigon, 2 vols, Paris, 1853–54 (Archives de l'art francais, vol. 4).

F. LABENSKY, *Livret de la Galerie impériale de l'Ermitage de Saint-Pétersbourg*, Saint Petersburg, 1838.

G.F. WAAGEN, *Die Gemäldesammlung in der Kaiserlichen Ermitage in St Petersburg, nebst Bemerkungen über andere dortige Kunstsammlungen*, Munich, 1864.

LIONEL CUST, *Anthony van Dyck, An Historical Study of his Life and Works*, London, 1900.

Imperial Hermitage. Catalogue of the Picture Gallery (compiled by A. Somov), part 2 (Netherlandish and German Painting), St Petersburg, 1902 (in Russian).

G. GLÜCK (ed.), *Van Dyck. Des Meisters Gemälde in 571 Abbildungen. Klassiker der Kunst*, XIII; Stuttgart – Berlin, 1931.

MARIE MAUQUOY-HENDRICKX, *L'Iconographie d'Antoine van Dyck. Catalogue raisonné*, 2 vols, Brussels, 1956.

V. LOEWINSON-LESSING (ed.), *The Hermitage. Department of Western European Art: Catalogue of Paintings,* 2 vols, Moscow, 1958 (in Russian).

O. MILLAR (ed.), *Abraham van der Doort's Catalogue of the Collection of Charles I*, Oxford, 1960 (The Thirty-Seventh Volume of the Walpole Society, 1958–60).

HORST VEY, *Die Zeichnungen Anton van Dycks*, 2 vols, Brussels, 1962.

MARIA VARSHAVSKAYA, *Van Dyck: Paintings in the Hermitage*, St Petersburg – Moscow, 1963 (in Russian).

Sir Anthony van Dyck, Agnew's, London, 1968.

GREGORY MARTIN, *National Gallery Catalogue: The Flemish School c. 1600 – c. 1800*, London, 1970.

ROY C. STRONG, *Charles I on Horseback*, London, 1972.

ALAN MCNAIRN (ed.), *The Young Van Dyck*, National Gallery of Canada, Ottawa, 1980.

ERIK LARSEN, *L'opera completa di Van Dyck*, 2 vols, 1626–41, Milan, 1980.

The Hermitage. Western European Painting. Catalogue, vol. 2, St Petersburg, 1981 (in Russian).

OLIVER MILLAR, *Van Dyck in England*, National Portrait Gallery, London, 1982.

CHRISTOPHER BROWN, *Van Dyck*, Oxford, 1982.

J.S. HELD, *Rubens and his Circle*, Princeton, 1982.

CHRISTOPHER BROWN, *Flemish Paintings*, National Gallery, London, 1987.

NATALIA GRITSAI, *The Hermitage. 17th-century Flemish Painting: A Guide*, St Petersburg, 1989 (in Russian).

Anthony Van Dyck (Exhibition catalogue by S.J. Barnes, A.K. Wheelock, Jr., and J.S. Held), National Gallery of Art, Washington, 1990–91.

CHRISTOPHER BROWN, *The Drawings of Anthony van Dyck*, Morgan Library, New York, 1991.

De Bruegel à Rubens. L'école de peinture anversoise 1550–1650, exh. cat., Koninklijk Museum voor Schone Kunsten, Antwerp, 1992.

P. SUTTON, cur., *The Age of Rubens*, exh. cat., Museum of Fine Arts, Boston, 1993.

S.J. BARNES and A.K. WHEELOCK, Jr., *Van Dyck 350*, National Gallery of Art, Washington, 1994.

Van Dyck and his Age, exh. cat., Tel Aviv Museum of Art, 1995.

Index of Works

A:o Van Dyck